759.05
J92S

BROOKLANDS COLLEGE LIBRARY
CHURCH ROAD, ASHFORD, MIDDLESEX TW1
Tel: (01784) 248666
CHURCH ROAD, ASHFORD
MIDDLESEX TW15 2XD

# IMPRESSIONIST
# WOMEN

122894

BROOKLANDS COLLEGE LIBRARY
WEYBRIDGE, SURREY KT13 8TT

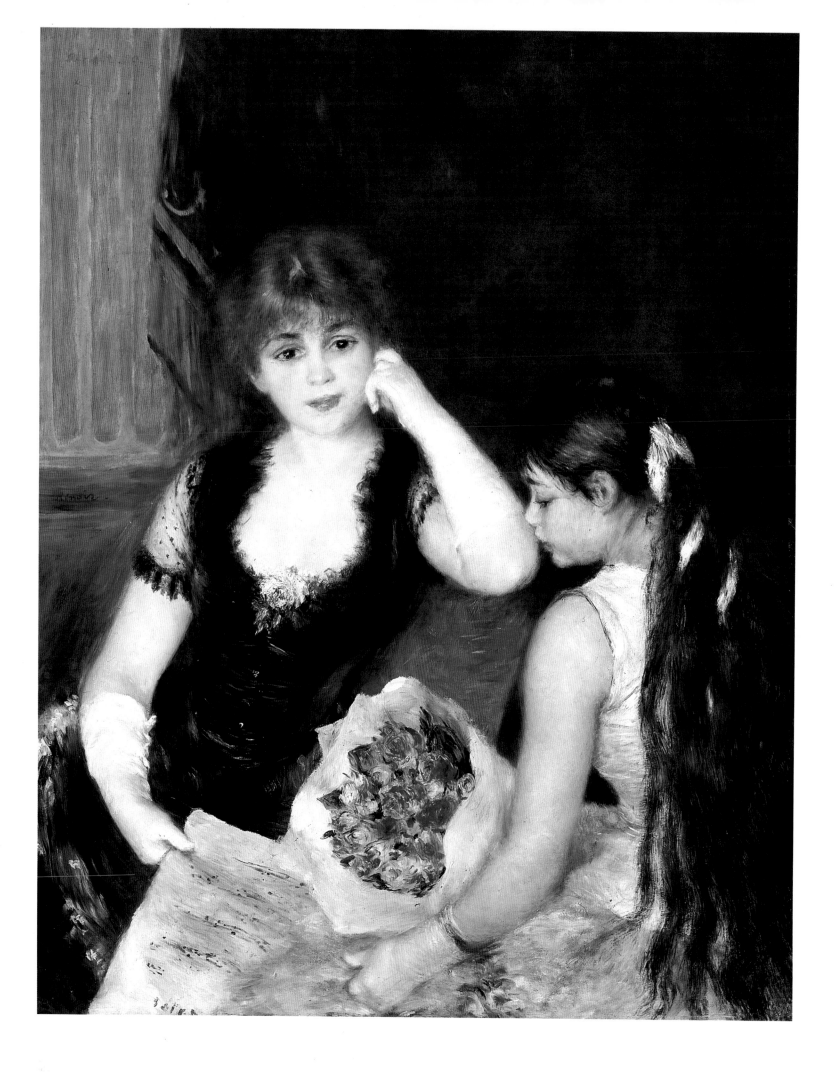

*Edward Lucie-Smith*

# IMPRESSIONIST WOMEN

PHOENIX ILLUSTRATED

Copyright © Edward Lucie-Smith, 1989

First published in 1989 by George Weidenfeld & Nicolson Ltd

This paperback edition first published in 1997 by Phoenix Illustrated
Orion Publishing Group, Orion House
5, Upper St. Martin's Lane
London WC2H 9EA

All rights reserved. No part of this publication may be
reproduced, stored in a retrieval system, or transmitted in any
form or by any means, electronic, mechanical or otherwise,
without prior permission of the copyright holder.

British Library Cataloguing-in-Publication Data
A catalogue record for this book is available from
the British Library

ISBN 1-85799-935-5

Designed by Ruth Hope
Printed and bound in Italy

Half title page: Mary Cassatt, *Femme cousant au jardin* (c. 1886)
Frontispiece: Auguste Renoir, *At the concert* (1880)

# CONTENTS

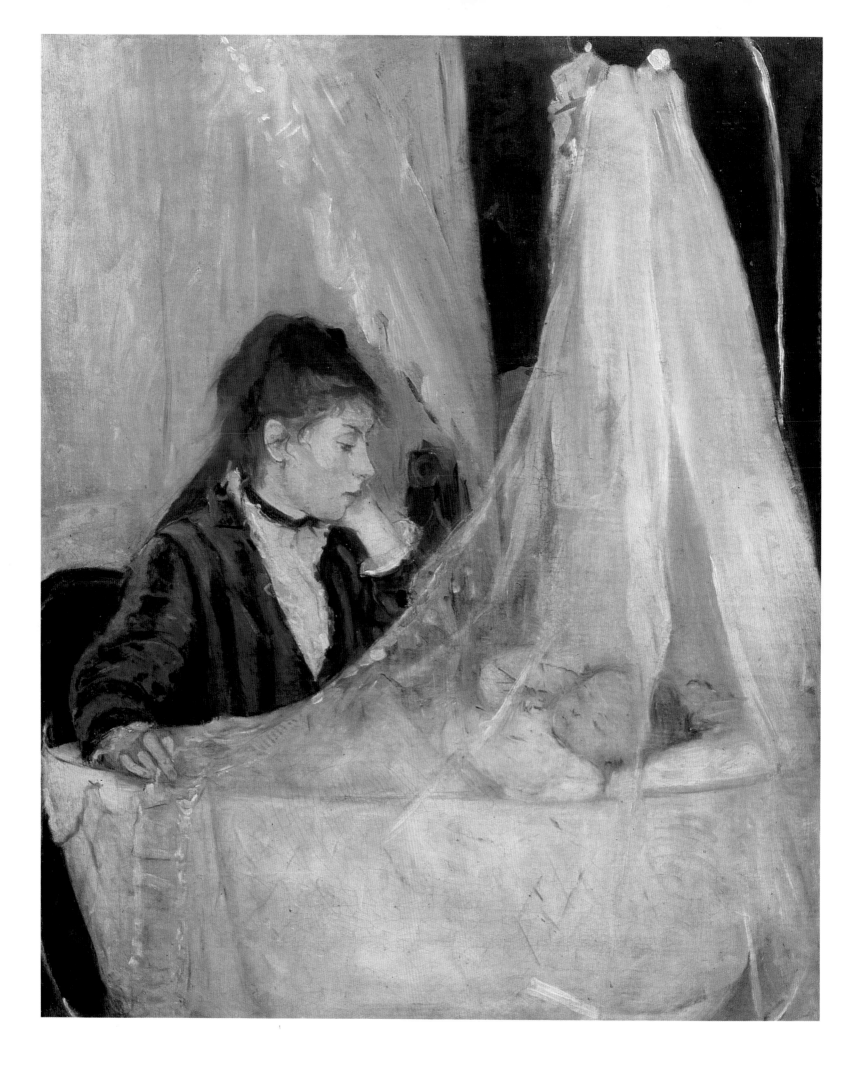

# Preface

The Impressionists were deeply concerned with women. Women and their activities formed a large proportion of their subject matter, rivalled only by pure landscape. Moreover, Impressionism was the first major art movement in which women played a leading role, both as innovators and as organizers.

The spectrum of attitudes towards women as revealed by Impressionist art is extremely wide. It ranges from the apparent misogyny of Degas to the instinctive sympathy with women's ideas, problems and feelings revealed by the work of Berthe Morisot and Mary Cassatt. It is important to remember, when attempting to draw a distinction between male and female attitudes within the group, that this is an issue revolving around class as well as gender. All the Impressionists, even Renoir – the only one with a genuinely working-class background, and the only one who married a working-class wife – aspired to bourgeois life styles, and indeed achieved them. However, the men were able to take advantage of a mobility within the class structure which was not granted to bourgeois women. A man could be in contact with women of a different class from his own, without causing comment. Many of Degas's behind-the-scenes ballet pictures are a commentary on this fact. He regards his little working-class dancers with sympathy, even at moments when he reveals the physical ugliness imposed on them by fatigue; he is less charitable about their upper-class male admirers. He even seems to have a kind of admiration for the prostitutes in his brothel monotypes, because he sees in them a cheerful imperviousness to their fate. This, however, is coupled with the fact that he often sees women as a completely different race –

1. Berthe Morisot, *Le Berceau* (1872)

more deeply animal, more instinctive, but also less intellectual and self-conscious. It is a paradox that Degas – of all the male Impressionist painters – was probably the one who did most to encourage his female colleagues. Friendly with Morisot as well as with Cassatt, he acquired their work for his collection. He also helped to arrange Morisot's memorial exhibition and it was of Cassatt, and not of a male colleague, that he remarked: 'There is someone who feels as I do.'

Of the other male Impressionists who are covered by this book, Manet and Lautrec had the most interestingly complex attitudes towards the opposite sex. Both, as can be seen from their work, had a great sympathy

2. Edgar Degas, *Répétition d'un ballet sur la scène* (1874)

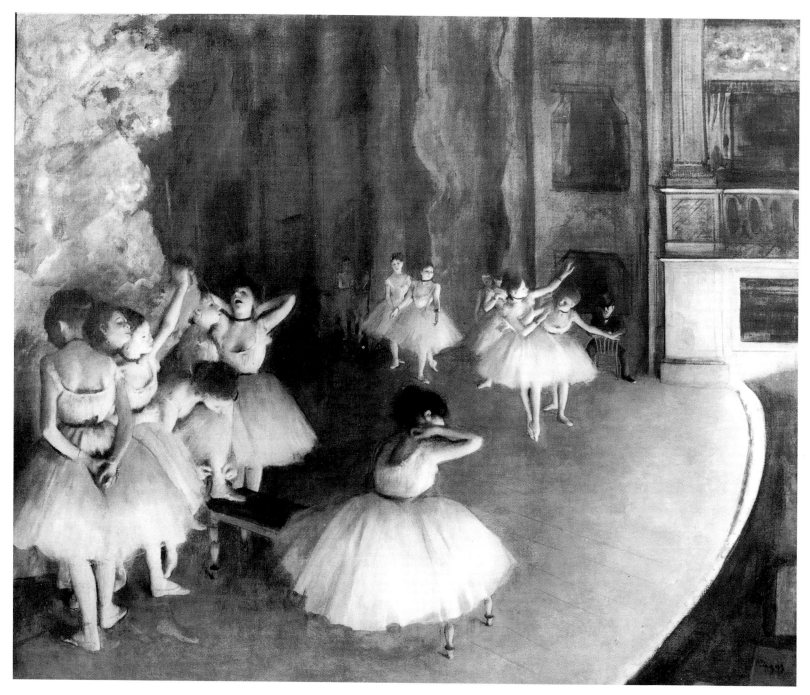

for women. Manet – notorious as a sexual aggressor, who traded frequently on the tolerance of his wife – was fascinated by 'femininity', and was an expert on the nuances of female finery. Many of his paintings – the celebrated *Olympia* most obviously (*see plate 92*) – represent women as dominant. When he shows the relationship of a couple, in *Chez Le Père Lathuille* (*see plate 16*), for example, and other 'courtship' paintings of the same type, the woman is generally in the process of rejecting the man's advances.

Lautrec, a grotesque dwarf, excluded by his appearance (or so he evidently felt) from relationships with women of his own class, shows a penetrating and sympathetic eye for female psychology – not only that of performers like Jane Avril, so different off the stage from the public persona she assumed when on it, but also that of the prostitutes who worked in the brothels where he lived for weeks at a time. The voyeuristic element in the brothel paintings, drawings and lithographs, while undoubtedly present, should not blind us to the balancing element of empathy.

Renoir, another great painter of women, is much less complicated. He sees women as indispensable members of the social make-up (as, for example, in *The Luncheon of the Boating Party* [*see plate 13*]); as objects of courtship (in the various *Dance* paintings [*see plates 10 and 11*]); as mothers and nurses (*see plate 30*); and – increasingly in his old age – as goddesses, idealized emblems of sexuality.

Morisot who, like Renoir, was affected during the second half of her career by the 'Boucher revival' – even painting a copy of a Boucher which she hung above her own mantelpiece – never ventures into this territory in her independent compositions. She is a domestic painter, and her two most frequent models are Edma, her sister, and Julie, her daughter. Mary Cassatt displays a similar restriction of subject matter. It is in fact this narrowness of theme which has been behind the tendency to withhold recognition from the work of the women Impressionists; their historical importance, their sheer originality and quality have only recently come to be acknowledged. They paint women's lives from the inside, looking out; Degas, Manet, Renoir and even Lautrec paint something which fascinates them because it still retains an element of mystery. Each time one of them paints a woman, he is trying to resolve his attitudes towards the female sex in general. Here can be seen the first symptoms of the great change in the relationship between the sexes, which is still working itself out at the present day.

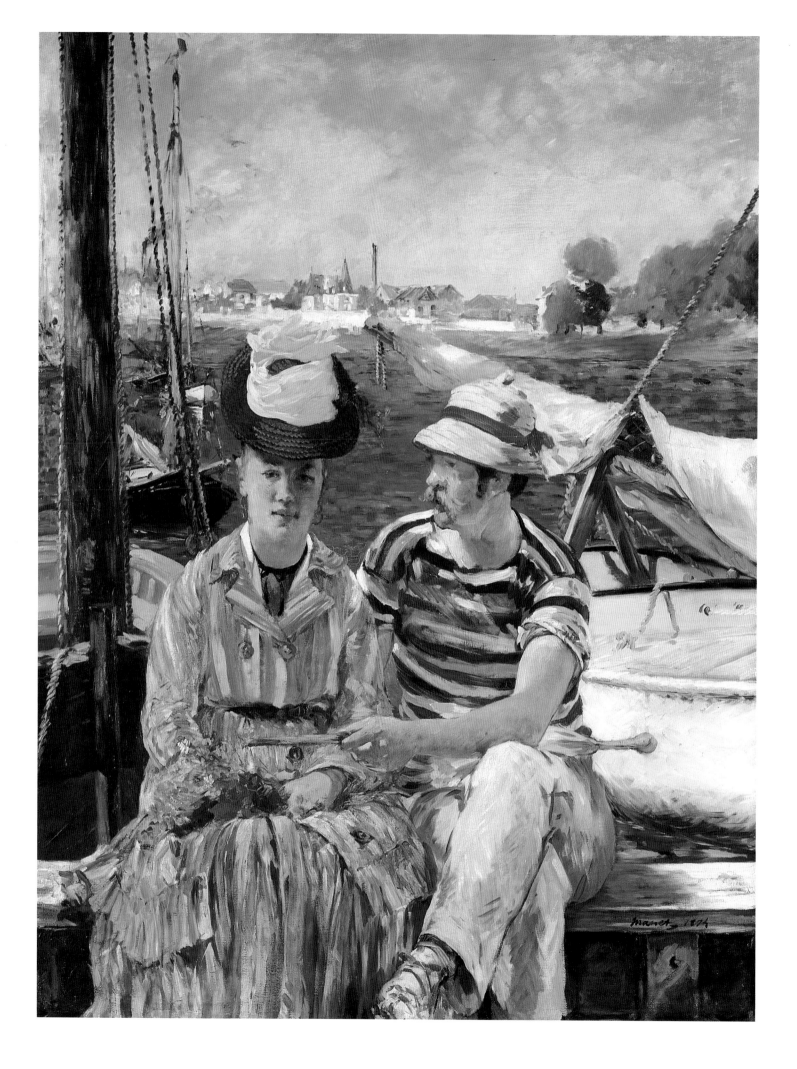

# REALITY
# OBSERVED

The Impressionist painters on occasion described themselves as 'realists' or 'naturalists'. Degas used the two words in a way which suggests that he thought that they were, for his purposes at least, interchangeable. The idea of realism was interpreted by the different painters in the group in a way which suited their own particular temperaments. Thus there is a world of difference between the dissolving luminosity of Monet's mature work, and the solidly constructed figures of Degas, himself still faithful to the doctrines of his master Ingres, the supreme advocate of drawing.

The range of subject matter tackled by Impressionist artists is also very wide – much wider than they have been given credit for, at least in the popular imagination. One leading Impressionist painter, Alfred Sisley, devoted himself entirely to landscape (and is therefore not represented in this book). Monet began as a figure painter, but, by the end of his career, was also devoting himself entirely to landscape, making a speciality of pictures painted in series, to show how a single, often wholly unremarkable motif, such as a group of haystacks or a row of poplars, changed its character according to different conditions of weather and light. Camille Pissarro was also primarily a landscape painter and, when he chose to paint figures, these were often the somewhat generalized peasants (*see plates 79 and 80*) derived from his study of the work of J.F. Millet.

Nevertheless a large number of paintings of figures remain to us as part of the glorious Impressionist legacy, and the vast majority of these feature women, rather than men. Even when a man is present, the focus of

3. Edouard Manet, *Argenteuil* (1874)

4. Auguste Renoir, *Diana* (1867)

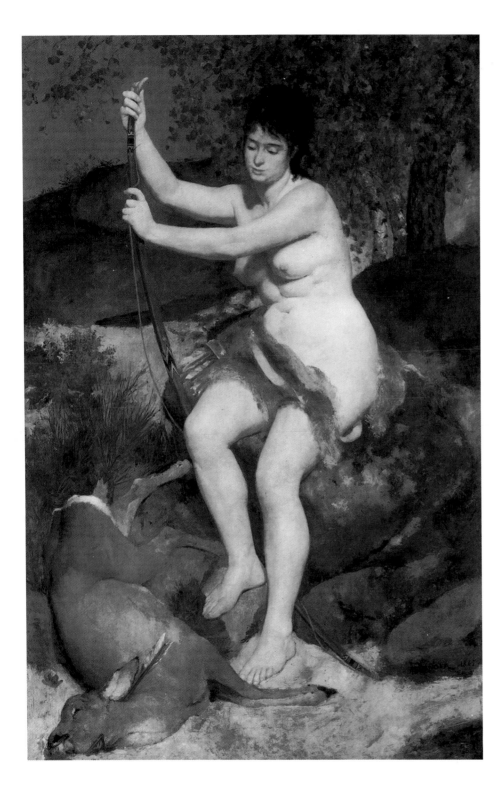

interest will generally be on his female companion or companions. But these women are often treated in a new and original way. The art world in which the Impressionists grew up, and which they rebelled against and tried to change, was dominated by the Salon, the huge exhibition of contemporary art held in Paris either annually or biennially throughout the nineteenth century. The Salon had its origins as early as 1699, and was at the height of its power after 1848, just when the Impressionists were

5. (opposite) Auguste Renoir, *Bather Arranging Her Hair* (1885)

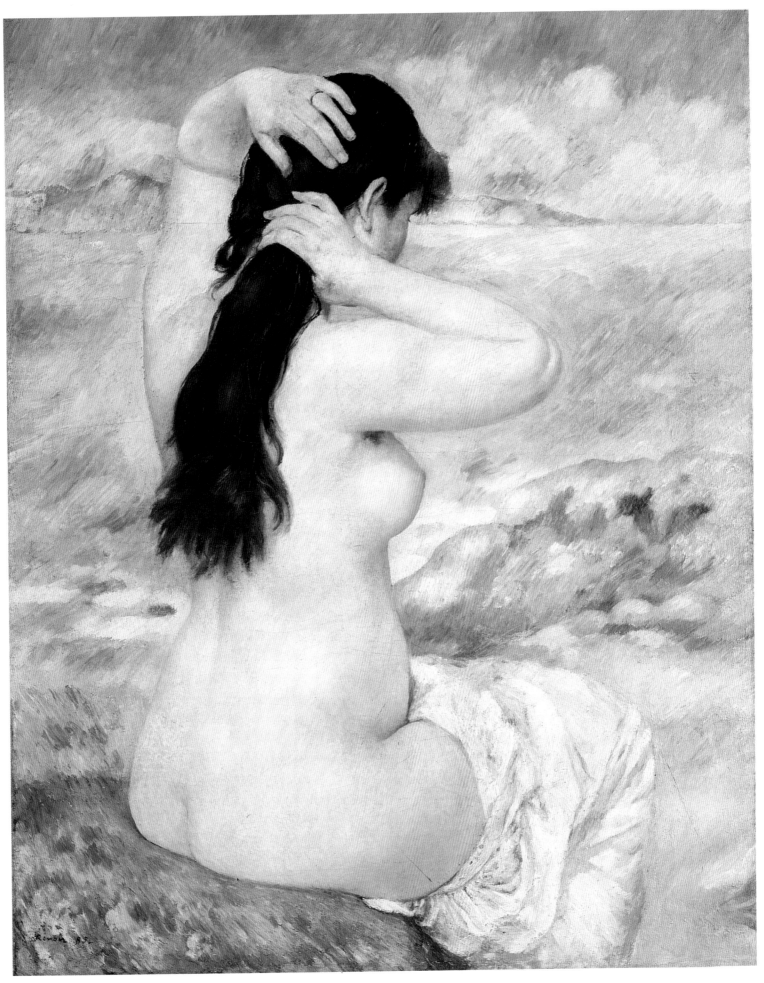

trying to make their mark. Thousands of paintings and sculptures were shown in each Salon, and thousands of visitors flocked to see them. Even after the French Government disengaged itself from the direct organization of the exhibition in 1880, this continued to represent, through the decisions of the jury responsible for choosing what was shown, an 'official' view of art. Painters who did well at the Salon could expect to be rewarded with the Légion d'honneur, both before 1880 and after it.

Both the Salon jury, and the critics who regarded the event as the be-all and end-all of art, were accustomed to arranging paintings in their own minds by categories, using an elaborate system of genres which had grown up since the end of the sixteenth century. At the top of the hierarchy was history painting. History painting was religious, allegorical, or depicted important historical events; the human figure was used on

6. (opposite) Edgar Degas, *Après le bain, femme s'essuyant les pieds* (1886)

7. Edouard Manet, *Skating* (1877)

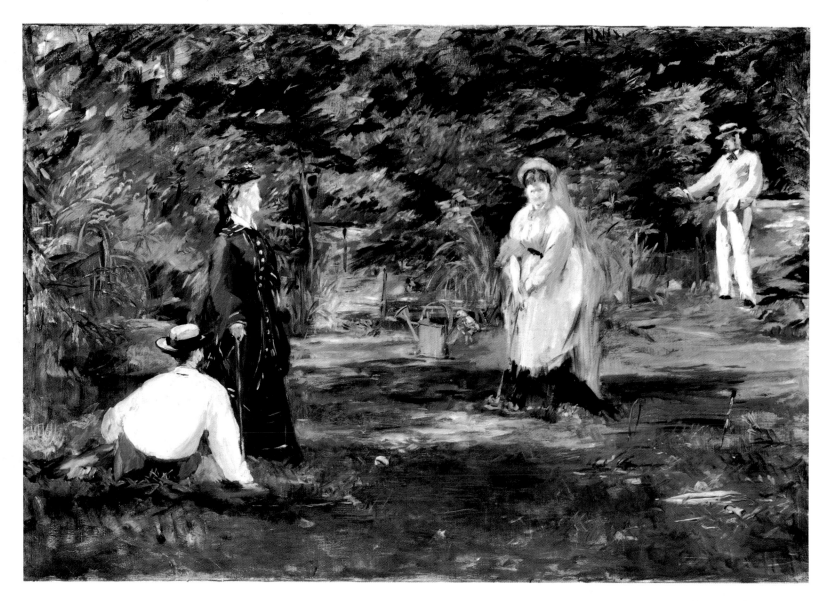

8. Edouard Manet, *The Game of Croquet* (1873)

the scale of life. Inferior to it, but still of major importance, was portraiture, often with the figure shown both life size and full length. Then followed genre painting, with small figures in realistic, generally contemporary settings; then landscape, and finally still life.

The Impressionists were not the first to challenge this system. They were preceded by Courbet, whose enormous depictions of contemporary scenes, such as his *Burial at Ornans*, shocked his contemporaries. They detected a political purpose in Courbet's art. By giving quite ordinary subject matter the dignity and massiveness of traditional history painting, he seemed to be issuing a challenge to the social hierarchy, as well as to a purely artistic one. This political purpose is not detectable in Impressionist figure painting. They accepted the existing categories and used them for their own needs on some occasions. At other times, they ignored them completely.

The traditional subject which interested them most, apart from landscape, was the female nude. Traditional art education laid great stress on drawing and then painting from the nude. But male nudes were often preferred to female ones, for reasons of Christian morality as well as for those of practicality. In the late fifteenth and early sixteenth centuries it was still the custom to draw from the *garzoni,* (young male studio assistants) even if a female figure was later to be represented. Female

models were, however, gradually introduced into artists' studios; and in sixteenth-century Venice artists, chief among them Titian, consistently began to make the female nude the subject of finished paintings. Almost invariably, these nudes were set in the context of classical mythology – Venus accompanied by Mars, or Diana surrounded by her nymphs. But there were also paintings where mythology was scarcely more than a pretext – the splendid series of reclining Venuses by Titian, for example, which begins with the *Venus of Urbino*. Paintings of this sort were undisguisedly erotic. The excuse for making them was that they were addressed to a special, courtly audience. To have access to such images was almost a mark of social status.

Erotic paintings of the female nude continued to be produced for court and aristocratic patronage throughout the seventeenth and eighteenth centuries. Some of the most elegantly playful were painted in France by François Boucher, during the first half of the eighteenth century. However, the social changes brought about by the French Revolution did not halt the production of female nudes. The main difference was that these paintings were now addressed to a new audience, bourgeois rather than aristocratic – the class which attended the official Salon in huge numbers every year, and which was now the main purchaser of paintings. This class had been created by the effects of the Industrial Revolution in France, and most of all by the favour extended by the July Monarchy of Louis-Philippe, and later by the Second Empire of Napoleon III, to the newly moneyed class of manufacturers and entrepreneurs. These new purchasers were more hedonistic and less well-educated than the patrons who had preceded them. They displaced the aristocracy and governmental agencies as the chief buyers, and what they bought reflected their own values, and what they wanted to see surrounding them in their own houses. There was a market for landscapes and flower pictures, for the exotic (the Orientalists did well), and for sentimental genre scenes. But nudes never went out of favour. Almost all the major French artists of the first half of the nineteenth century produced nudes – Ingres, Delacroix and Courbet – and these paintings are amongst their most dazzling works. Later artists such as William Bouguereau (1825–1905), whose paintings formed the backbone of the 'official' art which the Impressionists opposed, also produced many paintings of this type.

Ingres's nudes are amongst the most significant of the century, if one is trying to arrive at a definition of bourgeois attitudes. When he did not portray them in mythological or allegorical guise, he showed them as odalisques, that is, as inhabitants of some oriental harem, entirely subservient to male pleasure. These paintings are pervaded by a strange mixture of high and low impulses. On the one hand, there was Ingres's desire to produce something inhumanly perfect – an allusion to nature rather than a direct reflection of it. On the other, these languorous slaves are distinctly titillatory, full of a mixture of fascination with, and fear of, female sexuality.

The two Impressionist artists who paid most attention to the female

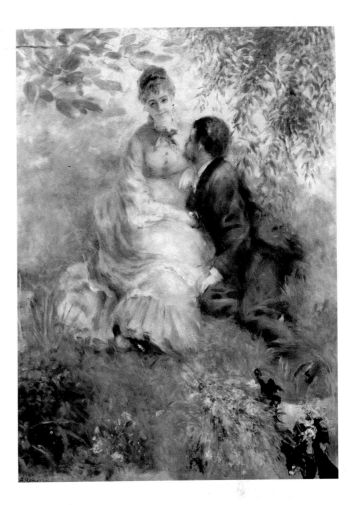

9. Auguste Renoir, *The Lovers* (c. 1875)

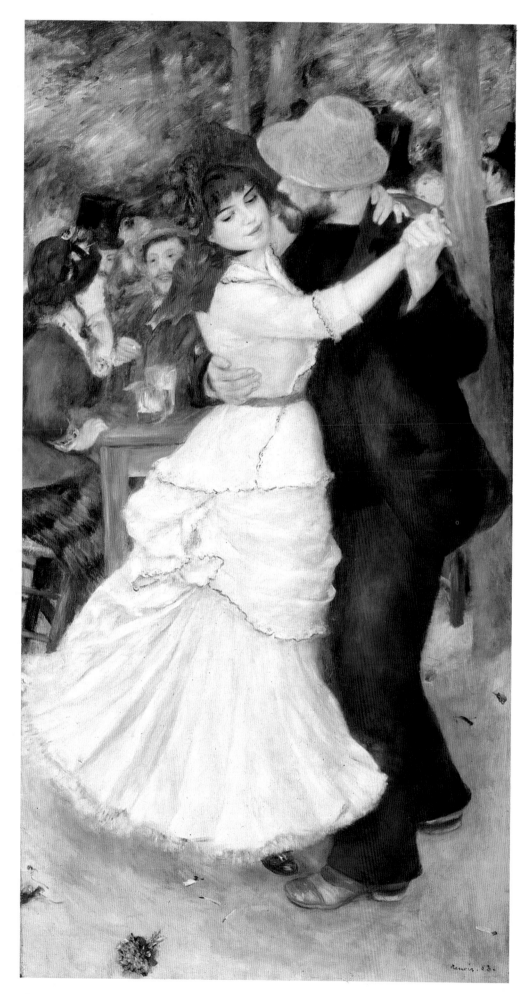

nude were Renoir and Degas, and their attitudes towards it are strikingly different from one another. At the beginning of his career Renoir produced a handful of female nudes which are an effort to respond to the prevailing academic conventions. Most ambitious is the *Diana* (*see plate 4*) of 1867. But this sincere effort to conform was turned down by the Salon jury of that year. The reason may have been that the figure, though equipped with appropriate mythological trappings – a bow, a quiver and a dead deer – is herself obstinately realistic; she is a typical artist's model of the time, and the painting is a dressed-up life study.

Of all the major Impressionist artists, Renoir was the one who struggled most vigorously to reconcile what he wished to do with what the public expected. One reason was that he, unlike Manet and Degas, was totally without private means. Another was that he was genuinely susceptible to what was in the air, to the general consensus of taste in his own day. One striking development in France, from about 1830 onwards, was an increasing passion for everything eighteenth-century. Artists like Watteau and Boucher, at one stage almost forgotten, were now eagerly sought by a new generation of collectors. Renoir, in any case, always had a hearty appetite for plump female flesh. Even when he is not painting the nude he comes across as the most sensual of all the Impressionist group; and nudes form a larger and larger part of his production as he grows older and more established. It was natural that he should look back to these eighteenth-century predecessors, and to Boucher in particular, who was so close to his own temperament. The female nudes he produced in these circumstances, however, delicious in form, texture and colour (they have sometimes been compared to plump, juicy fruit), were inevitably rather generalized (*see plate 5*). Even when we know the identity of the model – whether it is Aline Charigot, whom he eventually married, or Gabrielle, who lived with the Renoir family in the South of France and helped to look after the children – this is irrelevant to the purpose of the painting, which is simply a decorative object designed to radiate a joyous sense of wellbeing.

The nudes painted by Degas are also anonymous, but his approach and his purpose in making them were very different from Renoir's. Degas's nudes belong to the end of his life, and belong to a time when the artist had become increasingly reclusive. He was not merely reclusive, he was notoriously misogynistic, and the paintings (or pastels, rather, for by this stage he had almost entirely abandoned oils for this more flexible and experimental medium) necessarily embody his attitudes towards women, and towards human beings in general. Essentially he saw his subjects as almost purely animal. He once compared a woman washing to a cat licking itself. He wanted to catch his sitters completely off guard, behaving as if they were wholly unaware of the spectator's presence (*see plate 6*). He thus took the voyeurism already present in Ingres a stage further. Ever mindful of Ingres's dictum that drawing was 'the probity of art', he strove to render the physical presence of his models with great exactness, the precise shape and weight of bodies and limbs. But he also tried to get rid of all academic preconceptions – this was how the human

10. (opposite) Auguste Renoir, *Dance at Bougival* (1882–3)

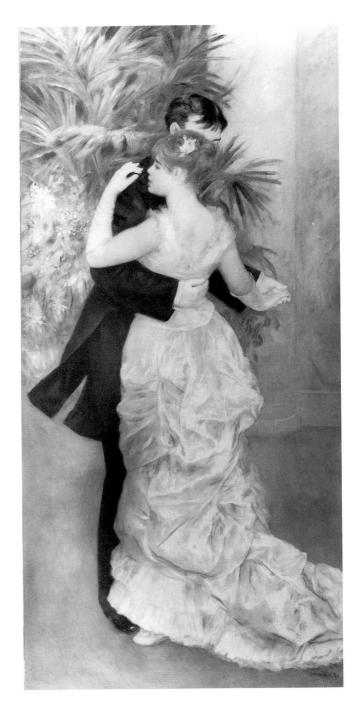

11. Auguste Renoir, *Danse à la ville* (1883)

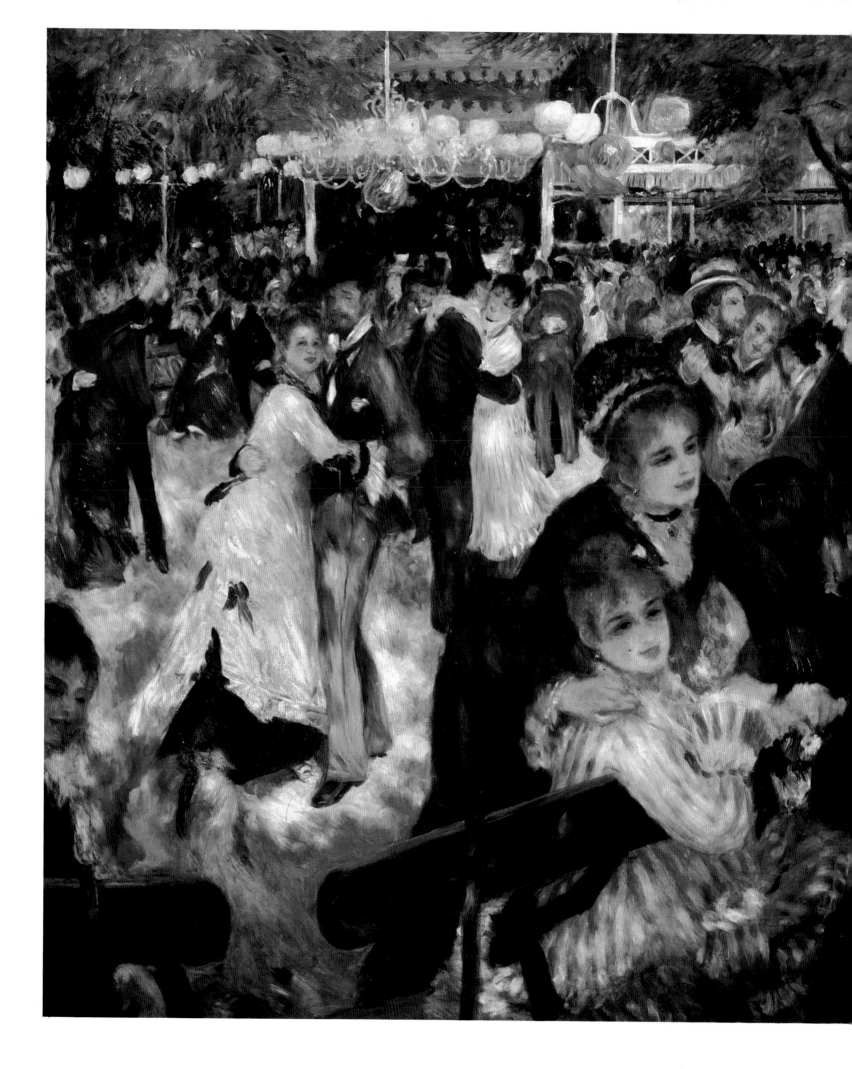

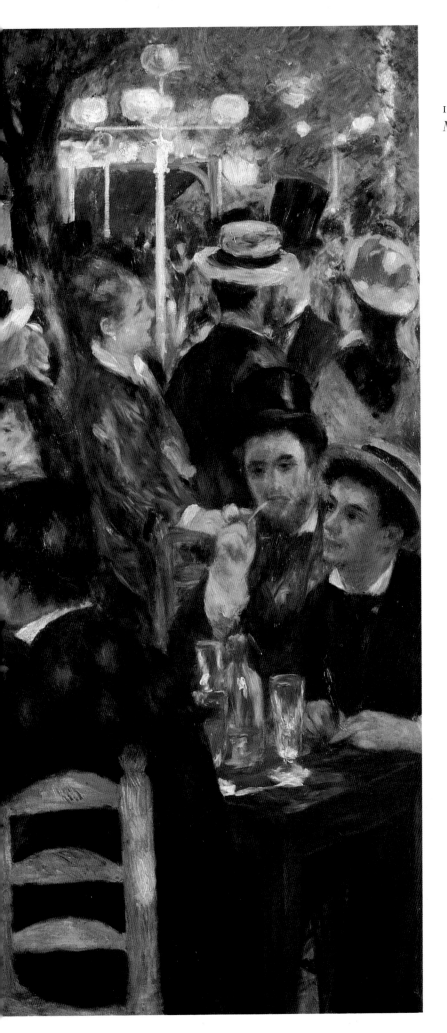

12. Auguste Renoir, *Le Moulin de la Galette à Montmartre* (1876)

figure actually looked, and not how it was supposed to look. The element of idealization, present in all academic paintings of the nude, and still there in Renoir, is entirely absent in these late nudes by Degas. His work represents a radical break with the tradition founded in the mid-sixteenth century and later modulated to serve the needs and tastes of the nineteenth-century bourgeois public.

The other established categories within which the Impressionists worked were portraiture, landscape and still life. These last two are not relevant to this book; the first will be dealt with in later chapters. What it is useful to consider here is the way in which Impressionist artists either abandoned the traditional hierarchy of subject matter altogether, or made radical alterations to its structure to suit their own artistic needs. Both of these topics affected the way they portrayed women.

13. Auguste Renoir, *The Luncheon of the Boating Party* (1881)

14. Auguste Renoir, *La Grenouillère* (1869)

Manet, for example, seems to have been influenced by popular prints. With the introduction of lithography in the early nineteenth century, leading artists had once again turned to print-making as a vehicle for their ideas. Géricault had been just one of those who was enthusiastic about the technique. These were not the prints to which Manet turned for inspiration, however; he was attracted by the naïve clarity of popular illustrations, which had no artistic pretensions and whose chief purpose was to convey information about a particular occasion or event. Paintings like *Skating* (*see plate 7*) and *The Game of Croquet* (*see plate 8*) represent a world of middle-class amusement more familiar in the illustrated periodicals of

the time than in serious art. There is no moral overtone, as there almost certainly would have been if Courbet had chosen to depict such intrinsically frivolous subject matter. Croquet was a new game, but merry skating parties are one of the stock subjects in seventeenth-century Dutch genre painting. In addition to using loose and free brushwork, quite different in style from the tight and meticulous work of the Dutch genre painters, Manet enlarges the figures in relation to their surroundings, and makes much more of their interaction with one another. Moreover, in these two paintings, he is portraying a world in

15. (opposite) Auguste Renoir, *Les Parapluies* (1882–3)

16. Edouard Manet, *Chez Le Père Lathuille* (1879)

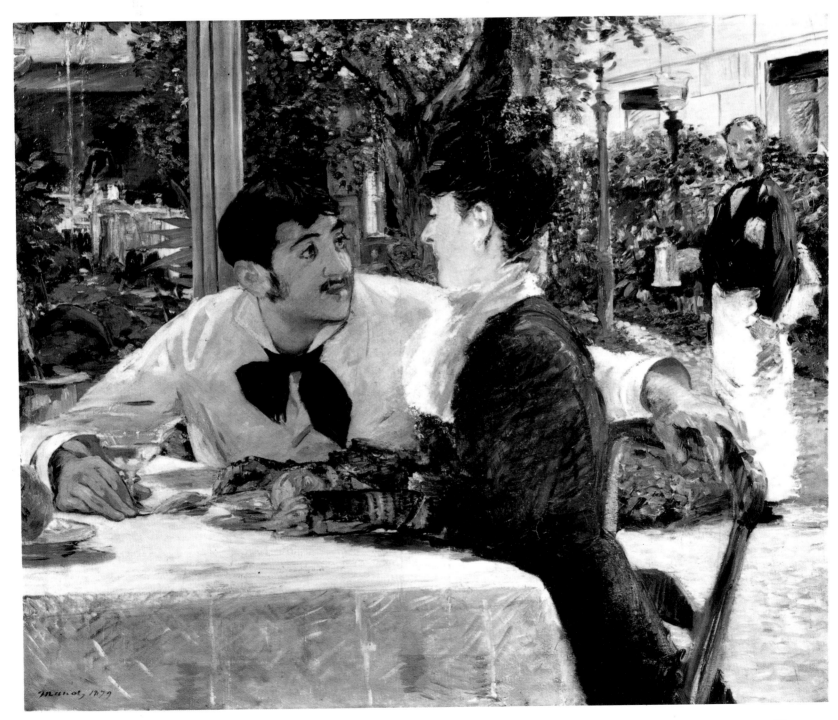

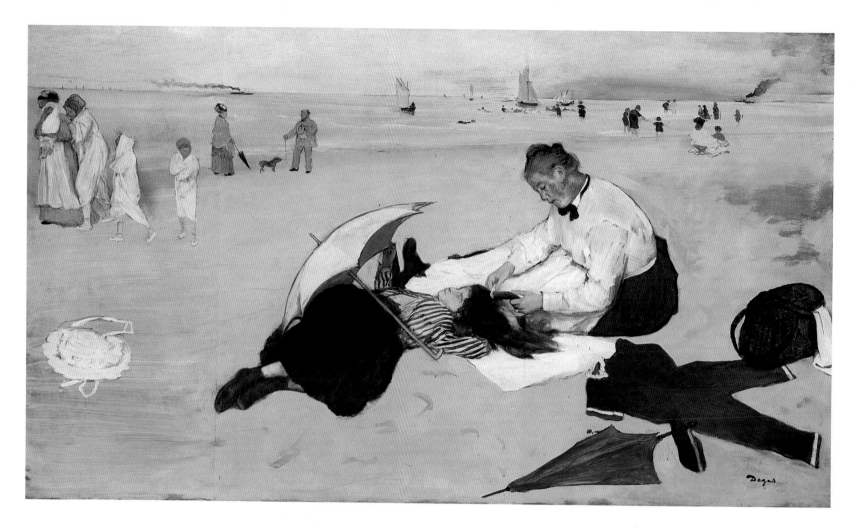

17. Edgar Degas, *At the Seaside* (*c.* 1876)

which women are more than a mere adjunct to the situation and the
men; they form the other half of the social equation.

This point is made, with more emphasis, in paintings by Renoir which
depict courting couples, *The Lovers* (*see plate 9*) in the Narodni Gallery,
Prague, for example, and the famous *Dance at Bougival* (*see plate 10*) in
Washington. *The Lovers* does undoubtedly have its precedents in the past.
This couple, seated in an idyllic rural setting, are the direct descendants
of the couples who appear in Watteau's *Voyage à Cythère*, and in numerous
other *fêtes champêtres* by that artist and his followers Pater and Lancret. All
that Renoir has done is to strip away the atmosphere of masquerade.

*The Dance at Bougival* is a different matter. It forms one of a group of
three paintings, all of which treat precisely the same theme – a couple
dancing. *The Country Dance* portrays a less prosperous, but nevertheless
flirtatious pair while, in the third painting, we see an upper-middle-class
couple in evening dress (*see plate 11*) who behave with appropriate
decorum. *The Dance at Bougival* is the most vigorous and forthright of the
three. The dance is openly a courtship ritual. The forceful eroticism of
the picture is greatly enhanced, not only by its lightness of tone and
bright colour, but by the fact that the figures are more or less life size.

Renoir provides a wider context for these courtship rituals in two large
scenes of 'modern life', *The Moulin de la Galette à Montmartre* (*see plate 12*) and
*The Luncheon of the Boating Party* (*see plate 13*). *The Moulin de la Galette* brings us to
the fringes of the Parisian world of entertainment to which the
Impressionists devoted many paintings (and examined in more detail
later). The place was an open-air dance hall in Montmartre, popular on

summer Sunday afternoons. Renoir represents a whole social cosmos, middle class and lower middle class. The focus has shifted from the dance itself to the group of young people chatting and flirting in the foreground. Two of the girls are especially striking. One, in a pink dress striped with blue, sits on a bench and turns right round to talk to a young man who has his back to us. Her companion, in black, clasps her shoulders and leans over to talk to the same young man. The whole situation is subtly nuanced – the girls are rivals for the man's attention, but at the same time allies in the game of flirtation. In no sense do they see themselves as inferior personalities to the men who surround them.

*The Luncheon of the Boating Party* offers an intimate view of a somewhat similar event – a jolly holiday luncheon under an awning, at the Restaurant Fournaise, at Chatou, on the banks of the Seine. Alphonse Fournaise, the son of the owner, is the figure standing on the right, wearing a straw hat and a singlet. This athletic garb is explained by the fact that he helped to launch the boats rented by the restaurant from the dock below this terrace. It is, in fact, neither this type of social occasion nor the place itself which acts as the subject of this picture; rather the relationships between men and women underlie the whole scene. The

18.  Edgar Degas, *Carriage at the Races* (c. 1872)

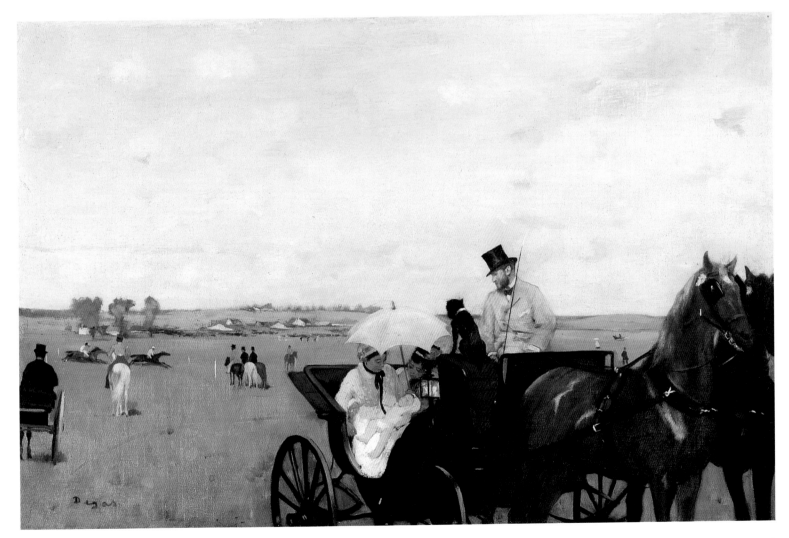

19. Mary Cassatt, *Woman and Child Driving* (1881)

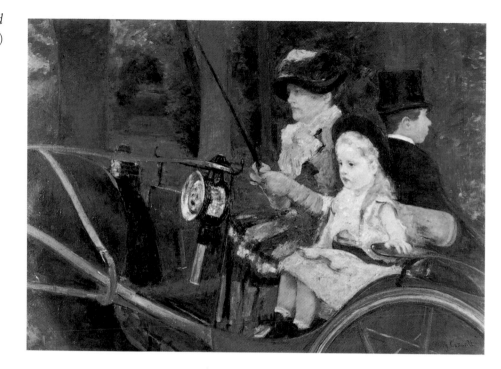

girl in the foreground on the left is Aline Charigot, Renoir's future wife; she is using the small dog she holds on her lap as an excuse for flirting with the man opposite her. Next to him at the table, a second girl turns to answer the suggestive remark made by the man who bends over her. Just outside the actual terrace, leaning on the railing which surrounds it, a third girl gazes speculatively at these dialogues, looking past a man with his back to us, who seems to stare boldly at her. The picture reflects a new enthusiasm for the outdoors, and sporting amusements. It also shows, as Robert I. Herbert remarks in his recent study of the Impressionists, 'a relaxed and harmonious society dominated by men (they outnumber women by nine to five) for whom the women are models and *matelottes* (female sailors) to be admired'. They are essentially as passive and as tempting, therefore, as the good things on the table.

*La Grenouillère (see plate 14)* was painted considerably earlier, when Renoir was perhaps less sure of his control over a figure composition of this type; it offers a distant view of a rather similar occasion. Here the figures are crowded on to a small artificial island, part of a resort where middle-class Parisians went boating and swimming. Here the effect comes, not from the interactions of figures seen at close range, but from the feathery sparkle with which the whole crowd is painted.

Like all the Impressionists, Renoir was a master at catching momentary effects, be they psychological or purely visual. His susceptibility to female charm and his quickness of eye manifest themselves in *Les Parapluies (see plate 15)*. The scene is a Parisian street. There has been a sudden shower of rain, and the pedestrians, mostly women, hold umbrellas. This motif seems to have been suggested to Renoir by Japanese *ukiyo-e* prints, then highly fashionable in Paris. In these the promenading geishas often make a similar pattern with their parasols.

20. (opposite) Mary Cassatt, *Mother about to Wash her Sleepy Child* (1880)

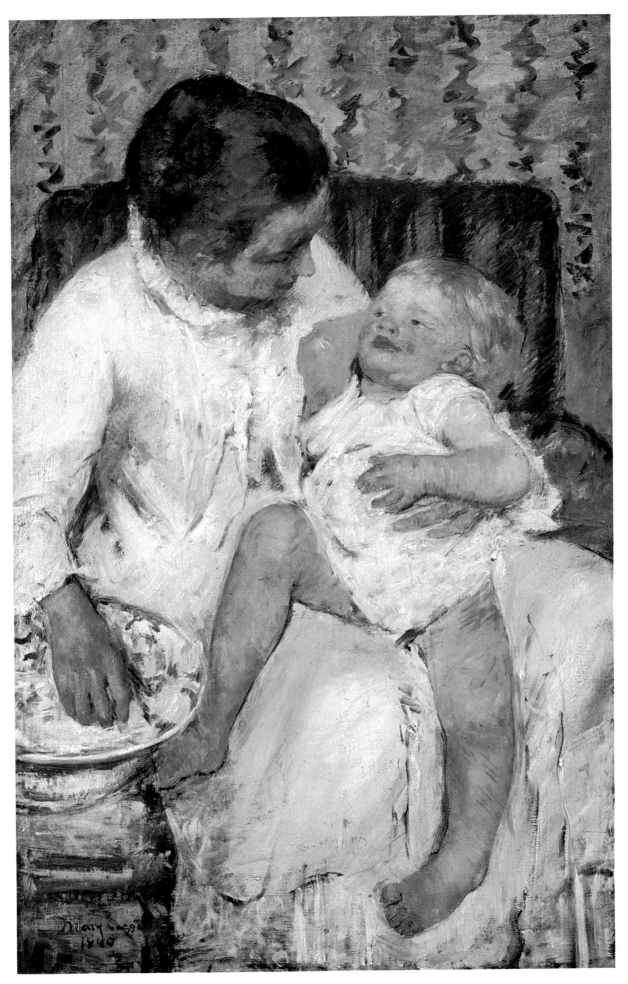

29

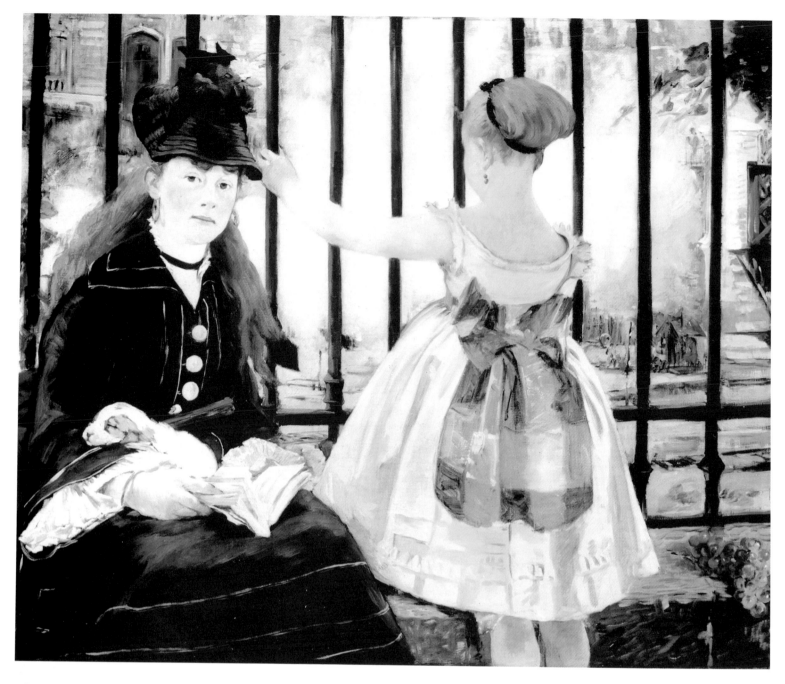

21. Edouard Manet, *Gare Saint-Lazare* (1873)

The passion for things Japanese had begun in 1854, when an American fleet under Commodore Perry had visited Uraga Bay, forcing the Japanese to open their country to foreigners. By 1862 the Japanese were participating in an international exhibition in London, and by the mid-1860s the fashion for Japanese artefacts was firmly rooted on both sides of the Channel. Prints, despised as valueless in Japan, frequently arrived in Europe as wrappings for things which were considered more important. Whistler, an artist closely associated with the Impressionists, must have been a major channel of information for them, as his earliest Japanese-inspired works date from this period.

*Les Parapluies* finds its emotional focus in the pretty girl to the right, holding a basket which suggests she may be some kind of *midinette* (shop girl). She has no umbrella, and the bearded man behind her tilts his in order to give her shelter. Meanwhile she gazes directly out of the canvas, with heart-stopping directness. One has the feeling that the whole ambitious canvas has been inspired by a fleeting encounter which could

only be exorcised from the painter's mind by creating a work of art.

The Impressionist painter who rivalled Renoir in his response to women was undoubtedly Manet. In different ways his *Argenteuil* (*see plate 3*) and *Chez Le Père Lathuille* (*see plate 16*) anticipate aspects of *The Luncheon of the Boating Party*. Both are courtship scenes, in specific settings. In *Argenteuil* a man, informally dressed for boating in a straw hat and striped singlet, pays court to a woman who is somewhat more elaborately clad and who

22. Claude Monet, *Le Déjeuner* (1868)

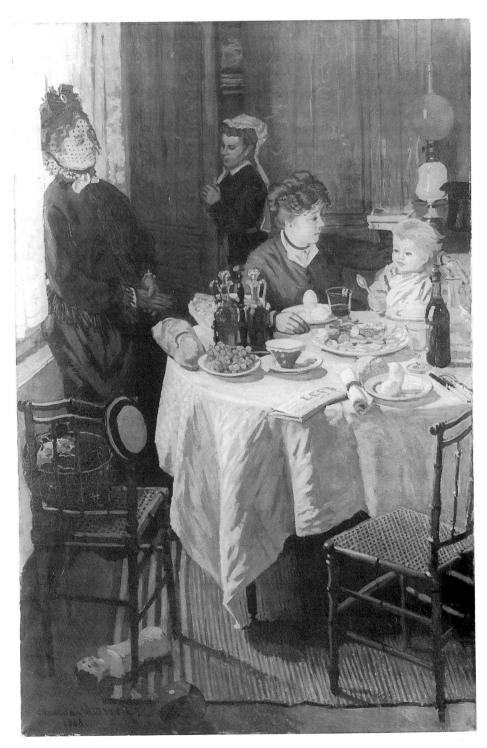

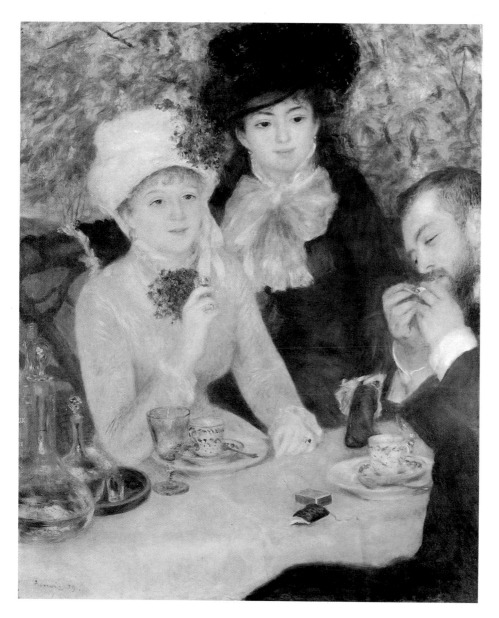

23. Auguste Renoir, *Le Fin du Déjeuner* (1879)

is carrying a spray of flowers. Her clothes mark her as lower middle class;
the man, despite his informal clothing, may in fact be her social superior.
Nevertheless she is impassive, and seems to ignore him; she is certainly in
charge of the situation. Her face has some of the calm of a Greek goddess;
even her posture makes her seem like a seated Demeter, the protector of
women.

*Chez Le Père Lathuille* is set, not at the waterside, but in the courtyard of
an old-established restaurant near the Boulevard de Clichy in Paris. It is
easy to assume that the couple shown are lovers lunching together, but
this is, in fact, not the case. While the woman has been taking a late lunch
– all the tables visible inside the restaurant are empty, and the waiter is
about to bring coffee – the young man, dressed as we would expect an
artist to be, is not seated, but kneeling on the ground, with his arms
stretched out to hold the back of her chair. She leans forward to listen,
but at the same time to avoid his gesture; he is, in fact, trying to 'pick her

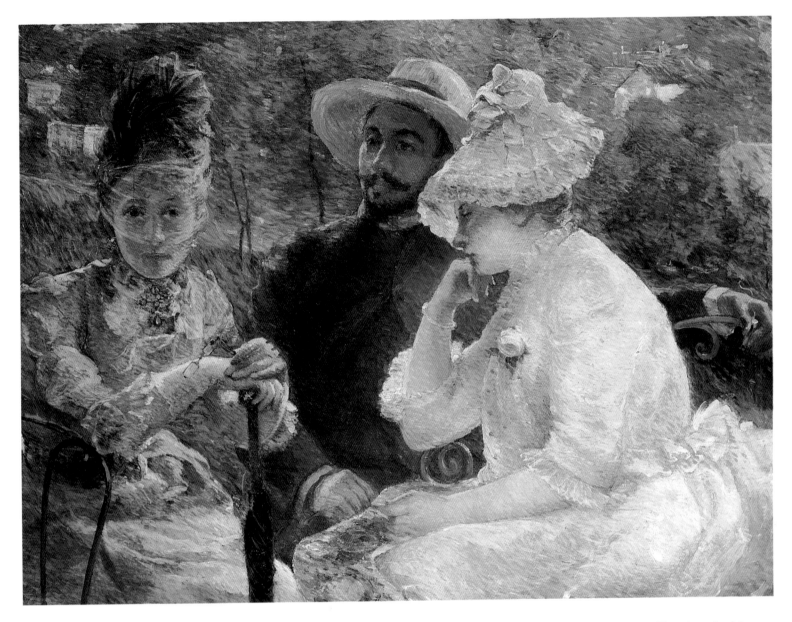

24. Marie Bracquemond, *Sur la terrasse à Sèvres* (1880)

up'. Her whole posture – the slightly sceptical poise of her head, chin drawn in a little towards the neck, and even the position of her hands in their lace mittens, resting lightly on the tablecloth but not pressing down on it – tells us that she is inclined to resist. The son of the proprietor of the restaurant posed for the male figure; for the female Manet used two sitters. One was the pretty actress Ellen Andrée; then, when Mlle Andrée failed to turn up for sittings, he switched to Judith French, a relative of the composer Offenbach. The sitters here are acting out a little drama, as they did in *Argenteuil* – a drama devised beforehand by the artist. In both cases, interestingly enough, Manet seems to sympathize with the female member of the duologue; his women are less passive than Renoir's, more able to act and decide for themselves.

Courtship scenes are almost absent in the work of the mysogynistic Degas – the nearest he gets to them are depictions of the young dancers receiving their admirers and actual or would-be protectors behind the

scenes at the Opéra. But he, too, especially in the earlier part of his career, could evoke a holiday atmosphere: *At the Seaside* (*see plate 17*), painted in 1876–7, for example, which shows a young girl lying on a beach, in the shelter of a propped-up sunshade, while her nurse combs her hair. Unlike the two Manet pictures discussed above, the main group of figures here was not painted *en plein air*. Degas said later that he posed the model in the studio on a flannel waistcoat instead of a towel. Yet the picture very successfully conveys a mood of privacy and physical intimacy.

*Carriage at the Races* (*see plate 18*) is more elaborate, and gives a subtle, and perhaps wholly unconscious glimpse of Degas's misogyny. It features the artist's friend Paul Valpinçon, with his wife, a newborn baby and a nurse. Valpinçon gazes down proudly from the box of his open carriage at his offspring, who is held in the nurse's arms and sheltered by a white sunshade. Mme Valpinçon peers in from the side – very much a secondary figure. By radical cropping of the various compositional elements – the carriage, for example, and the horses harnessed to it – Degas directs the audience's attention to the comparatively small figures, and to the emotional focus – the father's, not the mother's, bond with the child. Sporting paintings inspired by English exemplars had been introduced into French art by Géricault at the beginning of the nineteenth century; and had been further developed by the specialist painter of horses, Alfred de Dreux (1810–60). *Carriage at the Races* makes novel use of this tradition, by forcing the sporting element – a racecourse which must have been somewhere near the Valpinçon estate in Normandy – firmly into the background.

Degas's close friend, Mary Cassatt, may have been inspired by some

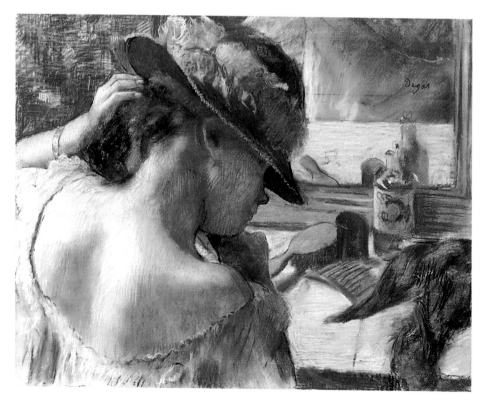

25. Edgar Degas, *Devant le miroir* (1889)

26. Berthe Morisot, *The Artist's Sister, Mme Pontillon, seated on the Grass* (1873)

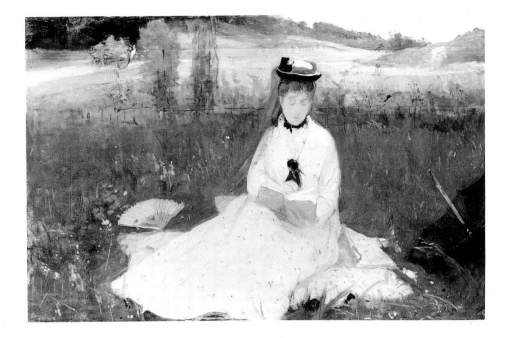

27. Eva Gonzalès, *Pink Morning* (1874)

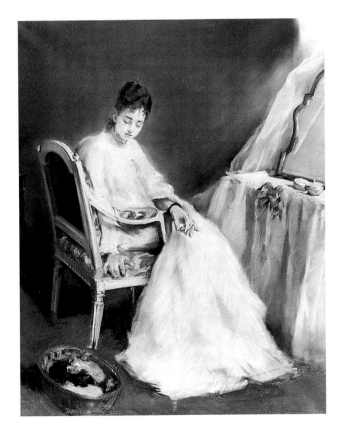

memory of *Carriage at the Races* when she painted the *Woman and Child Driving* (*see plate 19*), which is now in the Philadelphia Museum. In fact, there are about ten years between two pictures. In Cassatt's painting the spectator is brought much closer to the figures, which are larger in scale. Only the top half of the carriage is visible, and the rump of the horse. The woman driving is the artist's sister, and the little girl seated beside her is a niece of Degas. What is interesting here is the seriousness of their expressions, and their emotional separation. The woman looks nervous, tense, unaccustomed to what she is doing. The child pays no attention to her companion or her surroundings, but is lost in thought. It would somehow be difficult to mistake them for mother and daughter.

The mother and child theme does, however, appear very frequently in Cassatt's work. In fact, it is her chief preoccupation as an artist, as is beautifully exemplified by *Mother about to Wash her Sleepy Child* (*see plate 20*). One also finds it in the painting of Berthe Morisot; *Le Berceau* (*see plate 1*), which shows Morisot's sister, Edma, with her child, is a classic example.

Perhaps the most fascinating image of a woman and child, in Impressionist art, however, is Manet's *Gare Saint-Lazare* (*see plate 21*), in which it is uncertain what the precise relationship is. In this masterpiece, the 'painting of modern life', to use a term coined by Degas, achieves real symbolic force. What seizes the child's attention is the mechanical speed and energy typical of the late nineteenth century. She is looking down on the railway, which is out of sight, though its presence is revealed by swirling clouds of steam. The mature woman quite deliberately turns her back on all this activity, content to wait until the child has finished gazing. She occupies herself with a book, and the puppy asleep on her lap is the emblem of her tranquillity. It is appropriate that the setting chosen by the artist was very near the rue de Rome, a street inhabited by the subtle and ambiguous Stéphane Mallarmé, Manet's closest male friend in his latter years.

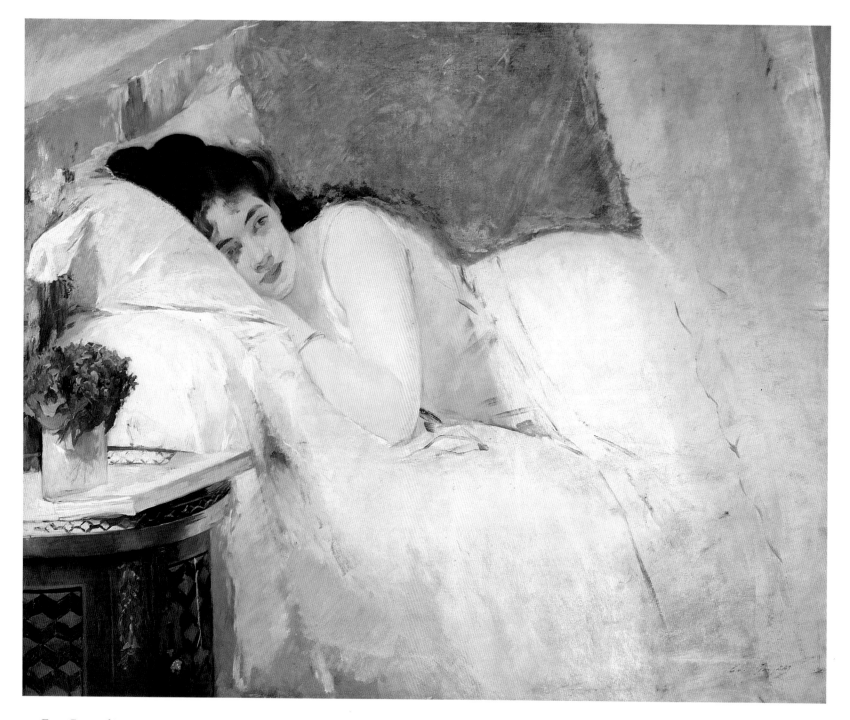

28. Eva Gonzalès, *Morning Awakening* (1876)

Generally, the Impressionist figure painters preferred some more obvious event: people at table, for example, offered an obvious way of delineating relationships, as we have already seen from *The Luncheon of the Boating Party* and *Chez Le Père Lathuille*. Every kind of meal is depicted in Impressionist art. The atmosphere can be politely raffish, as in Renoir's *Le Fin du Déjeuner* (see plate 23), or purely domestic, as in Monet's *Le Déjeuner* (see plate 22). However, this latter painting does have one curious feature. Monet's wife Camille appears in it twice — once seated at the table with her baby, and a second time standing in the window, gazing dreamily across the room. It is as if, by multiplying her presence, the artist was also

intent on stressing the universality of her role.

Even where nothing is being eaten or drunk – for instance in Marie Bracquemond's *Sur la terrasse à Sèvres (see plate 24)* – we are conscious that social interaction is one of the prime concerns of Impressionist art, with women playing the most important role.

There are also, however, many Impressionist works which portray women alone. *Devant le miroir* by Degas *(see plate 25)*, portrays its subject peering intently into the glass, competely absorbed by her own reflection. In Morisot's *The Artist's Sister, Mme Pontillon, seated on the Grass (see plate 26)*, the girl is completely absorbed by her book. Eva Gonzalès's *Pink Morning (see plate 27)* also creates a reflective mood, as the subject gazes contemplatively at some puppies in a basket: it is one of Fragonard's boudoir scenes transposed into a different and less licentious key.

There is greater directness, and also greater strength, in Gonzalès's *Morning Awakening (see plate 28)*, which shows her sister Jeanne just opening her eyes. The image conspicuously lacks the erotic quality which a male painter would almost certainly have brought to it.

In one of the most ambitious of all Impressionist canvases, Monet's *Femmes au jardin (see plate 29)*, the subject is both alone and not alone. Each of these four women is an image of Monet's first wife, Camille. In a series of fashionable costumes, she strikes poses reminiscent of Japanese beauties in their flowing kimonos – another example of the impact made on the Impressionists by Japanese art. But the picture is not a complete success, and one reason is that it is too impersonal. Monet, at this period in his career, was struggling desperately with what proved to be an intractable problem: the depiction of life-size figures in an open-air setting, lit exactly as they would be in nature. In order to achieve this exactness of vision, he had to paint out of doors. Previously it would have been customary to tackle such a large canvas in the studio, perhaps using sketches made *en plein air*. For the occasion, Monet also had to cultivate a kind of visual ignorance – to paint only what the eye told him, not what he *knew* to be there, by either memory or instinct. Camille was thus for the occasion drained of all individuality, to suit her husband's pictorial purposes. However, there will be plenty of opportunity to examine other images of her, as she appears in Impressionist painting almost more often than any other sitter.

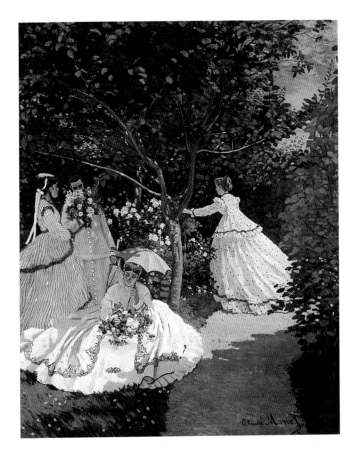

29. Claude Monet, *Femmes au jardin* (1867)

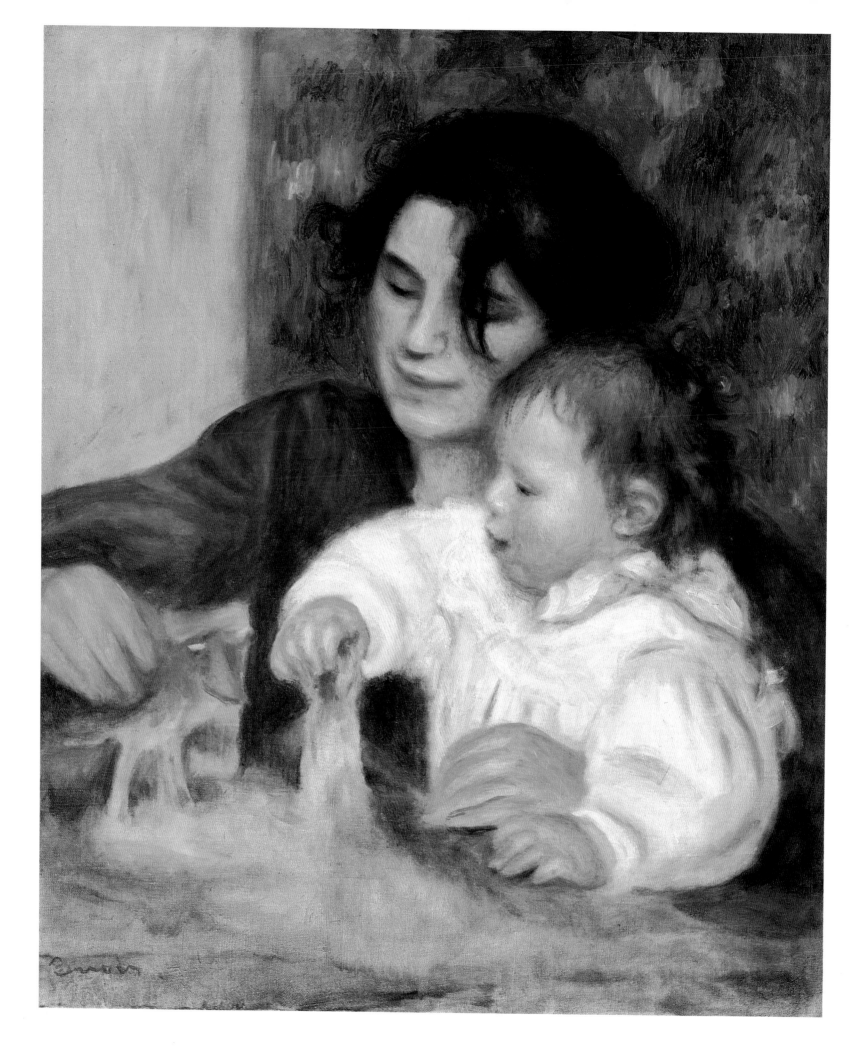

# FAMILY AND FRIENDS

It is not surprising that the Impressionist painters produced so many portraits of their wives, families and friends. They were conveniently to hand, and did not have to be paid modelling fees. More importantly, however, they were also part of the texture of the artist's everyday life, and it was this quotidian quality which Impressionism set out to render, and to glorify in the process.

Sometimes these family portraits seem to have been a kind of necessary tribute to bourgeois values, which the painters concerned did not wish to rebel against entirely. This is the case, for example, with Frédéric Bazille's *Réunion de Famille* (*see plate 31*), and with Gustave Caillebotte's *Portraits à la campagne* (*see plate 32*). These two men were amongst the most prosperous of the Impressionist artists. Bazille, till his early death in the Franco-Prussian War, was a constant source of help to his struggling fellow painters in the Impressionist group. Caillebotte was independently wealthy, and became one of the first major collectors of Impressionist art. He never had to market his own work, and painted entirely for personal satisfaction. *Portraits à la campagne*, which shows a gathering of female relatives, is unlike the rest of his work, where women rarely appear. The painting seems to owe a good deal to Fantin-Latour's paintings of his sisters Marie and Nathalie, seen reading or embroidering, and tells the same story of tranquil middle-class existence.

One of the best-known images in Impressionist art is that of Monet's first wife, Camille Doncieux (*see plate 33*). Like most Impressionist marriages, theirs began as an irregular liasion, and Monet came under heavy pressure from his family to abandon Camille, even after she

30. Auguste Renoir, *Gabrielle et Jean* (n.d.)

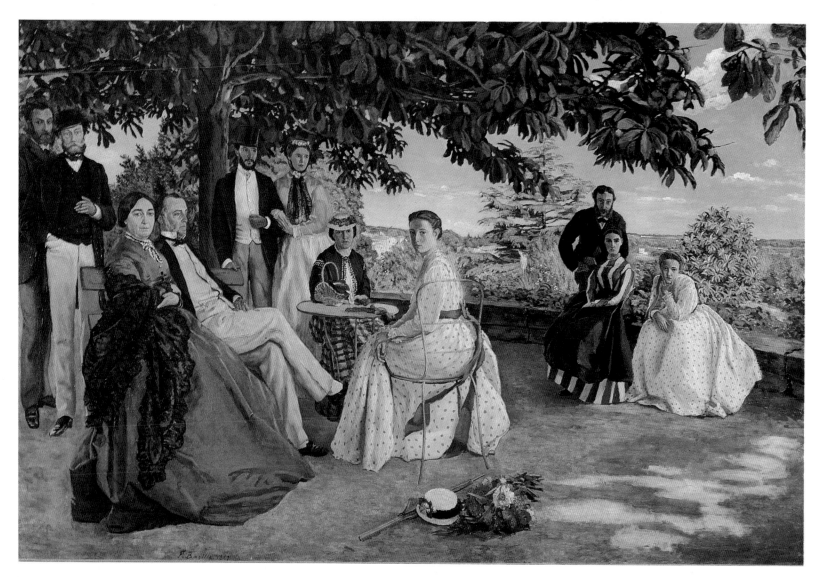

became pregnant. They met around 1865, but married only in the June of 1870, just before the outbreak of the Franco-Prussian War. Consequently, because Monet was determined to avoid military service, they were forced to flee almost immediately, to England. He crossed the Channel first and Camille followed later with their son Jean. They later returned to France and settled at Argenteuil on the Seine, just outside Paris. At first, Monet did comparatively well, largely as a result of the efforts of his new dealer, Paul Durand-Ruel, whom he had first met in London. Soon, however, the tide turned against him once more.

In the mid-1870s, Monet's life was complicated by a new relationship. He had a new patron, Ernest Hoschedé, the director of a Paris department store. Through Hoschedé, he met Alice, his wife. She and Monet were strongly attracted to one another and may have become lovers as early as 1875. By the spring of 1878, the situation had become more complicated still. Camille's health began to fail after the birth of her new baby, Michel. Hoschedé – never stable financially – was more or less bankrupt. For the sake of economy, the two households decided to amalgamate. They all moved to a house at Vétheuil, downriver from Argenteuil and a bit further from Paris. Here Camille died in September 1879. During her last illness she had been devotedly nursed by her husband's mistress. After Camille's death, the alliance became public knowledge. Ernest moved out, and in 1891, after his death, Alice and Monet were finally married.

31. Frédéric Bazille, *Réunion de famille* (1867)

Monet's portraits of Camille contain no hint of this tragic story, although he did make a heart-rending drawing of her on her deathbed. Two early full-length paintings, *Camille* (*see plate 33*), sometimes called *The Green Dress*, and *La Japonaise* (*see plate 34*) were both intended to demonstrate that Monet could produce the kind of full-length female portrait which was then in great demand with wealthy bourgeois patrons, for at that stage he still had ambitions for a career within the conventional mould. *Camille* was at least a momentary success. It won high praise from both conservative and 'progressive' critics in the Salon of 1866. Although the

32. Gustave Caillebotte, *Portraits à la campagne* (1876)

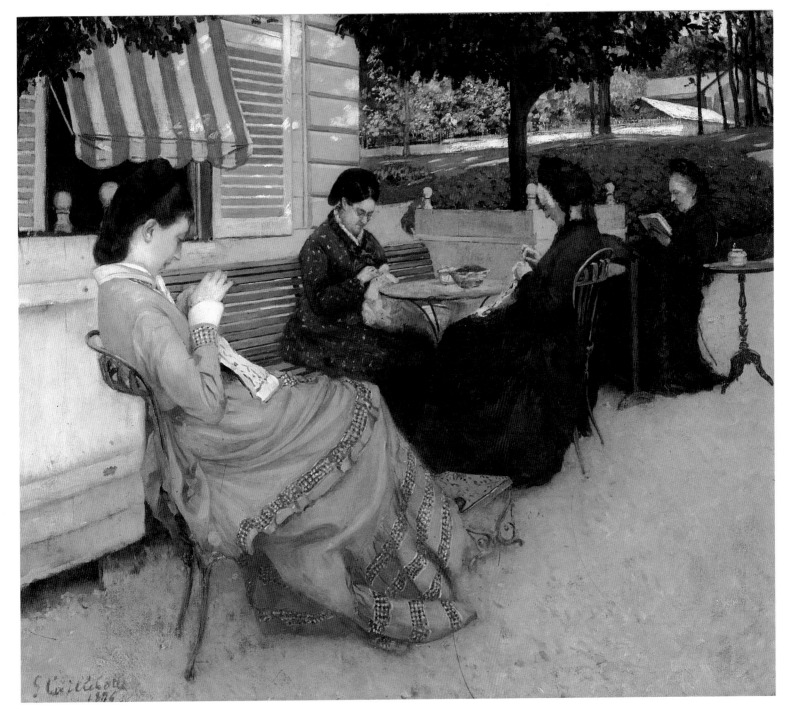

subject's considerable personal stylishness is easily and strongly conveyed in the first portrait, *La Japonaise*, in which she wears a kimono and flutters a fan – another tribute to the sudden European passion for Japanese art – is more charming. In fact, this second painting is Japan filtered through a Spanish sensibility. At the time one of the approved models for portraiture was Velasquez. Monet came to the great Spanish artist via Manet, who was heavily indebted to him. That alone might have made

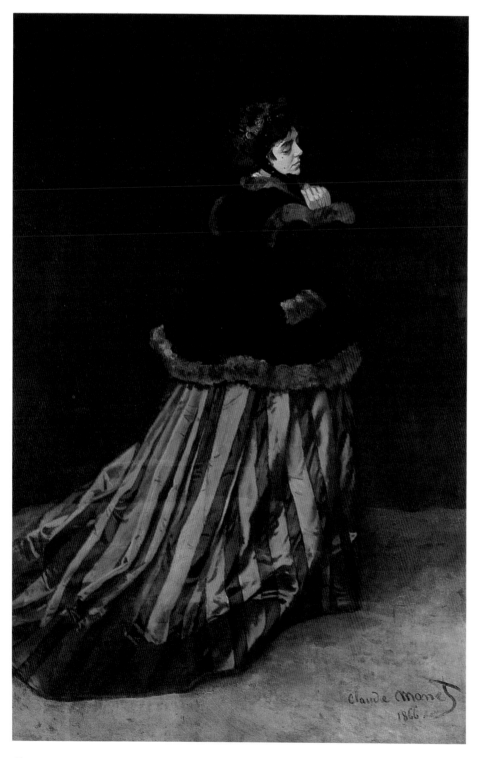

33. Claude Monet, *Camille* (1866)

34. (opposite) Claude Monet, *La Japonaise* (Camille Monet in Japanese Costume) (1875–6)

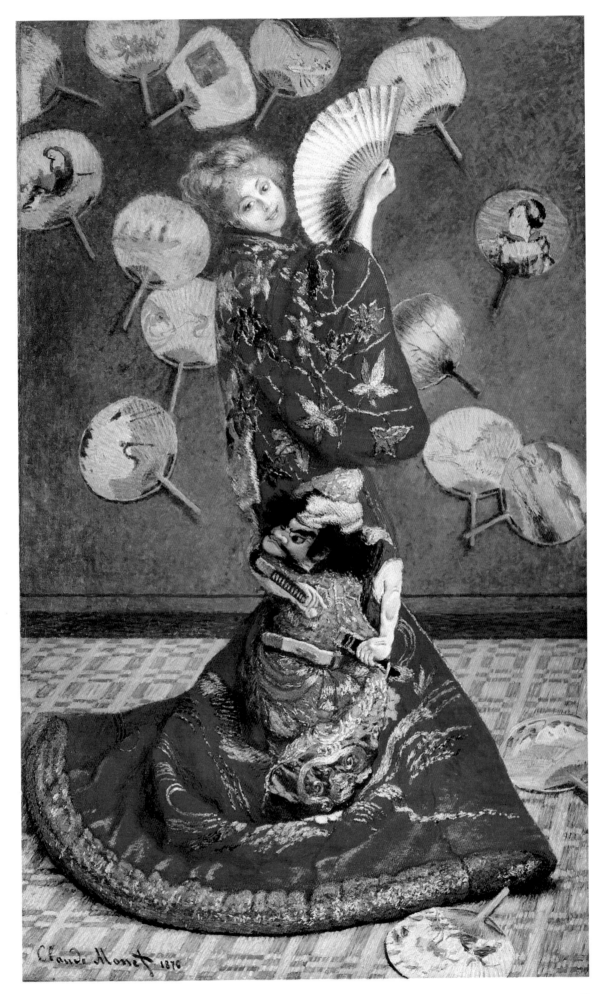

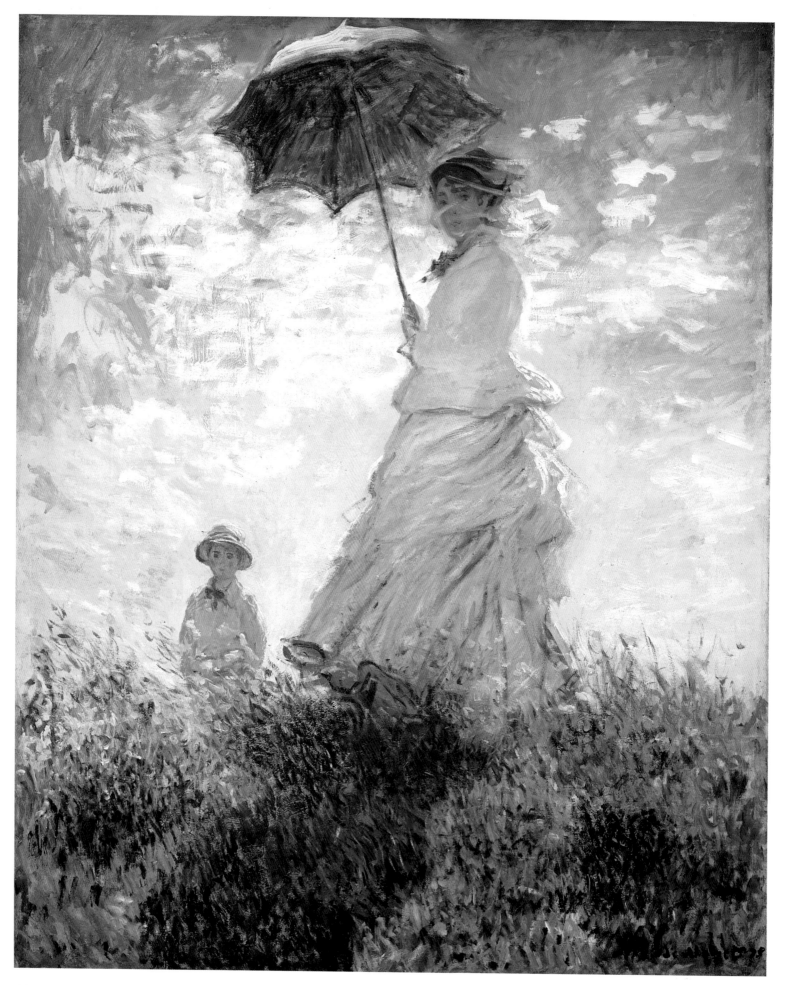

35. Claude Monet, *Woman with a Parasol — Mme Monet and her Son* (1875)

Velasquez an unwise choice of model — to conservative critics Manet was the devil incarnate — but Manet was not the only French interpreter of Velasquez at work in Paris at this time. Another, more acceptable artist was the young Carolus-Duran, then just coming into prominence as a successful portrait painter.

Far more significant, in terms of the direction Monet's career was to take, is his *Woman with a Parasol* (*see plate 35*), which shows Camille and her son Jean walking through the fields on a fine, slightly breezy day. The viewpoint is low, so that the figures tower above the spectator. Camille, dressed with her customary elegance, wears gauzy clothes that flutter in the wind. Although her face is turned towards us, she wears a veil, so that the features remain slightly indistinct. Impressionist art produced few more bewitching images than this, but the painting is really almost as impersonal as the earlier *Femmes au jardin* (*see plate 29*). In fact, Monet never became as fully engaged with figure painting as he did with landscape, although, when he attempted it, the results could be extremely successful in their own rather specialized terms. More and more, however, after the 1870s, he tended to move away from it. Monet did return rather briefly to figure painting at a later stage in his career. His subjects were now his second wife, Alice, and his stepdaughters Blanche, Marthe and Suzanne (Blanche was to marry Monet's elder son by Camille, Jean). *In the Woods at Giverny* (*see plate 128, page 154*) is typical of this group; the figures are scarcely individualized but are just incidents in the flowering landscape that contains them.

During the period when Monet lived at Argenteuil, the best known Impressionist painters were close to one another personally, and the Monet household received visits from both Manet and Renoir. Manet made a number of informal sketches: one of Monet himself, painting in his studio boat; and another of Camille Monet seated in the garden with her son Jean sprawling beside her and Monet himself gardening in the background (*see plate 36*). Renoir painted a very similar composition, but with the figure of Monet himself omitted. Both paintings convey the feeling of an idyllic summer day, and the poses of Mme Monet and Jean are so similar that it is likely that both artists were working simultaneously. Renoir had painted Camille on an earlier occasion as she reclined on a white sofa, reading a newspaper, from which she glances up enquiringly (*see plate 37*). These paintings seem to contradict the details of Monet's first marriage that have come down to us. Mme Monet is always beautifully dressed and apparently at leisure; there is no hint of encroaching ill health or underlying tension. It is clear of course, that when Monet's early letters to his family and friends contained piteous outcries about his 'poverty', he was talking about a very different kind of situation from that grinding poverty which harassed Van Gogh throughout his life. Paintings of the Monet household often suggest the presence of servants; a maid appears, for example, in *Le Déjeuner* (*see plate 22*). It is nevertheless true that Monet did suffer at this time from constant financial insecurity — the middle-class façade was preserved only with great difficulty. This struggle has been carefully edited out of the

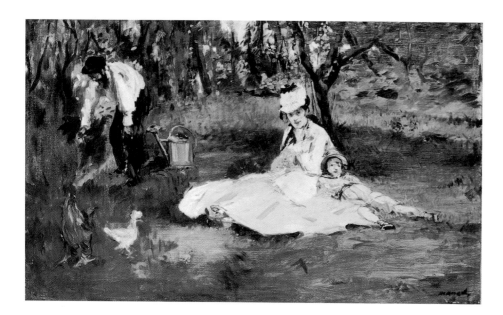

36. Edouard Manet, *The Monet Family in their Garden* (1874)

images of Camille produced by her husband and by his friends. She, who did not live long enough to enjoy the real fruits of Monet's professional success (which came bountifully even if they came late), is preserved for us in these portraits as the symbol of an eternally charming and pleasurable manner of life.

Edouard Manet was socially more sophisticated than Monet, much more of a *boulevardier*, much more attached to the city life of Paris. These aspects of his personality are accurately conveyed in his paintings of women. We also get the idea of a closer-knit but also more varied circle of friends than the one enjoyed by the Monet family at Argenteuil.

*Mme Manet dans la serre* (see plate 38) is one of a number of portraits Manet painted of Suzanne Leenhoff. In *Sur le plage* (see plate 39) she is seen with the painter's brother, Eugène Manet, but, wrapped in a veil, she is scarcely recognizable. Suzanne was Dutch, a gifted musician, with plump cheeks and fair hair. She came into Manet's life when she was appointed as piano teacher to himself and his brother. Suzanne and Manet were soon lovers, and she became pregnant. Both the relationship and the pregnancy, however, were carefully concealed from Manet's father, a high-ranking legal official and rather a severe character. When their son was born he was not registered in his father's name, and Suzanne presented the child to the world as her brother. Indeed, he was never to be officially recognized by Manet. The liaison was hidden from the world at large for thirteen years, until Manet's father died. Only at this stage did Manet marry Suzanne. She seems to have had an easy-going temperament, and was liked by the painter's friends, who admired her musicianship. It is likely that she had little understanding of Manet's art, even though she occasionally posed for him.

After Manet's death, having been left less well off than she expected, Suzanne began to sell off the work which remained in his studio. Her son – by this time grown up – did much of the business for her. Ambroise Vollard, the great dealer who acted as one of the promoters of Manet's

posthumous reputation, found her somewhat exasperating to deal with, as she did not always keep her promises to him, and sold to his rivals things which he had expected to get himself. She did, however, have copies made of works to which she was sentimentally attached. After her death, her son had these stamped with the words 'Inheritance of the dowager Madame Edouard Manet'. When the paintings bearing this inscription also got into the picture trade they caused confusion much worse than that already created by Mme Manet's business methods, or lack of them. Vollard was himself the representative of a new phenomenon – the rise of the private dealer. Durand-Ruel, who took up the cause of Impressionism in the years immediately after the Franco-Prussian War, had been the first. It was the hostility of the Salon juries towards the Impressionists, and their reciprocal hostility, which gave men

37. Auguste Renoir, *Portrait of Madame Claude Monet* (1872)

38. Edouard Manet, *Mme Manet dans la serre* (1876)

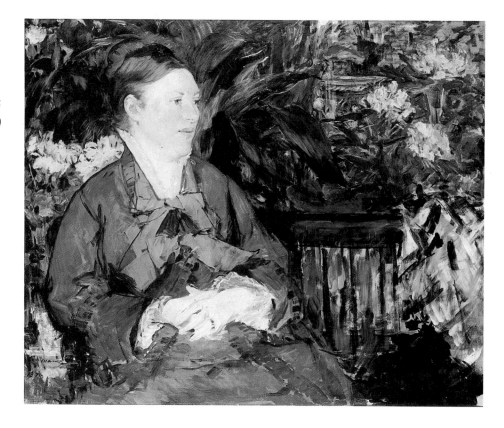

like Vollard and Durand-Ruel their chance. They helped create artistic reputations through one-man exhibitions, and they enabled the artists to live by buying their work on a contract basis; but they were not above a little sharp practice from time to time – from which the artists suffered.

Manet was better served by two intelligent female disciples – both represented in this book as painters in their own right. Of both he painted stunning full-length portraits. Berthe Morisot was a descendant of the eighteenth-century painter Jean-Honoré Fragonard; she was already twenty-seven years old when she was introduced to Manet by Fantin Latour. Manet already knew her work; he had seen and admired one of her townscapes in the Salon of 1866. Later he painted a version of his own, taken from the same viewpoint. An instinctive sympathy between Manet and Berthe developed immediately – it is not too much to say that they fell in love, although they had the good sense not to make any declarations to one another. Berthe was to pose for him on a number of occasions: she is one of the two women in *Le Balcon* (Manet's heartfelt tribute to Goya); and she appears alone in *Le Repos* (*see plate 40*), wearing a spotted white dress, and seated on a deep sofa. This is one of the most tenderly reflective likenesses painted by any Impressionist, and it is disconcerting to realize how poor a reception it got when it was seen for the first time. 'This slut in a white skirt, flopping on a couch, might be sleeping off her wine,' wrote one irritated critic.

Berthe jealously guarded her relationship with Manet, and was not pleased by the arrival in his life of another good-looking female artist. Eva Gonzalès, the daughter of an immensely successful popular novelist, was eight years younger than Berthe. Manet tended to play one women off against the other. He had met Berthe when she was already a fully trained artist, a veteran of the Salon. Eva, though gifted, was really more of a beginner, and Manet made her his pupil – the only real pupil he was ever to accept. When he painted a full-length portrait of her (*see plate 41*),

39. Edouard Manet, *Sur le plage* (1873)

he decided that it should show her as a working painter, at work on a still life of flowers. The point cannot have been lost on Morisot, who complained at the time that 'Manet lectures me, and holds up that everlasting Mlle Gonzalès as an example.... Meanwhile he is starting her portrait all over again for the twentieth time.'

Gonzalès's career did not last long. In 1879, nine years after Manet painted her portrait, she married Henri Guérard. In 1883 she died of an embolism, shortly after giving birth to a son. However, during the brief span fate did allow her, she produced some charming work. One of her most original and ambitious paintings, reminiscent of Cassatt's *Woman and Child Driving* (*see plate 19*) in the way the canvas is filled by the subject, is the unfinished *Donkey Ride* (*see plate 42*) of c.1880. This shows Gonzalès's sister Jeanne riding side-saddle, while Henri Guérard leans on the beast's neck, gazing up at her. Jeanne at one stage had ambitions to become an artist too. Apparently Eva did not approve of her sister's productions; across one of them she scrawled 'Stupid Jeanne *pinxit*'.

Berthe Morisot survived, on the other hand, to become one of the

pivotal figures amongst the Impressionist milieu, with an influence there that she would never have enjoyed in the Salon. In April 1874 she participated in the first Impressionist exhibition, the only woman to be invited to take part; later, she would be one of the chief organizers of subsequent Impressionist shows. It cannot be said that Berthe's influence was due entirely to talent and character: it owed something to her marriage, in 1874, to Eugène Manet – the painter's brother. She did not always find it easy to make her way as a woman artist. Certainly, in the earlier part of her career, male colleagues often felt they had a

41. Edouard Manet, *Portrait of Eva Gonzalès* (1869–70)

40. (opposite) Edouard Manet, *Le Repos* (Portrait of Berthe Morisot) (1870)

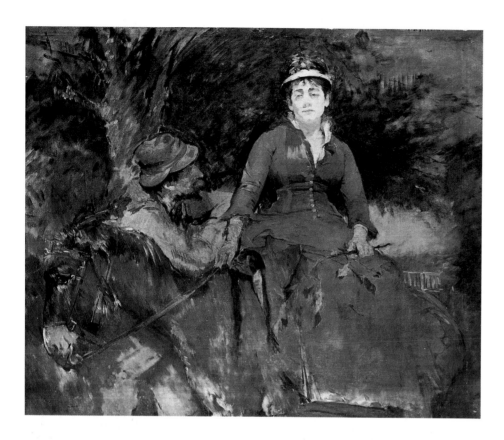

42. Eva Gonzalès, *The Donkey Ride* (c. 1880)

prescriptive right to alter and 'improve' her work. *The Mother and Sister of the Artist* (*see plate 43*), which Morisot painted in 1870, was first criticized by Puvis de Chavannes – prompting the artist to wipe out and repaint the head of the mother – and then heavily retouched by Manet. Although Morisot did not altogether like the result, she was afraid of offending her mentor, and sent this collaborative venture to the Salon, where it was accepted without hesitation. Four years later she seems to have thought more kindly of the painting, for it was one of those she showed at the first Impressionist exhibition.

Morisot's subject matter was alway domestic – she never attempted the broad range of themes used by her male colleagues. Early paintings often feature her sister Edma; later Julie Manet, her daughter, became a favourite subject for her brush.

Although within the Impressionist group Morisot's work is closest stylistically to the painting of Manet, she was admired by all her Impressionist colleagues, even those whose methods were quite different. One of her sincerest fans was the notoriously hard-to-please Degas, who helped to arrange a memorial exhibition after her death in 1895. He also later played matchmaker to Berthe's daughter Julie Manet bringing her together with Ernest Rouart, one of the sons of his old friend the wealthy collector Henri Rouart.

Because of his lifelong obsession with the work of Ingres, it might seem that Degas himself was predestined to be a major portraitist. He did, in fact, produce a large number of portraits during his early years, nearly all representing members of his large family. The masterly study of Julie

43. (opposite) Berthe Morisot, *The Mother and Sister of the Artist* (1869–70)

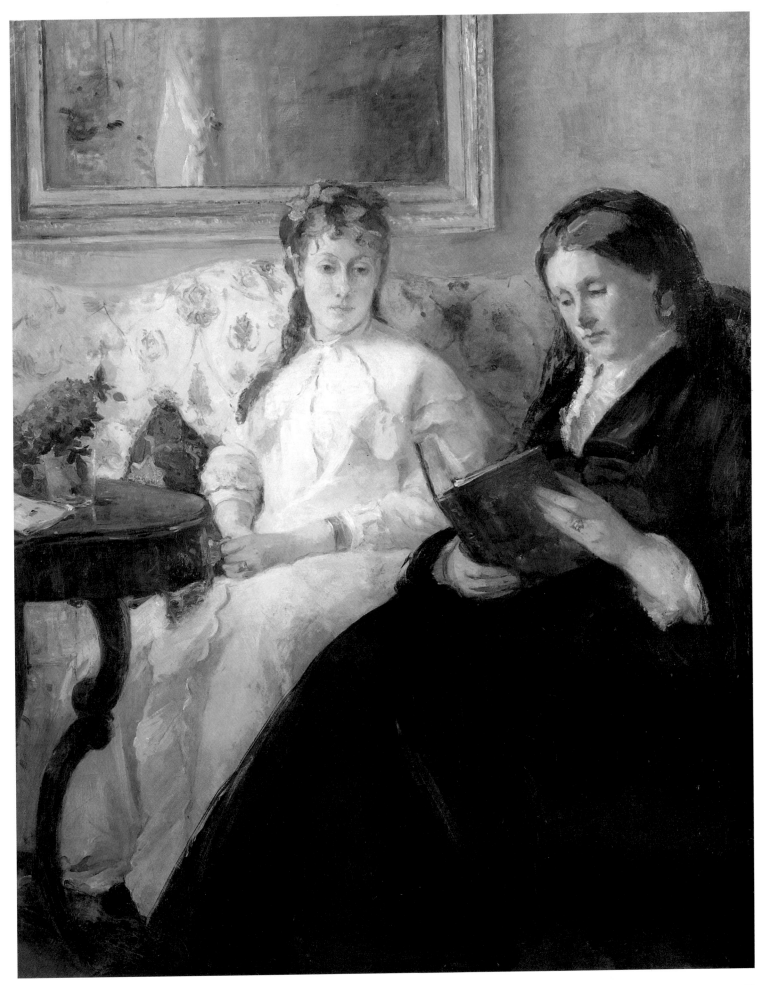

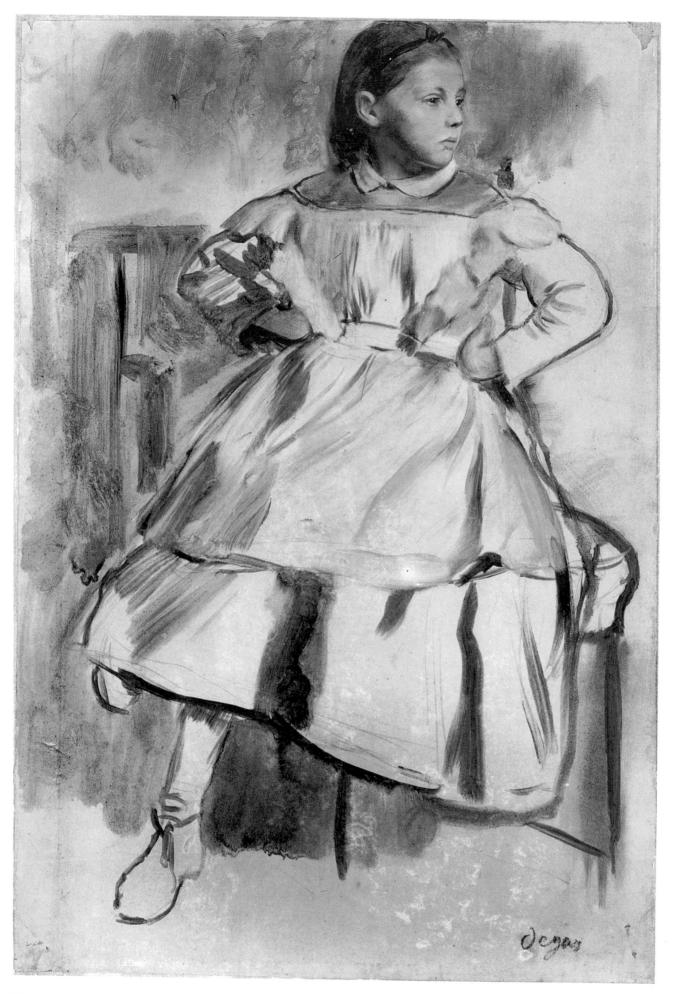

54

44. Edgar Degas, *Portrait of Julie Bellelli* (Study) (1859–60)

Bellelli (*see plate 44*), made for his ambitious group portrait *La famille Bellelli* (*see plate 45*), was started in Florence in 1858 but not fully completed until 1867; it bears witness to the brilliance of his gifts in creating likenesses. But Degas was too independent, and also too irascible, ever to make a success with likenesses painted to order. His one formal portrait commission was a disaster: the sitter rejected the picture because she said it made her look drunk. When Degas began to explore the subjects which he was to make peculiarly his own – dancers, laundry girls, bathing women – his output of portraits slowed to a trickle, and finally dried up altogether. If he did choose to paint a particular individual it was always because he or she had some personal meaning for him. Hélène Rouart (*see plate 46*), the subject of a strangely withdrawn and melancholy likeness, was the daughter of Henri Rouart, one of Degas's few real intimates. In 1897, when Degas had already become very reclusive, we find him writing to Henri: 'There is no task, no labour, nor any sacrifice I would not make for the pleasure of seeing you, believe me, my old friend.' In the painting, Hélène seems to be retreating behind the furniture, overwhelmed by the personality of her father's chum.

Degas's closest female friend was probably the American artist, Mary Cassatt. Cassatt, like Degas himself, was privately wealthy; like him, she possessed an astringent tongue. Degas had been aware of her work for some time before they met in 1877, and she of his. 'There is someone who feels as I do,' he remarked, after seeing one of her paintings in the Salon (she exhibited there in 1872, 1873, 1874 and 1876). Cassatt, who moved to Paris in 1873, first saw a work by Degas in the window of his dealer Durand-Ruel's gallery. She later recalled: 'I used to go and flatten my nose against the window and absorb all I could of his art. It changed my life. I saw art then as I wanted to see it.' Soon after they met Degas asked her to stop showing her work at the Salon and to exhibit instead with the Impressionist group. She accepted with great enthusiasm; 'Finally I could work with absolute independence, without concern for the eventual opinion of a jury.'

Professional esteem soon ripened into something closer and more personal, though the friendship remained strictly platonic. Degas said: 'I would have married her, but I could never have made love to her.' Perhaps Cassatt came to resent Degas's physical indifference to her, or perhaps his astringency of vision was difficult for even her to bear. At any rate, it is clear that she disliked the picture which comes closest to being a formal portrait of her. She is shown seated, holding some playing cards (*see plate 47*). Nevertheless the artist presented it to her. In 1912 she decided to get rid of it; she wrote to Durand-Ruel:

> I particularly want to get rid of the portrait Degas made of me which is hanging in the room beside the drawing room (my studio). I don't want to leave this portrait by Degas to my family as one of me. It has some qualities as a work of art but it is so painful and represents me as such a repugnant person that I would not want anyone to know that I posed for it. . . . If you think my portrait

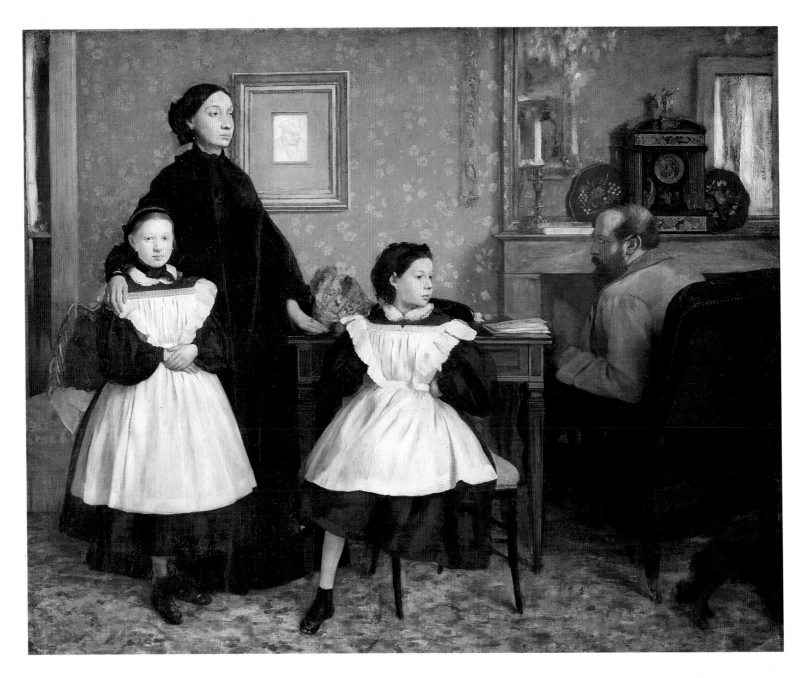

saleable I should like it sold to a foreigner and particularly that my name not be attached to it.

She may have been better pleased with the painting entitled *Mary Cassatt au Louvre* (*see plate 48*), which shows only her back. Degas was so fascinated with this that he made a number of versions, some of which also include the image of Cassatt's sister Lydia. The figure is a practical demonstration of the theory, put forward by the nineteenth-century critic Edmond Duranty, that a back view could be just as effective as a formal portrait in revealing both the social position and the actual character of the sitter. Certainly these pictures of Cassatt reveal, not only her personal elegance (she was always very well dressed), but her intense absorption in what she is observing.

Cassatt often painted members of her own family, and especially her sister Lydia, whom we have already seen portrayed in *Woman and Child Driving* (*see plate 19*). She appears in a wide variety of different guises in her sister's work: *Woman Reading* (*see plate 49*) is rather severe – it contrasts

45. Edgar Degas, *La famille Bellelli* (1858–60)

46. (opposite) Edgar Degas, *Portrait of Hélène Rouart* (1886)

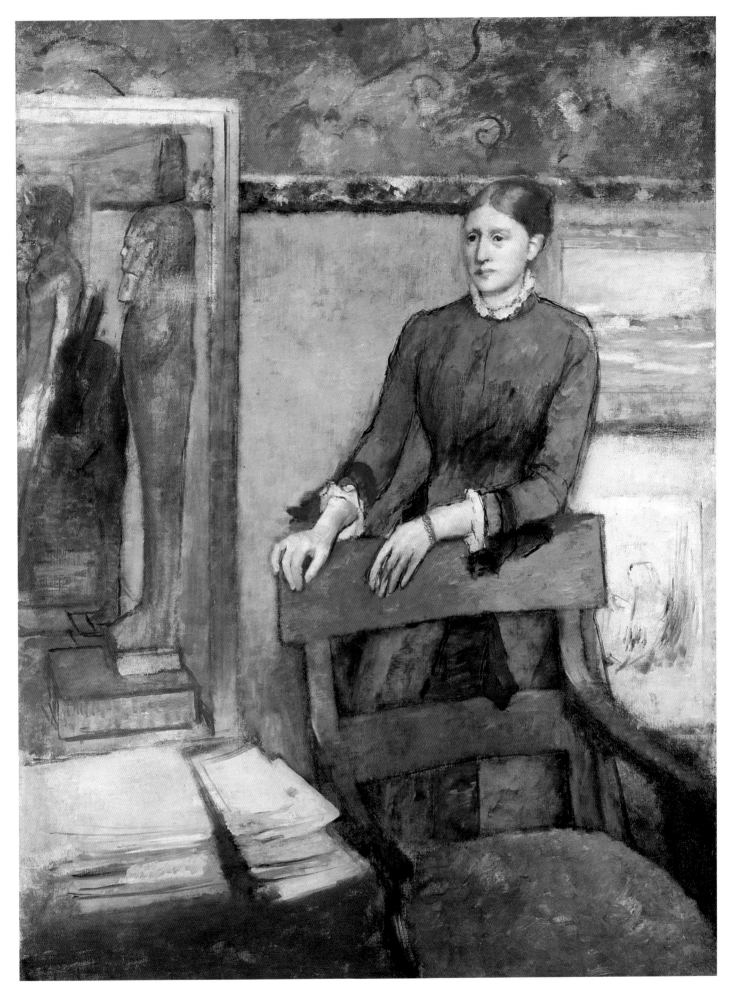

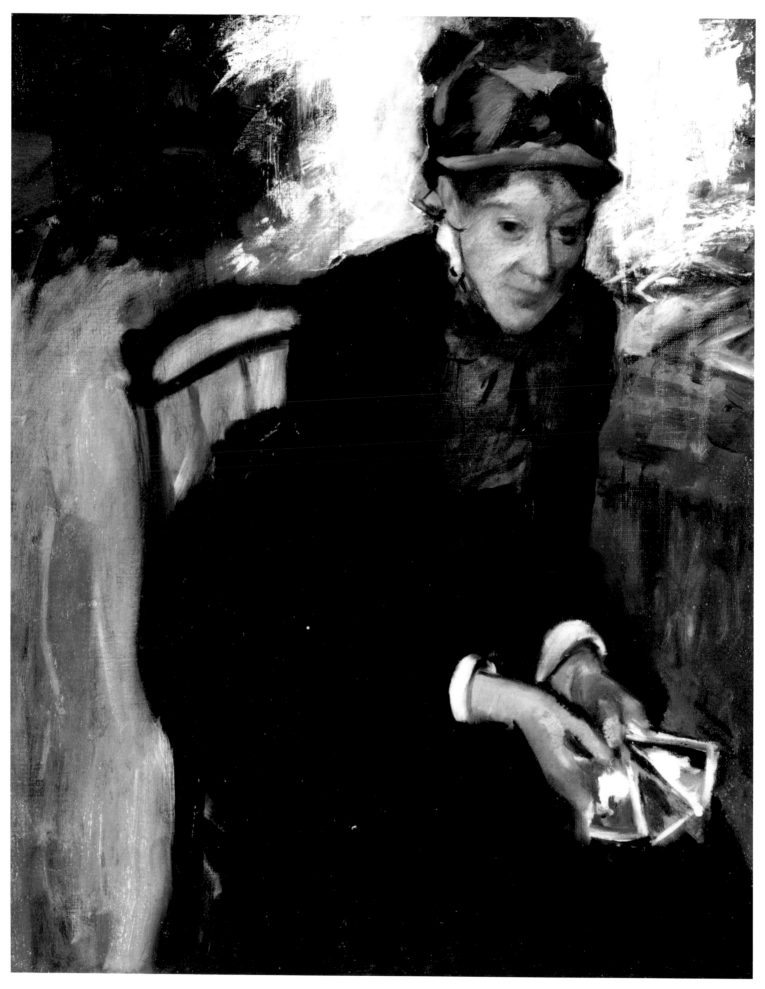

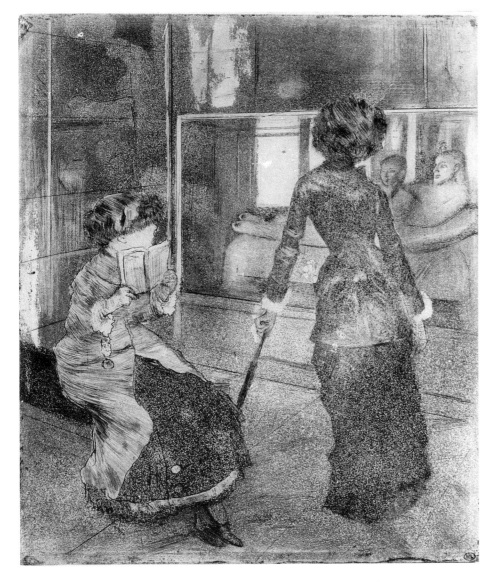

strongly in mood with Renoir's relaxed portrait of Camille Monet engaged in the same occupation; *Lydia at a Tapestry Frame* (*see plate 51*) looks back to the cloistered domestic world evoked by Fantin-Latour in his portraits of his sisters at home. *Five O'Clock Tea* (*see plate 50*) shows Lydia entertaining a visitor – the latter's status as a 'caller' is established by the fact that she is wearing a hat and gloves, while Lydia is bareheaded and barehanded. The mood of the painting is softer than that of the majority of Cassatt's canvases, which sometimes have a disconcerting emotional bleakness. When it was shown in the fifth Impressionist exhibition of 1880, J.K. Huysmans (the author of *A Rebours*) decided that he preferred Cassatt's work to that of some of her contemporaries who treated similar subject matter:

> Here is still the bourgeoisie, but it is no longer like that of
> M. Caillebotte; it is a world also at ease but more harmonious, more
> elegant. In spite of her personality, which is still not completely free,
> Miss Cassatt has nevertheless a curiosity, a special attraction, for a

47. (opposite) Edgar Degas, *Portrait of Mary Cassatt* (*c.* 1880–4)

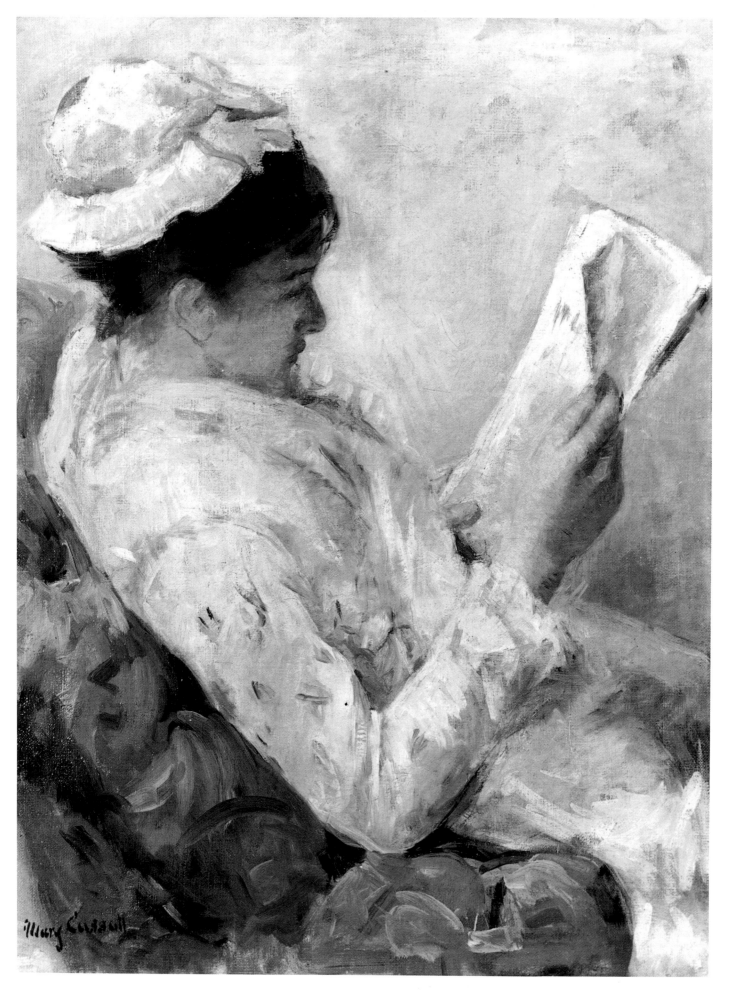

49. (opposite) Mary Cassatt, *Woman Reading* (Portrait of Lydia Cassatt, the Artist's Sister) (1878–9)

flutter of feminine nerves passes through her painting that is more poised, more peaceful, more capable than that of Mme Morisot, pupil of Manet.

Today, it is not Morisot's, but some of Cassatt's paintings, which seem to radiate a slight air of unease. This is more easily comprehended when one understands her family circumstances. Cassatt's sister Lydia is often the artist's surrogate in her early work, and Lydia was, as Cassatt knew, the victim of a debilitating illness, doomed to an early death. There may have been something else as well. Cassatt was – all her biographers tell us – particularly strong-minded and independent in character. She must have chafed more than most at the limitations imposed on women. She knew, for example, that Degas, for all his misanthropy, inhabited a larger world, and that this benefited his art.

50. Mary Cassatt, *Five O'Clock Tea* (1880)

It would be hard to think of a greater contrast of temperament and

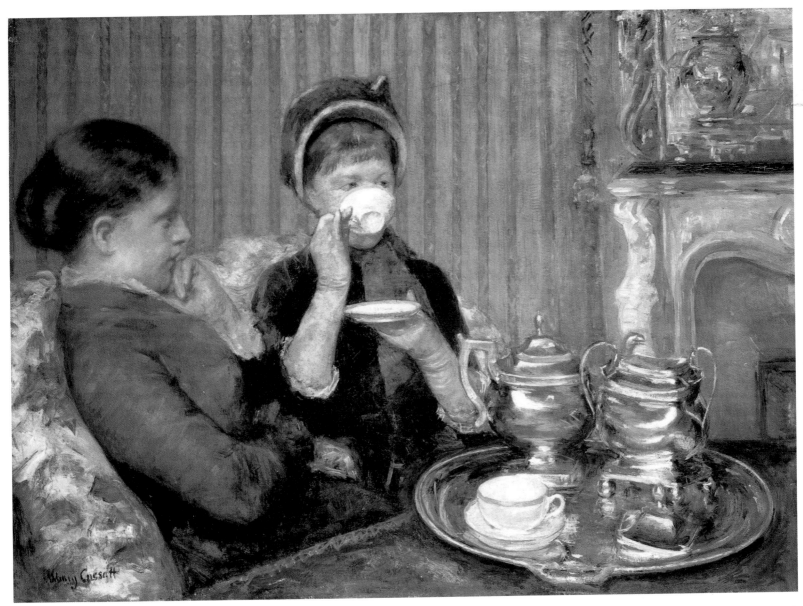

51. Mary Cassatt, *Lydia at a Tapestry Frame* (c. 1881)

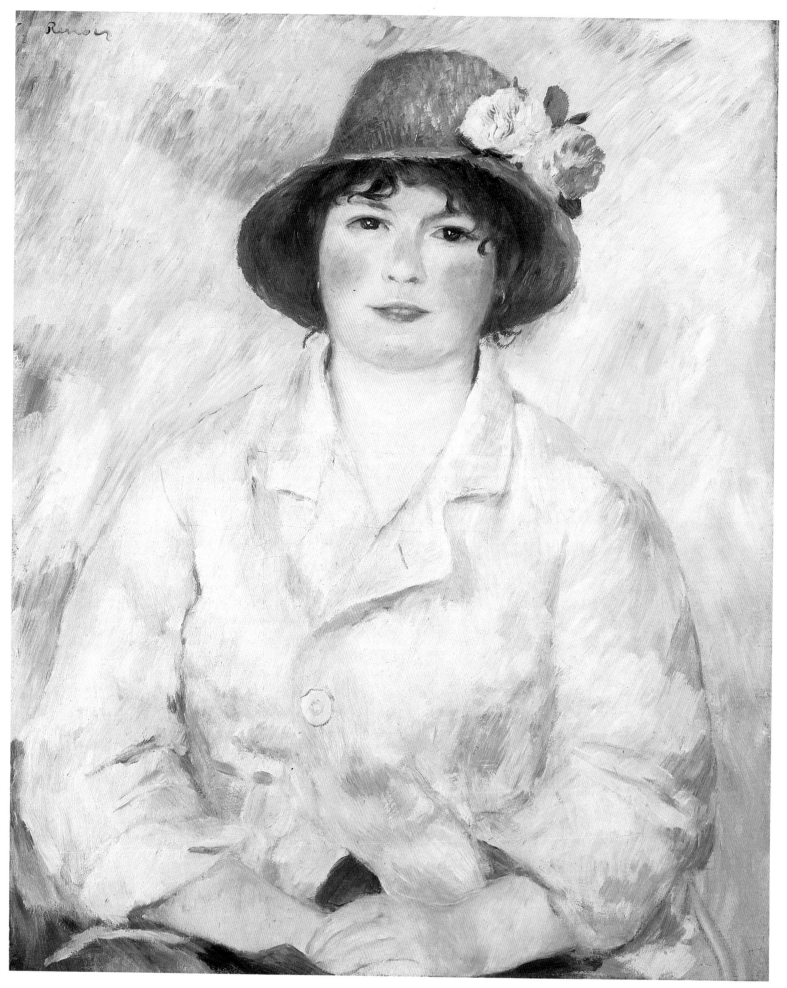

64

52. (opposite) Auguste Renoir, *Portrait of Madame Renoir* (c. 1885)

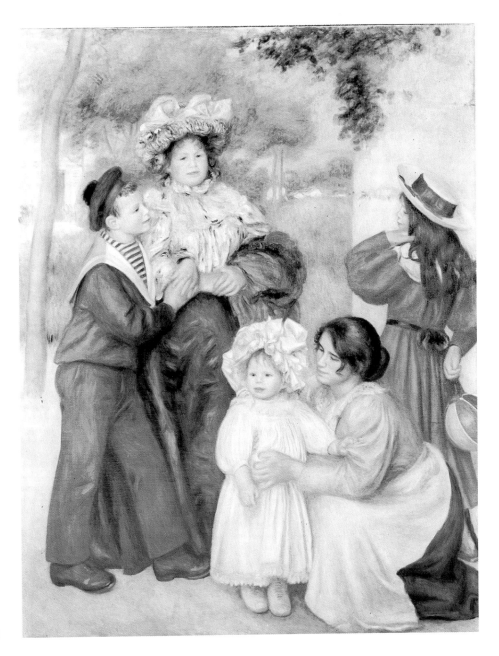

53. Auguste Renoir, *The Artist's Family* (1896)

circumstances than that between Cassatt and another Impressionist – Renoir. Of all the leading Impressionist painters, Renoir came from the humblest background. His father was a tailor, who moved from Limoges to Paris in 1846 (five years after Renoir's birth) and settled in a working-class area of the city. Renoir's family were thus part of that great flood of provincial artisans who came to the capital in the mid-nineteenth century, attracted by the economic boom generated first by Louis-Philippe's fiscal policies, and then by Napoleon III's. Renoir's schooling ended when he was fifteen years old. He was then apprenticed to a china-painter. Later he was able to attend the state-run Ecole des Beaux-Arts and train as a fine artist. From the very beginning of his career he was forced to live from hand to mouth, and in his youth he owed his survival to the kindness of various friends, some of them fellow students (and members of the Impressionist group, then still in the process of formation). He stayed frequently with Alfred Sisley's family; and later he shared a studio with the generous Frédéric Bazille, who was much better off than he.

In true bohemian fashion, Renoir's models were often also his

mistresses. The relationship between Aline Charigot, the future Mme Renoir, and the painter grew from a situation like this. Her origins were as humble as those of Renoir. She met the artist in 1879, when she was twenty; it so happened that she lived near Renoir's studio, and did his laundry. The thirty-eight-year-old Renoir was attracted by her looks, persuaded her to model for him, and then took her to his bed.

Aline was a buxom, good-natured country girl from Essoyes in Burgundy. She exactly suited Renoir's physical taste, as is obvious from the portrait Renoir painted of her in 1885 (*see plate 52*), while she was still in

54. Auguste Renoir, *Monsieur et Madame Sisley* (1868)

her twenties: she is already plumpish, and wears a simple, cream-coloured jacket and a far-from-smart straw hat, ornamented with a couple of roses. She looks out at the spectator directly, but still rather shyly. The couple did not in fact get married until 1890, and even then there was a good deal of obfuscation about the development of their partnership. As late as 1895, Julie Manet, Morisot's daughter, was busy recording in her diary that 'Mme Renoir was talking about her trip to Italy after her wedding. It amuses us when we hear her telling all about it, since we have so often heard M. Renoir talking about it as though he had taken the trip all alone, when we didn't know his wife. She was twenty-two and very slim, she says, which is hard to believe.' In fact, the trip took place in 1881, about two years after Renoir's first encounter with Aline, and long before they actually married. Renoir had deliberately hidden her presence in his life from his friends, a little afraid that they might laugh at the relationship because of Aline's rusticity. He continued to do so for a long time after their marriage, although he duly acknowledged their first son, Pierre, when he was born out of wedlock in 1885. It was not until 1891 that he finally got up the courage to bring his wife and son to see Berthe Morisot, and even then he did not introduce them formally: Morisot and her husband Eugène Manet were left to work the relationship out for themselves. Morisot later wrote to the poet Stéphane Mallarmé: 'Renoir spent some time with us, without his wife this time. I will never be able to describe to you my amazement [when I first found myself] in the presence of this very heavy person, who, I don't know why, I had imagined as resembling her husband's painting.'

Despite these inauspicious beginnings, it was a happy and successful match. When Aline grew too old and too stout to model for him, he replaced her with girls who looked very much as she had done when he first encountered her. These girls often also acted as nursemaids to the children. The best known today is the faithful Gabrielle, whom Renoir painted with his son Jean (*see plate 30*). A more elaborate group portrait of *The Artist's Family* (*see plate 53*) also documents her place in Renoir's household. Aline continued to run the painter's household, maintaining the conditions considered necessary for his work. A portrait painted in 1910, showing her with her pet terrier, Bob (*see plate 127, page 150*), is an eloquent testimony of his respect and affection. However, the portrait also shows that Aline aged rapidly. In 1906 she was suffering from bronchitis and emphysema, and in 1915, having travelled to a military hospital to see her son Jean, she died of a heart attack. She was fifty-six years old.

Renoir painted occasional portraits of friends, although often these friends were also important patrons, who could well afford to pay for the likenesses he made of them. One of his most attractive essays in portraiture is the early likeness of his friend and fellow artist, Alfred Sisley and his wife (*see plate 54*), painted in 1868. Marie Sisley's gown is extremely elegant, an example of the latest Paris fashion, and the whole picture breathes romance. This is appropriate enough, as the Sisleys, though already married for two years when the picture was painted, were still

55. Paul Gauguin, *Portrait of Madame Mette Gauguin* (1884)

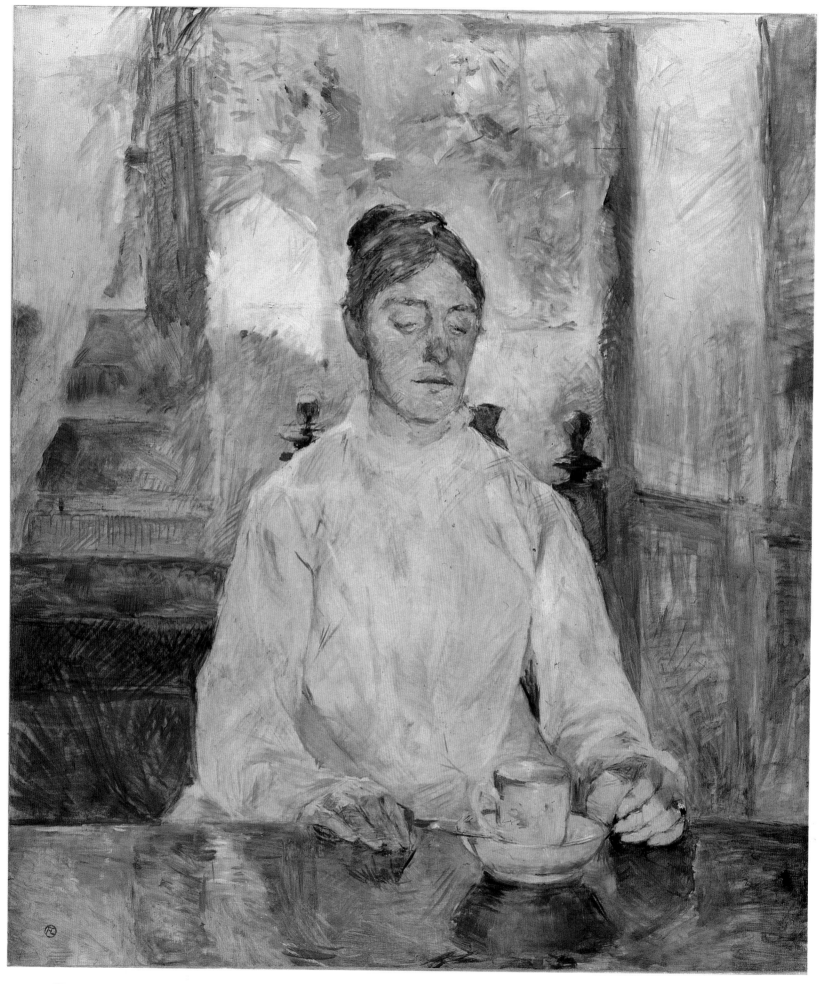

68

very much in love, as indeed they continued to be throughout their life together. What casts a shadow over the happiness which Renoir represented here is the knowledge that, from 1870 onwards the Sisleys endured a constant financial struggle because his father's business had been ruined by the Franco-Prussian War. By the early 1890s, both were in poor health – Sisley himself was already suffering from the early stages of the throat cancer which was to be responsible for his death. Yet it was Marie Sisley who died first, in October 1898. Renoir, still a close friend, described her husband as 'the soul of devotion, looking after her tirelessly, watching over her as she lay in her chair, trying to rest.' The effort exacerbated Sisley's own condition, and he died only a few months later. Of all the major Impressionists, he was the one to receive the least recognition during his lifetime.

These sad deaths were still a long time in the future when Renoir's double portrait was painted. The picture serves to emphasize the fact that Impressionism was a middle-class movement, and that the artists connected with it expected to live their lives according to established middle-class standards. As a group, the Impressionist painters had a keen eye for what was fashionable. Despite the opposition it aroused from the official art world – with its control over what was exhibited at the Salon – and from many critics, and also a large section of the general public, Impressionism soon established itself, and promoted its own standard of elegance. Artists of a newer generation, such as Gauguin and Toulouse-Lautrec, drew on what were essentially Impressionist models when they chose to depict people who were close to them. Admittedly, Gauguin's portrait of his Danish wife, Mette Gad (*see plate 55*), does belong to a period when he was still in thrall to the Impressionist way of seeing, and had not as yet evolved his own style. Later, such an image would be symbolic of everything against which he wanted to rebel.

Lautrec's likeness of his devoted mother (*see plate 56*) noticeably lacks the harsh edge which he brought to his other portraits, but the tranquillity and elegance of the image reflect the character of the sitter, as well as the artist's respect for her.

Only Cézanne remained completely intractable in his portrayals of his wife. These are monumental images; painted at great cost to the sitter's patience, they are completely drained of any personal character. From this evidence it is difficult to guess at the artist's attitude towards his sitter – or hers towards him – although perhaps it is not surprising to learn that Marie Cézanne (the artist's sister) nicknamed her 'The Dumpling' (*see plate 57*). When we look at these portraits by Cézanne, we realize we have entered a different artistic world.

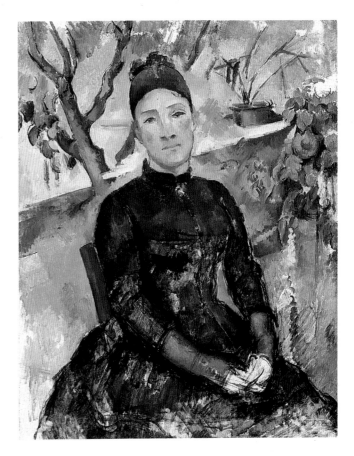

57. Paul Cézanne, *Madame Cézanne in the Conservatory* (Hortense Fiquet) (*c.* 1890)

56. (opposite) Henri de Toulouse-Lautrec, *Portrait of Madame la Comtesse de Toulouse-Lautrec* (1883)

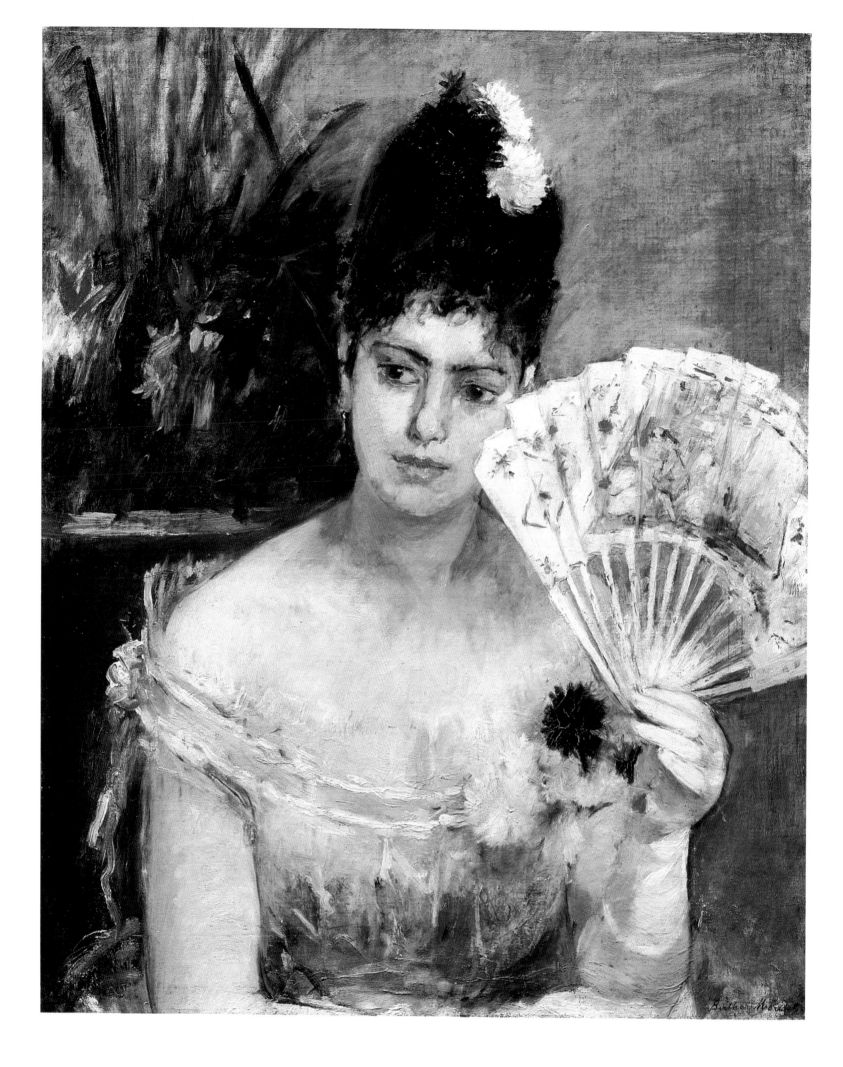

# HIGH SOCIETY

Despite the invention of photography in 1837 by Louis-Mandé Daguerre, and its subsequent rise (after its invention had been given official confirmation by the French Académie des Sciences in an announcement early in 1839), there was still an active demand for portraiture throughout Europe. Scale and colour were still lacking in photographs as they would continue to be for a long time to come. Portrait photographs were also objective: in the sitters' eyes, that often meant disconcertingly unflattering and therefore unacceptable. Many professional painters continued to look to portraiture for a livelihood: while painting portraits might not be quite as prestigious an occupation as producing the historical and allegorical canvases which took pride of place at the official Salon every year, it did produce a steadier income, and if the artist caught the eye of important patrons, this income could be generous indeed.

Until his death in 1867, Ingres had enjoyed unique prestige as a portraitist in France, particularly of women. By this time, however, portraits were no longer his chief source of income and they were undertaken with great reluctance, because the artist thought of them (just, in fact, as he always had done) as a distraction from higher and worthier things. He required a great deal of courtship from would-be sitters. The Baronne James de Rothschild laid siege to the artist in 1841, and only persuaded Ingres to accept a portrait commission in 1843. Her portrait was eventually completed in 1848. Other Ingres portraits of this period, such as the two, one seated and one standing, of Mme Inès Moitessier, had similarly tortuous histories. It is said that the deciding

58. Berthe Morisot, *At the Ball* (1875)

factor in each of his late portrait commissions was the beauty of the sitter; but it is also clear that all of them were wealthy women. The artist has spared nothing to render the expensive elaborations of the fashionable dress of the day. In taking such pains with sartorial details, he was continuing a tradition of portraiture which reached back at least as far as the Renaissance. He was also maintaining, in a more general way, a tradition which held that the painter must do work which could be 'read' as well as simply looked at. In Ingres's portrait, the text was an unequivocal statement about money and social influence.

In a purely commercial sense, the most successful portraitist of the mid-nineteenth century was Franz-Xavier Winterhalter. German-born, Winterhalter pursued a far more international career which – compared with his contemporaries – he conducted at an unusually elevated social level. He was admired and commissioned by members of nearly all the various royal houses of Europe. Among his sitters were Queen Victoria and Albert the Prince Consort; their son Albert Edward (later King Edward VII) and his wife Alexandra; the Emperor Franz-Joseph and Empress Elizabeth of Austria; and the Empress Maria Alexandrovna of Russia. Winterhalter's career in France began at the court of Louis-Philippe, but the Revolution of 1848, which replaced the July Monarchy with the Bonapartes, made no difference to his success; soon he became the beautiful Empress Eugénie's favourite portraitist. Posterity's impression of the court of Napoleon III at the Tuileries owes much to the likenesses made by Winterhalter of its chief personages; and in particular to his portraits of the Empress herself, and of the equally beautiful women with whom she surrounded herself, such as Princess Murat, the Duchesse de Mouchy (born Troubetskoy), and Comtesse Edmond de Portalès.

In all these portraits there is, of course, a careful rendering of fashionable dress; but Winterhalter was also an expert in almost every kind of flattery. Where necessary he discreetly slimmed the figures of the great ladies who sat for him, and almost invariably he regularized their features. Most of all, he was an expert in the control of lighting. Although he learned a great deal about the use and control of light from Van Dyck – whose work he obviously studied carefully – much was his own invention. Indeed it has been said of him that he invented Hollywood 'glamour lighting' long before the rise of Hollywood itself. His true disciples were thus the stills photographers who worked for the great Hollywood studios in the 1930s.

Ingres died before the end of the Second Empire, and Winterhalter's reign of glory finished with its fall, though he lived on for another five years. However, their work inevitably set a standard which their successors, the Impressionists among them, were hard pressed to meet. One difficulty encountered by portraitists after 1870 arose from the fact that the rigid hierarchies of society were beginning to break down. The court of Napoleon III was frequently condemned, especially by foreigners, as vulgar and *nouveau riche*, a pinchbeck imitation of what royalty ought to be. Yet at least there was still a structure which could be

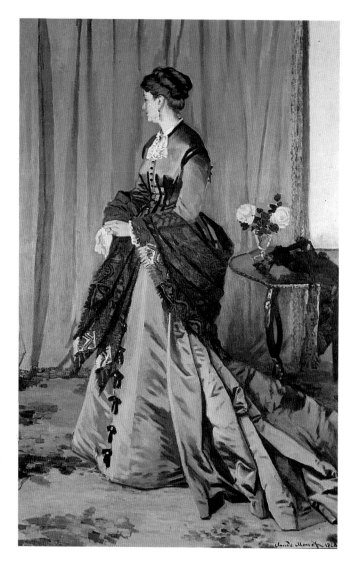

59. Claude Monet, *Madame Gaudibert* (1868)

60. (opposite) Auguste Renoir, *Lise with a Parasol* (1867)

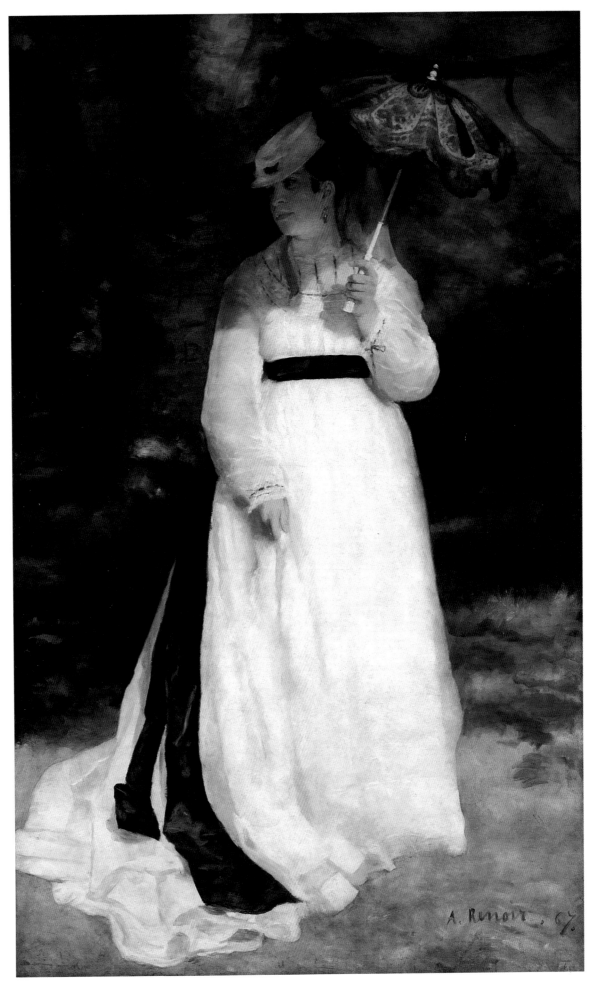

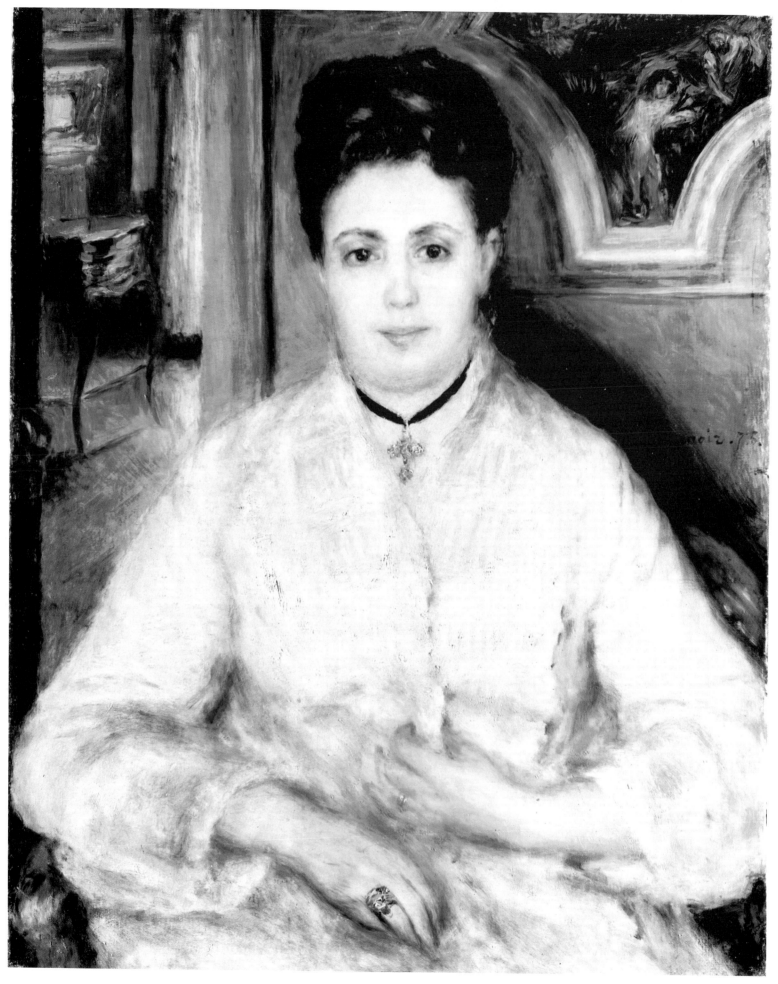

74

61. (opposite) Auguste Renoir, *Portrait of Madame Choquet in White* (1875)

recognized by universal 'signs'. After 1870, this was no longer the case. This complicated the portraitist's job, because the artist still had to respond appropriately to the context as well as to the individual.

The only major Impressionist painter who involved himself to any great extent in the portrait tradition was Renoir, though it is clear that one or two of his colleagues, notably Monet, were tempted by the idea. Monet's full-length portrait of Mme Gaudibert (*see plate 59*), like those of his wife Camille painted during the same period (*see plate 33*), is obviously

62. Auguste Renoir, *La Parisienne* (1874)

64. (opposite) Auguste Renoir, *Madame Henriot en Travesti* (c. 1875–7)

63. Auguste Renoir, *Portrait of Madame Henriot* (c. 1876)

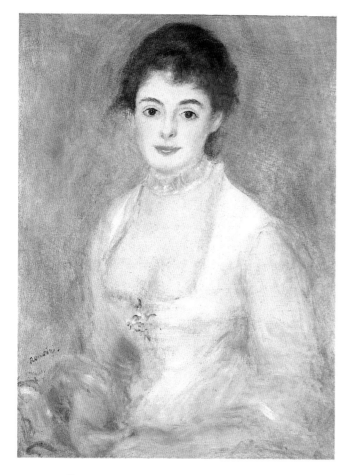

intended as a proof of his skill in the portrait genre, and also as a declaration of a willingness to undertake commissions of this sort. His model in this case was the daughter-in-law of one of Monet's most important early patrons, Louis-Joachim Gaudibert, who was himself a member of a wealthy merchant family who lived near Le Havre (the Norman seaport where Monet had grown up). Compared with the aristocratic fantasies still being produced by Winterhalter at this time (1868) the general effect of Monet's painting is stodgy. The sitter seems weighed down by her clothes, and the painting has none of the vaporous elegance of *Woman with a Parasol*, produced seven years later. But then, as has already been said, in that painting the artist felt no duty to present a fully recognizable likeness.

At the same date Renoir was making a similar statement of his willingness to accept employment as a portraitist. *Lise with a Parasol (see plate 60)*, painted in 1867 and exhibited in the Salon of 1868, was intended as a challenge to the established portraitists of the day. He has chosen to take as his sitter not a well-established bourgeois lady but his current model and mistress. The painting pursues several different preoccupations at once. It was painted *en plein air*, like Monet's *Femmes au jardin (see plate 29)*, and it also experiments with ideas about strong contrasts of dark and light and the absence of middle tones, which he took from Manet.

Because of all this, the reception it received was somewhat mixed, Zacharie Astruc, a critic sympathetic to the emergent Impressionist group (which, of course, had not yet received its sobriquet), declared *Lise* to be 'the prettiest girl in Paris'. Some of his colleagues were not so friendly. One concentrated on the technical aspects (the *plein air* method), saying that 'this painting holds the attention of connoisseurs as much by the oddity of its effect as by the accuracy of its tones. It is what is called, in the language of the realists, a fine spot of colour.' Another critic wrote:

In the back room, the one known as the Room of the Reprobates, I discovered, labelled with the single name of *Lise*, the figure of a fat woman daubed with white, whose originator, M. R. (may I be allowed to designate him only by an initial) obviously took his inspiration no longer even from the great examples of Courbet, but from the curious models of M. Manet, and this is how, from imitation to imitation, the realist school threatens to fade out completely … by leaps and bounds. So be it!

As Renoir's career developed, he, like Monet, began to be offered occasional portrait commissions by patrons enthusiastic about other aspects of his work. In 1875 he met the customs official Victor Choquet, an early and perceptive enthusiast for Impressionist art. Choquet asked Renoir to do portraits of himself and his wife. The likeness of Mme Choquet (*see plate 61*) has a modest charm, but also radiates a feeling of discomfort. It looks as if the sitter found the whole business of being painted something of an ordeal – one gets the impression that she

consented only to give pleasure to her husband. On the wall we get a glimpse of one of the gems of Choquet's collection – a sketch by Delacroix.

Renoir also continued to do likenesses which were not commissioned – because the sitters pleased him, and also, presumably, as a further advertisement for his skills. *La Parisienne* (*see plate 62*), one of the best-loved of his paintings of women, has tended more and more to be regarded as a picture of a type, not an individual. It is in fact a likeness of the enchanting young actress Henriette Henriot, who played at the Odéon. The painting is clearly one of the masterpieces of the first flowering of Impressionism, but whether it is a good *portrait*, as opposed to a good *picture*, is somewhat open to doubt. The dazzling blue of the costume inevitably distracts the spectator's attention from the person who is being portrayed – the tactful Winterhalter would never have permitted himself such an error. The Neo-Impressionist Paul Signac was enraptured by *La Parisienne* when he saw it in 1898, and made a note in his diary:

> The dress is blue, an intense and pure blue which, by contrast, makes the flesh yellow, and, by its reflection, green. The tricks of colour are admirably recorded. And it is simple, it is beautiful and it is fresh. One would think that this picture painted twenty years ago had only left the studio today.

Significantly, Signac offers no comment on the girl herself. Because of the way in which the figure is isolated against an almost plain ground, *La Parisienne* has often been compared to a fashion plate. Illustrations of this type may indeed have been amongst the sources used by Renoir but, although Mme Henriot's dress is indeed beautifully painted, the costume mysteriously lacks real chic. This is not the creation of a great dressmaker, just a reasonably pretty dress with a certain provincial fussiness about some of the details.

Henriette Henriot modelled for Renoir on a number of occasions. Some of these likenesses are simple tributes to her prettiness (*see plate 63*), but, like the actress she was, she took on different characteristics to suit each occasion. In another painting, she appears in theatrical costume (*see plate 64*), in what appears to be a kind of tribute to the cross-dressing which tickled the fancy of Romantic painters and writers, and which retained its appeal later in the century. Indeed, Sarah Bernhardt – the famous *fin de siècle* actress – once essayed the role of Hamlet.

Renoir's most determined assault on the fashionable portraiture market did not occur until 1879. The preceding year he had broken with his Impressionist colleagues in order to return to the Salon, which they had agreed to renounce completely. Théodore Duret, in his pamphlet *Les Peintres Impressionistes*, published at this time, stressed Renoir's claims as a portraitist:

> Renoir excels in portraits. Not only does he capture the exterior features, but on the features he establishes the model's character and inner way of being. I doubt that any painter has ever interpreted

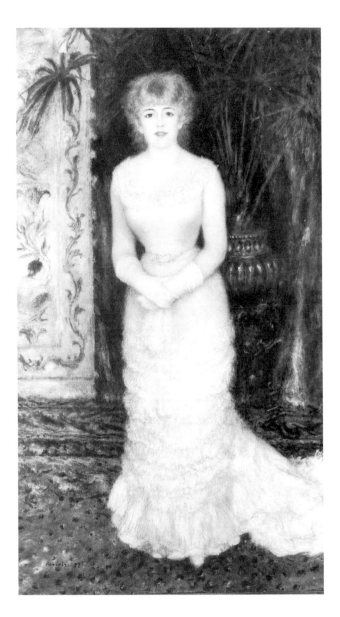

65. Auguste Renoir, *Portrait of the actress Jeanne Samary* (1878)

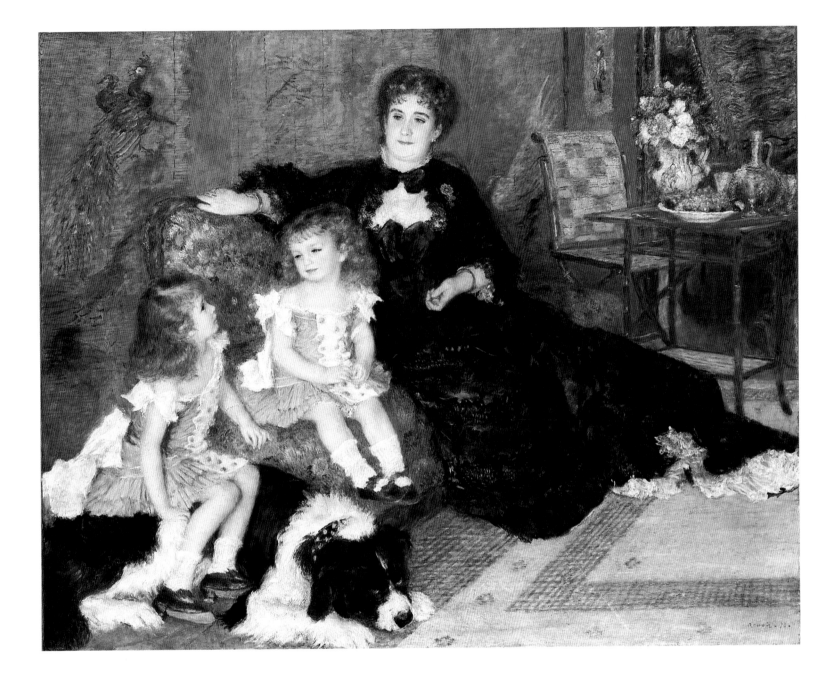

woman in a more seductive way. Renoir's fast, light brush produces grace, suppleness, and abandon, makes flesh transparent, and tinges the cheeks and lips with a brilliant red. Renoir's women are enchantresses. . . . You will have a mistress. But what a mistress! Always sweet, gay, smiling, needing neither dresses nor hats, able to do without jewels, the truly ideal woman!

Duret reinforced the point by asking the artist to do a pen-and-ink drawing of the much-abused *Lise* to serve as a frontispiece.

In one of his offerings for the Salon of 1879, Renoir was clearly trying to live up to this encomium. His subject was another actress, Jeanne Samary (*see plate 65*). He painted her almost life size, standing in the foyer of the

66. Auguste Renoir, *Madame Charpentier and Her Children* (1878)

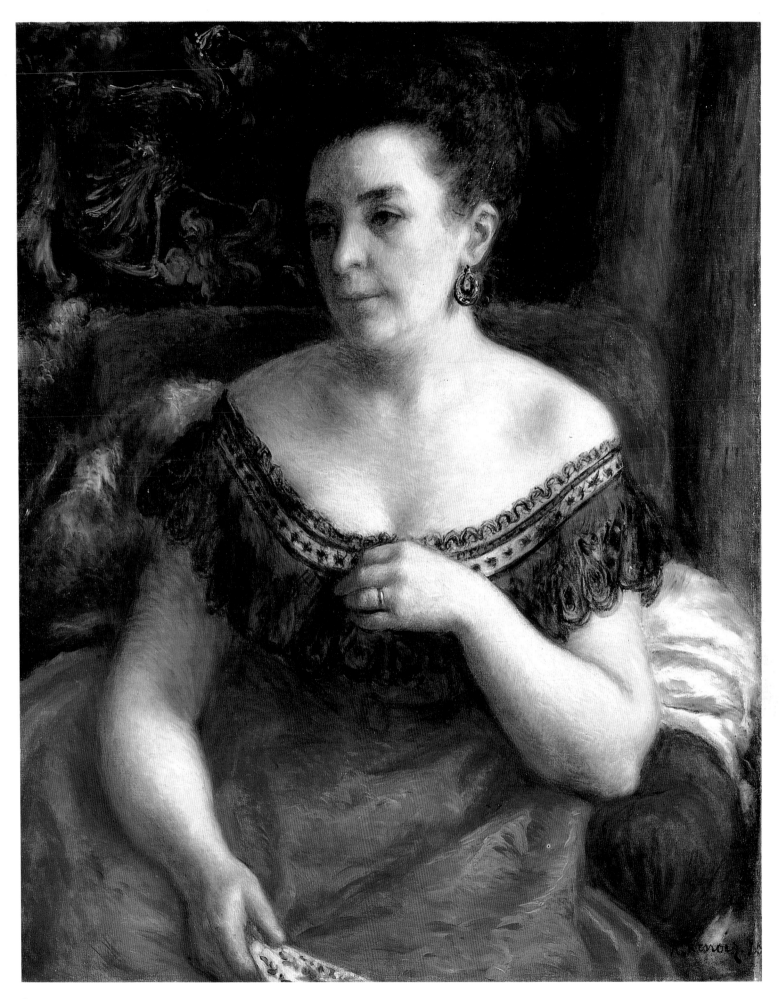

67. (opposite) Auguste Renoir, *Portrait of Countess Edmond de Portalès* (1870)

Comédie Française. Renoir was quite pleased with the result. He wrote to Duret: 'I have finished a standing portrait of the little Samari [*sic*] that delights women, and especially men. She is wearing a low-cut evening dress.' Once more, the sitter lacks the indefinable something which spells real chic, but there is no denying that the artist has again made her look extremely attractive.

It was not on this portrait, however, that Renoir pinned his real hopes of success. He had been asked by Georges Charpentier to paint a portrait of his wife, Marguerite, and their two children. Georges Charpentier was the head of a large publishing house. He and his wife owned a luxurious mansion in the rue de Grenelle, and here Mme Charpentier presided over an influential salon, which attracted a wide variety of 'important' people. There were writers of the calibre of Zola, Flaubert and Daudet; composers such as Massenet, Saint-Saëns and Chabrier, while among the established Salon painters were Carolus-Duran and Jean-Jacques Henner. Renoir himself was drawn into this circle around 1875, and the Charpentiers gave him financial assistance as well as moral support. In 1876 he painted two large decorations for their staircase, and in 1879 he was commissioned to produce a major work to take a prominent place in the Charpentiers' drawing room. Mme Charpentier, and her son Paul (still in petticoats) and daughter Georgette are seated informally amidst an ultra-fashionable Japanese décor (*see plate 66*). Renoir's brother Edmond reveals that nothing was moved or altered for the picture – the room was to be just as visitors normally saw it, and the sitters (in theory at least) were to be the image of their everyday selves. 'He will ask his model to maintain her customary manner,' Edmond wrote, 'to sit in the way she sits, to dress the way she dresses, so that nothing smacks of discomfort or

68. Auguste Renoir, *The Children's Afternoon at Wargemont* (The Bérard Children) (1884)

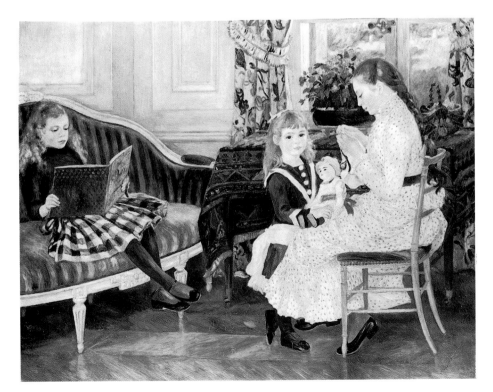

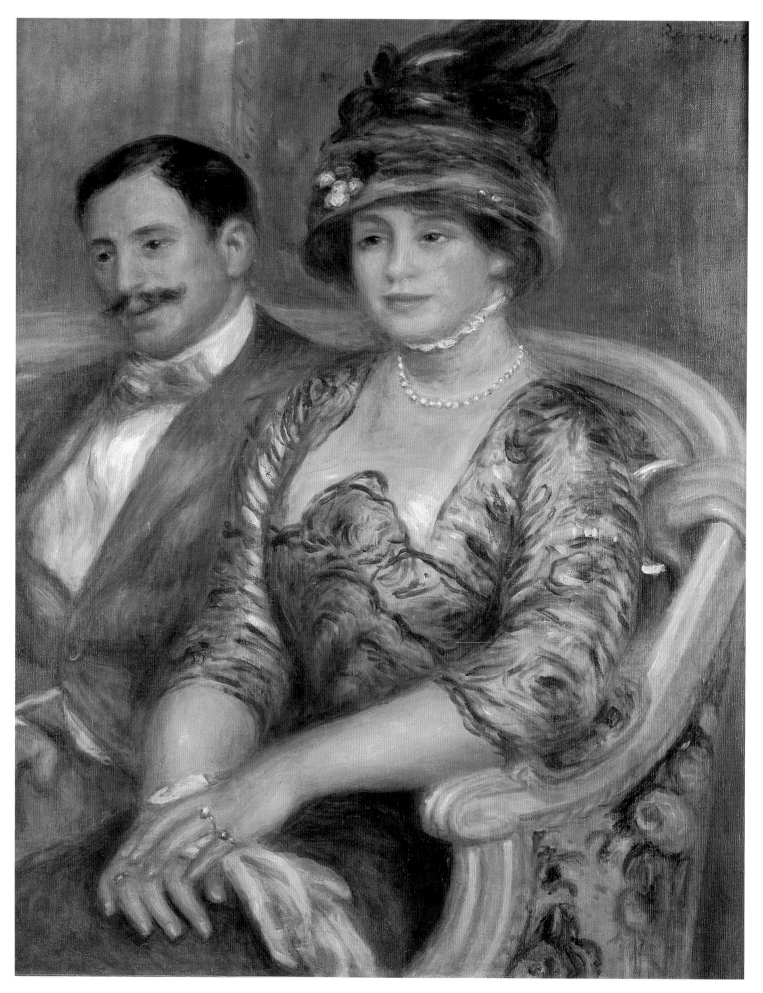

preparation.' In fact the likenesses, if photographs are to be trusted, were discreetly flattering, but Renoir nevertheless succeeded in making them recognizable. He took enormous pains with the picture, and after it was finished both he and his sitter orchestrated a vigorous publicity campaign. For six months before the work was submitted to the Salon jury, the faithful were shepherded into the Charpentiers' house to see it and to be encouraged to spread the news of its merits. There was, of course, no question of the picture being refused at the Salon with the influence of Mme Charpentier behind it. Moreover, it was well hung. As Renoir explained later: 'Mme Charpentier wanted it in a good position, and Mme Charpentier knew the members of the jury, whom she lobbied vigorously.' It is easy to imagine that his formidable lady, while happy to have commissioned an 'avant-garde' artist like Renoir, had nevertheless maintained contact, through her weekly Salon, with the more conservative painters and sculptors of whom the Salon jury was composed.

The critics too were largely favourable – even the influential Castagnary: 'Not the slightest trace of convention, either in the arrangement or the technique. The observation is as clear as the execution is free and spontaneous.'

Today, *Mme Charpentier and Her Children* seems a curious hybrid. Of all the Impressionists, Renoir was the one who was most influenced by the rising fashion for things eighteenth-century French, which went hand in hand with the new passion for Japanese art. This picture illustrates his careful study of the eighteenth-century *petits maîtres*, such as Moreau le Jeune, who often portrayed fashionable figures in equally fashionable interior settings. But these eighteenth-century artists, who in turn based themselves on the Dutch genre painters of the seventeenth century, had always painted on a small scale; here, on the other hand, Renoir was following in the wake of Courbet, and was painting contemporary life on a big canvas. The group portraits of Van Dyck and his successors in the past had been a great deal more formal in setting and arrangement; viewed against this historical background, Renoir's picture is a little disconcerting. Meant as a statement not only of the sitter's wealth, but of her far-reaching cultural influence, the additional protestations of modesty and simplicity of taste, which are intended to be conveyed by the sitter's pose and those of her children, and by what surrounds them all, tend to ring false. Nevertheless the picture is a compelling bourgeois icon, as significant for the society of the newly founded Third Republic as Ingres's portrait of the newspaper magnate M. Bertin was for the reign of Louis-Philippe.

The painting proved itself important enough to win Renoir a number of portrait commissions over the next few years, although his patrons were seldom from the very highest reaches of society. The *Portrait of Countess Edmond de Portalès* (*see plate 67*), a version of which had previously been painted by Winterhalter, was the exception. Admittedly Renoir faced a problem because his sitter was now some years older, but it cannot be said that his picture has the grace or flair achieved by the

69. (opposite) Auguste Renoir, *Portrait of Monsieur et Madame Bernheim de Villers* (1910)

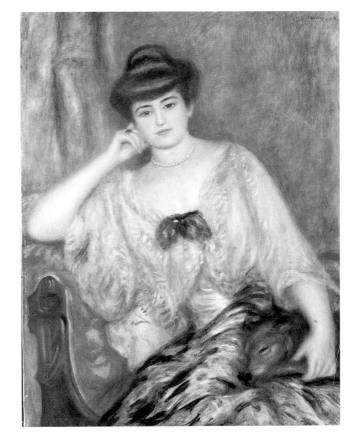

70. Auguste Renoir, *Portrait of Misia Sert* (1904)

84

German court painter. Surprisingly, the earlier portrait – despite Winterhalter's notorious tendency to idealize – is probably less generalized than the Impressionist version. It is in fact only rarely that Renoir's portraits of women provide any very distinct rendering of personal character. His likeness of Mme Charpentier is an exception, in offering at least a glimpse of her formidable bossiness.

Renoir was always at his ease when he was painting children. *The Children's Afternoon at Wargemont* (*see plate 68*) which Renoir produced in 1884 is only a little smaller than the portrait of Mme Charpentier. It is a picture of Paul Bérard's three daughters. Bérard, who had been a friend and patron of Renoir since 1879, had establishment credentials, but also stood a little apart. He was rich, an ex-banker and ex-diplomat who had retired from both professions in order to enjoy the pleasures of country life in his château near Dieppe. He was also a firm Republican, and a Protestant. Renoir stayed with him often and painted no less than sixteen portraits of his family.

Of these, *Children's Afternoon at Wargemont* is the most ambitious. Renoir was just evolving a new style at around this date, which is apparent in the picture; there is a much greater reliance on sharply defined silhouette and outline, and a lighter, cooler, more acid palette. Ingres was behind this change of direction, the master who haunted so many of his immediate successors. The composition depicts, from left to right, Marguerite, Lucie and Marthe Bérard. All the figures, especially that of Marthe, are cut-out shapes, with a deliberate avoidance of volume. These shapes interlock with one another and with the furniture to make an intricate pattern dappled with light, bright colours. But the colour is far from random – it modulates from cool on the left to warm on the right, with the curtain in the centre background marking the main division between the two zones.

It is not merely Renoir's adroitness in the manipulation of colour and line which makes the picture charming. It exudes a real sense of innocence and tranquillity, creating an enclosed world of childhood. (The psychology of children had not yet acquired the sinister undertones which the subject often has today). Unfortunately, the direct successors to this sunlit masterpiece in our own century are the disturbing pictures of young girls in interiors painted by Balthus.

Painting portraits on commission never aroused Renoir's unqualified enthusiasm, and when success came to him he was glad to escape from the drudgery it entailed. He did continue to produce occasional portraits as favours to particular people during the later part of his career, but these portraits were more and more assimilated into his late style so that those who appeared in them are more easily identifiable as 'Renoirs' than they are as individuals. Often he painted such portraits of his business connections. He painted Gaston and Suzanne Bernheim de Villers, for example (*see plate 69*), because Gaston and his brother Josse were not only personal friends but also important dealers with whom he had an ongoing relationship.

Renoir's 1904 portrait of Misia Sert (*see plate 70*), now in the National

71. (opposite) Henri de Toulouse-Lautrec, *Madame Misia Natanson* (Study for poster for *La Révue Blanche*) (1895)

72. Edouard Manet, *La Parisienne* (Portrait of Ellen Andree) (*c.* 1876)

Gallery, London, is one of three which he was commissioned to paint of the same lady. Misia played a prominent part in the cultural life of Paris at the time – a more important one, perhaps, than Marguerite Charpentier had before her. When the picture was painted she was living with the immensely wealthy financier, Alfred Edwards, whom she was later to marry, only to lose him to the music-hall star Polaire.

Misia's alliance with Edwards represented the peak of her material prosperity, but was not, perhaps, the most interesting period in a long and varied life. Slightly earlier, when she was still living with her first husband Thadée Natanson (one of the founders of the important Symbolist periodical *La Revue Blanche*), Misia had been the muse of the Nabis, a group of artists rebelling, in the 1890s, against the realist element in Impressionism. She was particularly close to Vuillard, who painted her often, but she had also been a friend of Toulouse-Lautrec. In 1895 – nearly ten years before Renoir portrayed her – Lautrec made a sketch of her, and this was the skating figure which was used for a *Revue Blanche* poster (*see plate 71*). This image has a lot more sparkle than Renoir's ponderous

73.  Edouard Manet, *La dame aux éventails* (Portrait of Nina de Callias) (1873)

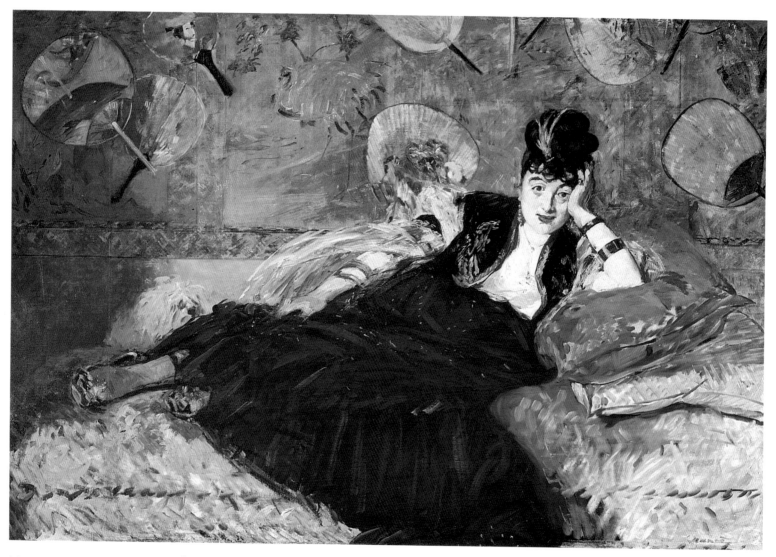

likenesses, which show Misia as a torpid beauty plump enough for an oriental harem, the stereotype of the cosseted, kept woman.

Before Edwards more or less bought Misia from her first husband (as her own memoirs reveal to be the case), she had been fairly frolicsome. She left a charming account of how she and Lautrec spent their time together:

> I would sit on the grass, leaning against a tree, engrossed in some entertaining book; he would squat beside me, armed with a paintbrush, and dexterously tickle the soles of my feet. This entertainment, in which his finger sometimes played a part at propitious moments, sometimes lasted for hours. I was in the seventh heaven when he pretended to be painting imaginary landscapes on my feet.

Misia regained her verve after Edwards left her. Diaghilev, the director of the Ballets Russes, took her as his chief confidante, and she became a famous troublemaker within the company. She was also a close friend of the great dressmaker, Coco Chanel. Her third husband, José Luis Sert – notoriously unfaithful to her – was one of the chief decorative painters of the Art Deco epoch. Renoir seems to have caught her at the only period in her life when she was truly bored, and the boredom is obvious. She and Renoir struck no sparks off one another.

Manet did not paint portraits on commission; he produced them because of his own personal interest in the character he was painting (his likenesses of Emile Zola and Georges Clemenceau, for example, and of his old friend Antonin Proust, who became Minister for Fine Arts and who was responsible for getting Manet his much-coveted Légion d'honneur). Manet's portraits of women were often an expression of straightforward attraction – some of these sitters, indeed, were women who became his mistresses; others were women who maintained a comfortably flirtatious relationship while resisting anything more. Fortunately, Mme Manet took a very tolerant attitude towards these infidelities or would-be infidelities. It was not the high-society women who attracted Manet; he preferred his fellow artists Morisot and Gonzalès, and the elegant *demi-mondaines*, with their easy-going charm, light-heartedness and wit. He was a passionate student of feminine fripperies, and these women were able to display to him all that was newest and most daring in the fashions of the day.

Manet's portraits of women invariably demonstrate his eager response to feminine grace and style. Ellen Andrée (*see plate 72*) was an actress who was herself part of the Impressionist circle, going to the cafés frequented by the painters. In addition to posing for Manet, she also sat for both Renoir and Degas. One reason for her popularity – like that of Henriette Henriot – may have been her skill in assuming any role required of her: in Degas's *Au café, dit l'absinthe* (*see plate 82*) she looks suitably downtrodden; in Manet's *At the Café* she is slightly coquettish.

Manet's relationship with some of his other sitters, however, was more

74. Edouard Manet, *Portrait of Isabelle Lemonnier* (c. 1879)

complex. The reclining Nina de Callias with her fan (*see plate 73*) was the estranged wife of the journalist Hector de Callias, of *Le Figaro* – no admirer of Manet's work, if his reviews are anything to go by. She lived with the Bohemian inventor, Charles Cros, who discovered the principle of the gramophone before Edison but who was too disorganized to exploit his discovery. It was Cros who invited Manet to the rue des Moines to Nina's salon, which had a much more relaxed and informal atmosphere than the gatherings presided over by Mme Charpentier. From Manet's point of view, the most important result of his visits to the gatherings under Nina's hospitable roof was the emergence of his friendship with the Symbolist poet Stéphane Mallarmé, Manet's earlier friendship with Baudelaire – whose memory Mallarmé worshipped – being a major bond between them.

Nina herself seems to have attracted Manet because of her wildness – her constant air of slight hysteria. Edmond de Goncourt rather acidly described her salon as 'the studio of mental craziness'. Manet's portrait catches this hysterical edge, and displays the flamboyance of her personal style of dress – she brandishes her fan, and reclines on a sofa wearing a Japanese robe. Despite these oriental props, the picture has a Spanish air: Nina is a predatory version of the traditional Spanish *maja*. Her end, which came not many years after the portrait was painted, was sad. In 1881 her hysteria became outright insanity and she had to be confined to an asylum, where she died in 1884. At her own request, she was buried in the robe which she had worn for her portrait. Hector de Callias came to her funeral but was totally intoxicated.

Isabelle Lemonnier was the daughter of a jeweller, and the sister-in-law of the publisher Georges Charpentier. Manet was strongly attracted to her, and painted a whole series of portraits of her (*see plate 74*), but she seems to have resisted his advances. Even after he had fallen seriously ill, he continued to send her flirtatious little notes, adorned with watercolour sketches. One with a picture of a single, luscious mirabelle plum, read:

> *A Isabelle,*
> *Cette mirabelle,*
> *Et la plus belle,*
> *C'est Isabelle.*

Manet had a much closer relationship with Méry Laurent (*see plate 75*), the love of the last years of his life. The two met in 1876, after two major pictures by Manet had been rejected by the Salon jury (despite their acceptance of his work the previous year); he held a private exhibition in his studio instead. The show was a huge, if controversial, success, with a queue of people forming outside in the street, as they waited to get in; Méry Laurent, who lived nearby, was one of the visitors. Hiding behind a curtain in order to hear the reactions of the spectators, Manet was delighted by her spontaneous exclamation of pleasure, and at once came down to greet her.

75. Edouard Manet, *L'Automne* (1881)

76. (opposite) John Singer Sargent, *Portrait of Madame X* (Madame Pierre Gautreau) (1884)

Méry Laurent was a *grande cocotte* – one of the expensive women so characteristic of the period. Technically they were prostitutes, since they exchanged sexual favours for money, but at such a high level that the transaction was turned into a vehicle for the conspicuous display of wealth. A man who could afford to support a woman of this type was well-established indeed, both financially and socially. The *grandes cocottes* were the nearest western society has come to the Japanese geisha girl, who was valued as much for her powers of conversation and her elegant turn-out as for her sexual skills. Méry came from Nancy, where she had married at the tender age of fifteen. After only a few months, she left her husband and made her way to Paris, where she appeared successfully in cabaret. She graduated from the stage, falling into the arms of a succession of rich protectors – first those of Marshal Canrobert, a distinguished soldier, then those of Dr Evans, the society dentist who aided the escape of the Empress Eugénie after the collapse of the Second Empire.

Evans not only kept Méry in style; he was reasonably accommodating about her granting her favours to other lovers, and only put out when confronted with them face to face. She usually chose artists and writers. Manet and she were made for each other, and soon became lovers, though on an entirely casual basis. When Manet became ill, however, Méry showed remarkable constancy in friendship. She sent rich collectors to him, one of whom bought four thousand francs' worth of paintings on a single visit; she went to see him often to cheer him up, and sent her maid with bunches of flowers for him to paint. These flowers form the subject of a ravishing series of late pictures, and it is tempting to see in them, not only the reflection of Manet's exquisite sensibility and strong love of life, but his gratitude and affection for the donor.

Among the professional portrait painters, Manet's true heir was not one of the members of the Impressionist group, but the Paris-educated American, John Singer Sargent, who trained in Carolus-Duran's studio. In 1884, the year after Manet's death, Sargent exhibited a sensational full-length portrait at the Salon. Discreetly labelled *Portrait of Madame X*, it was in fact a likeness of the American-born Mme Pierre Gautreau (*see plate 76*), a successful banker's wife, who was notorious for her numerous love affairs. In 1883, when he was hard at work on the picture, Sargent wrote to an old friend in Florence, the writer Vernon Lee, that his subject was in his opinion 'a great beauty', but added: 'Do you object to people who are *fardées* [made up] to the point of being uniform lavender blotting-paper colour all over. If so you would not care for my sitter.'

In fact, Sargent was all too successful in rendering an emergent social type – a woman in good society who imitated the manners and perhaps the morals of the stars of the *demi-monde*. The vision he had of Mme Gautreau was undoubtedly derived from Manet's portraits of sitters like Méry Laurent; there is the same delighted response to feminine elegance, accompanied by the desire to enhance and display it. The portrayal was all too exact: the sitter was furious, and her mother even more so. From their point of view, the picture caused a sensation of quite

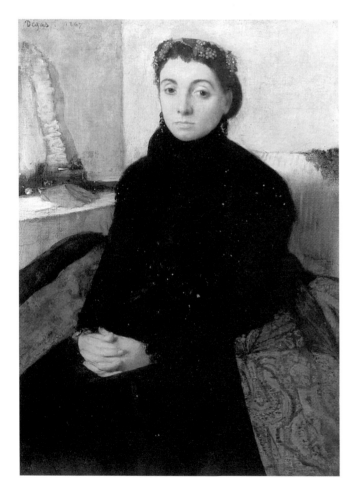

77. Edgar Degas, *Portrait of Madame Gaujelin* (1876)

the wrong kind. A perceptive critic, whilst praising it, scarcely helped by remarking that it was a wonderful analysis of the psychology of the professional beauty. It was the scandal aroused by this portrait which largely decided Sargent to make his career in England where he was able to apply his brilliant technique (which owed so much to Manet) to making likenesses of somewhat stodgier sitters. The portrait of Mme Gautreau remained in his studio, and for the rest of his life he continued to consider it the best thing he had ever painted.

Fashionable life meant comparatively little to the remaining members of the main Impressionist group, and they touched on it comparatively seldom. Degas's early *Portrait of Madame Gaujelin* (*see plate 77*) clearly is heavily influenced by Ingres. It is so unrelentingly severe, and apparently so aristocratic, that it comes as a surprise to discover that the sitter, Josephine Gaujelin, was, in fact, a dancer-turned-actress of no very great repute. Degas later (1873) used her as the model for a series of drawings of a figure in ballet costume, demonstrating the basic positions of classical dance.

Four years after Degas painted Mme Gaujelin, Berthe Morisot painted a likeness of her sister Edma, Mme Pontillon (*see plate 78*), which is curiously similar in mood. It was executed when Edma was expecting her second child, and at a moment when she was perhaps beginning to realize some of the disadvantages of marriage. She, too, was a painter, and had exhibited regularly in the Salon during the 1860s. After her marriage, however, she found it difficult to continue. Morisot wrote to her: 'Men incline to believe that they fill all of one's life, but as for me, I think that no matter how much affection a woman has for her husband, it is not easy to break with a life of work.' Edma, with her sombre dignity, to which is added a faint air of dissatisfaction, makes a striking contrast with Manet's butterfly sitters, whose social position was often so much more precarious than her own.

Morisot's *At the Ball* (*see plate 58*), of 1875, is lighter in mood. It may have been painted using a professional model; the name of the sitter is unknown. In costume and in mood it reflects the secure upper-middle-class world to which the artist herself belonged, but from which she was unable to break away – not because she lacked talent, but because of her gender. While Manet (the nature of whose attraction for her she could never fully admit) had the choice, she did not.

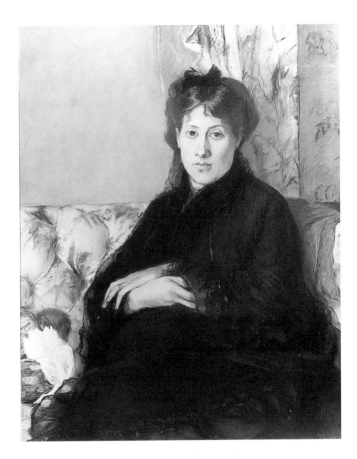

78. Berthe Morisot, *Portrait of Madame Pontillon* (1871)

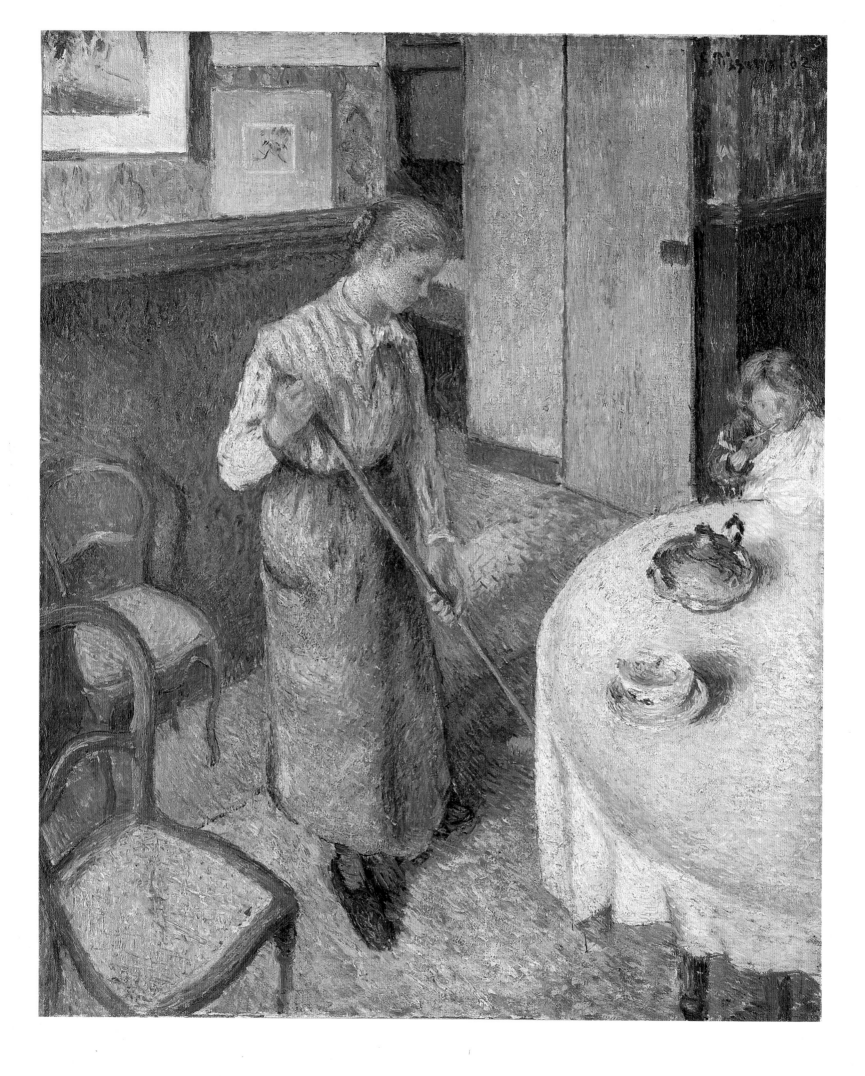

# LOW LIFE

The Impressionists' commitment to the idea of realism, led them to think of the whole of modern life as being their province. However, they differed from the realists of the preceding generation – that of Courbet and Millet – in the emphasis they put on living in or near Paris and on producing images of urban life. It was the writers rather than the artists who first came to be fascinated by the urban world. Charles Baudelaire, for instance, experienced a piercing melancholy as he saw what Baron Haussmann's vigorous building operations were doing to Paris:

> Paris has changed, but in my grief no change.
> New palaces and scaffolding and blocks,
> To me are allegories, nothing strange.
> My memories are heavier than blocks.

The Impressionist artists were less introspective. They saw it as their duty to record what was there; only rarely did they suggest a judgement, or hint that what they painted was also a projection of inner feelings.

Camille Pissarro proved to be the exception; politically he stood firmly on the left, although his paintings only hint at his political views in various subtle ways, rather than declaring them openly. Rooted strongly in the country, he was primarily a landscapist, and his pictures show how new factories were beginning to invade the countryside on the outskirts of Paris. When he ventured into town, as he sometimes did, he represented the city as a bustling microcosm. His townscapes – of the Avenue de l'Opéra in Paris, for example, or of the rue de l'Epicerie in

79. Camille Pissarro, *The Little Country Maid* (1882)

93

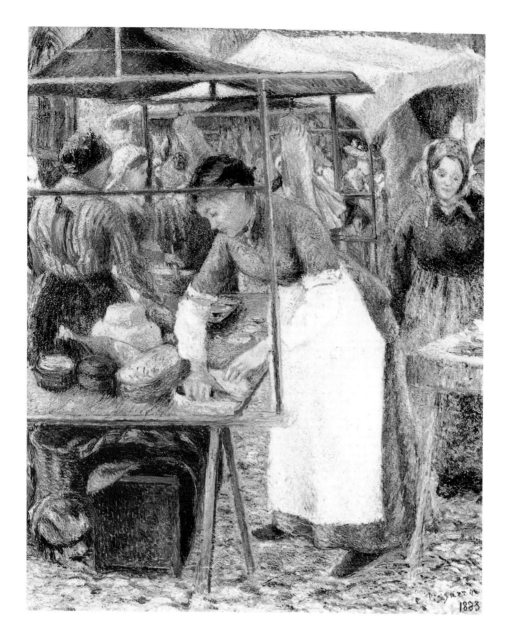

Rouen – tend to be painted from a viewpoint high up in some tall building, and the many figures are not fully individualized: their personality is a collective one.

When Pissarro did paint the figure, his subjects were country people, and his representation of them illustrates his debt to the work of J.F. Millet. Many of his preferred subjects can also be found in Millet's *œuvre* – figures tending animals or bringing in the harvest, women in farm interiors, sewing or spinning. There are, however, ways in which Pissarro extends Millet's themes. Pissarro was Jewish, and of bourgeois origin. His background was distinctly exotic, as he had been born and brought up on the island of St Thomas, in the West Indies. Like the rest of the Impressionist painters, he aspired to a comfortable bourgeois life style. His painting *The Little Country Maid* (*see plate 79*) gives us a glimpse of the Pissarro household sometime around 1882, just before he settled permanently at Eragny-sur-Epte. In some ways the image is rather like Claude Monet's *Le Déjeuner* (*see plate 22*), much of the picture space is occupied by a round table, at which a child sits eating. In Monet's painting, however, the focus is on the double portrait of his first wife Camille – she appears both sitting and standing. Although there is a maid present, she is pushed into

81. (opposite) Edouard Manet, *The Street Singer* (*c*. 1862)

94

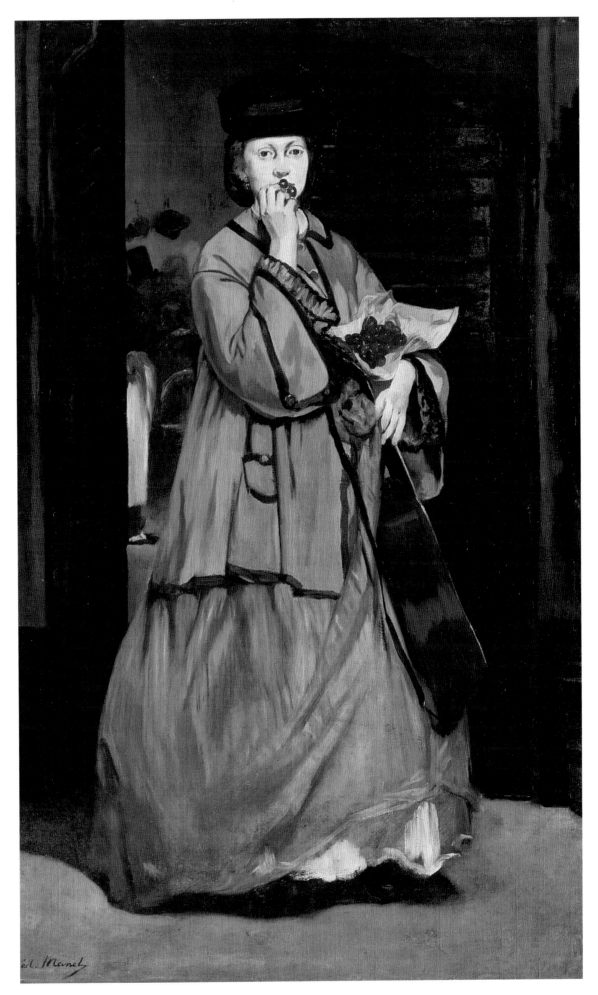

the background. The little servant of Pissarro's painting has become the subject of the picture, and the artist treats her in a characteristically sympathetic way.

Some of the most striking of Pissarro's figure paintings are those which stress the economic links between country and town. *The Pork Butcher* (*see plate 80*) shows a woman tending a stall in a bustling market. Probably the scene depicts the town of Pontoise, and very similar markets exist in French country towns to this day. Once again Pissarro presents his subject with great simplicity and dignity – we get the feeling that this is an independent female entrepreneur. The situation is, however, staged. X-rays show that the stallholder was originally an older and less attractive woman. When Pissarro decided to portray someone younger, he persuaded his niece Eugénie Estruc, known as Nini, to pose (as we know from a letter written to his son Lucien while the picture was being painted). It was Lucien who bequeathed the picture to the National Gallery, London, in 1949; it was transferred to the Tate Gallery in the following year.

Manet's *The Street Singer* (*see plate 81*), dated two decades earlier, was created in a somewhat similar way. Manet's friend Antonin Proust explains how the painting came about:

> One day we were ascending what has since become the boulevard malesherbes, in the midst of demolitions intersected by the yawning gaps of newly levelled properties. . . . A woman was come out of a sleazy cabaret, lifting up her skirts, holding a guitar. He went right up to her and asked her to come pose for him. She simply laughed. 'I'll nab her again,' he said, 'and then if she still doesn't want to, I have Victorine.'

Manet was referring to the professional model, Victorine Meurent, who often posed for him during this period. In the end, it seems to have been she whom he used for the painting.

*The Street Singer* describes a purely urban, and also a socially marginal type. Manet painted a number of other works which represent people from the same social stratum – *The Old Musician* of 1862, for example, and *The Ragpicker* of 1869. He found precedents for these paintings in seventeenth-century Spanish art: *The Old Musician* is related to *The Drinkers* by Velasquez, of which Manet made a copy. But such people were also very much part of the Parisian street scene, especially in the Batignolles quarter where Manet had his studio. Here the new buildings of Baron Haussmann's master plan stood side by side with warehouses, vacant lots, and the surviving slums which belonged to the old, pre-Second Empire Paris. What distinguished *The Street Singer* from the pictures of her male counterparts are the hints of sexuality contained by the canvas: the exposed petticoat where her skirt is hitched up and the cherries she is eating, often used by the Old Masters as a symbol of temptation.

*La Serveuse de Bocks* (*see plate 83*), painted nearly twenty years after *The Street Singer*, shows Manet freed from the thrall of the Spanish masters, but still

82. Edgar Degas, *Au café, dit l'absinthe* (1876)

intensely interested in urban working-class life. A waitress whom he had admired in a café concert is the model. She agreed to pose, but on condition that her boyfriend accompanied her to the studio; he is the figure in a blue workman's smock, who sits in the foreground, smoking a pipe. Manet catches brilliantly not merely the model's robust attractiveness, but her professionalism: she sets down a mug of beer with one hand, while holding two more in the other. At the same time she looks across the café, to see if some distant customer needs her attention. Even the drinks have social significance. The man in the smock is drinking not beer, but rough red wine, the traditional choice of urban manual workers. Beer only became popular in Paris after the mid-nineteenth century; the great influx of provincials, especially from beer-drinking regions in the east and north of the country was partially responsible for this, but the rise in the number of foreign tourists – English, Dutch and German – also contributed to the development of the taste.

Absinthe was another popular beverage but it enjoyed a bad

83. Edouard Manet, *La serveuse de bocks* (1878—9)

reputation. Having been purely a working-class drink, the communards (the left-wing revolutionaries who seized control of Paris in the brutal civil war of 1871) were described by their opponents as 'apostles of absinthe'. The truth was that, by this date, it had become the most popular variety of strong drink amongst nearly all classes in France. Degas's celebrated café scene called *Au café, dit l'absinthe* (*see plate 82*) shows two people, a depressed and perhaps slightly tipsy woman with a glass of absinthe in front of her, and a bohemian male drinking what has been recognized as a '*mazagran*' — a hangover cure compounded of cold black coffee and seltzer water. Members of the Impressionist circle posed for the figures — the actress Ellen Andrée and the artist Marcellin Desboutins. The intention, however, was to present a 'real' scene, emblematic of urban rootlessness: the two figures are the drifters typical of any big city, and the composition is arranged to stress their utter lack of psychological contact with one another.

Sometimes a single theme would catch the attention of several members of the Impressionist group. One such was the milliner's shop, depicted a number of times by Degas (*see plates 87, 88 and 91*), but also by Manet (*see plate 85*) and Eva Gonzalès (*see plate 84*). Manet's attention may have been drawn to it by his own appreciation of feminine fashion. A man-about-town, or *flâneur*, eager to observe and analyse all the foibles of the day, might very reasonably visit such a place, escorting the woman of his choice, giving advice, perhaps buying her a hat as a present. His pupil Gonzalès took a significantly different view. Her milliner is a working woman, slightly careworn in spite of the cheerful light blue of her dress; the trimmings she handles so matter-of-factly are simply a way of making a living. Gonzalès in fact used her own daily cleaner as a model. This painting makes a striking contrast with another depicting a milliner, painted less than a decade later by an artist who had at one time hovered on the fringe of the Impressionist group. James Tissot's shop assistant (*see plate 86*), standing tall and straight with her back to the show window, is an improbably glamorous figure, a symbol of Parisian chic, not a living, breathing individual.

Degas, a close friend of Tissot when they were both at the beginning of their careers, treated the theme with greater subtlety than Gonzalès, and also very differently from Tissot. In *The Millinery Shop* (*see plate 88*) — now in the collection of the Art Institute of Chicago — a plainly dressed woman, shifted very much to one side of the composition, holds up a hat. She looks at it, not admiringly, but as if she thought it needed some kind of extra touch. On hat stands beside her are a series of extravagant creations, of a kind which she herself would never dream of wearing. In a pastel in the Metropolitan Museum (*see plate 87*), the emphasis has shifted to the customer, who is trying on a bonnet — something not nearly as grand and fashionable as the hats in the Chicago picture. She raises one hand to the back of her head and slightly narrows her eyes as she peers at herself in a full-length glass which half-conceals the figure of the milliner herself, who is holding two more hats, one in each hand, ready to be tried in their turn. In this image, the working woman has become almost an

84. Eva Gonzalès, *The Milliner* (c. 1877)

85. (opposite) Edouard Manet, *At the Milliner's* (1879)

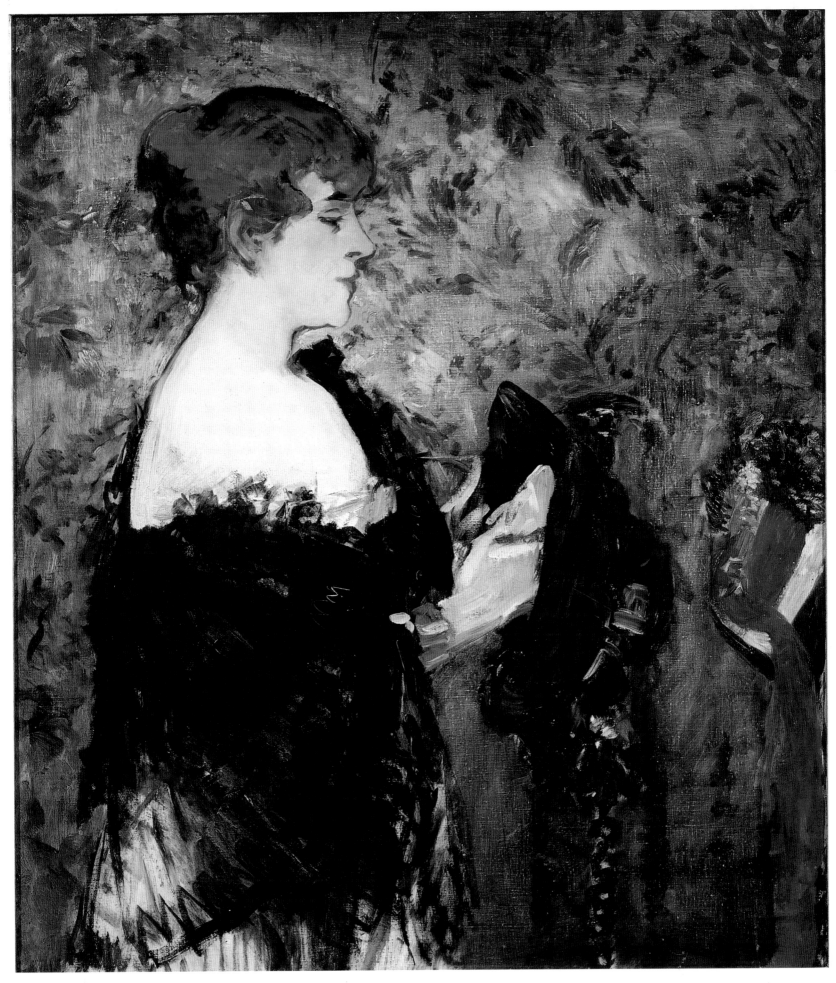

86. James Tissot, *The Milliner's Shop* (1883–5)

inanimate object, not much better than a hat stand. In a third variation on the theme, in the Thyssen-Bornemiza Collection (*see plate 91*), there is no sign of a shop assistant at all: one woman is trying on a hat, and another is advising her.

What Degas's paintings of millinery shops bring home to the spectator is the way hats functioned as totem objects: emblems of wealth and leisure amongst the women of the bourgeoisie; tokens of an outbreak of holiday spirit among women who had to work.

We can judge the subtlety of Degas's handling of the theme not only by looking at Tissot, but also by examining a variation done by Toulouse-Lautrec. In 1900, towards the end of his career, Lautrec was persuaded to explore the fashionable world of the rue de la Paix as an alternative to the cabarets and dance halls which encouraged his drinking. The project did not progress very far, but he did paint a portrait of a *modiste* (*see plate 89*) who was a long-time friend. Mlle Renée Vert had a shop at 56 Faubourg Montmartre, and was the mistress of a painter who was one of Lautrec's

87. Edgar Degas, *At the Milliner's* (1882)

friends. The study Lautrec made of her is beautifully composed and lit, but is curiously lacking in that characteristic Lautrec incisiveness. The painting has none of the psychological insight of comparable works by his exemplar, Degas.

Indeed, the only member of the Impressionist group who tried to explore the true harshness of working women's lives was Degas, his

BROOKLANDS COLLEGE LIBRARY
WEYBRIDGE, SURREY KT13 8TT

88. Edgar Degas, *The Millinery Shop* (1879–84)

magnificent studies of laundresses at work being the most notable attempts (*see plate 90*). When Degas went to visit his brothers in New Orleans in 1872–3, he wrote to Tissot that he found 'everything' beautiful, but that he would not change it for one Paris laundry girl. The steam laundries which proliferated all over the city are vividly, if melodramatically described in Emile Zola's novel *L'Assommoir* (1877), the story of a laundress who is exploited by both her husband and her lover, takes to absinthe, and eventually dies in misery.

For working-class girls, almost the only alternative to heavy physical labour of this kind was prostitution. This was widespread in all large nineteenth-century cities. Walt Whitman, for example, eloquently describes its prevalence in New York:

> Especially of the best classes of men under forty years of age living in New York and Brooklyn, the mechanics, apprentices, seafaring men, drivers of horses, butchers, machinists . . . the custom is to go among prostitutes as an ordinary thing. Nothing is thought of it – or rather the wonder is, how there could be any fun without it.

Nowhere was prostitution more institutionalized than in Paris. Quite apart from the prostitutes of all social ranks who worked on their own account, there were also the inmates of the licensed brothels, which were

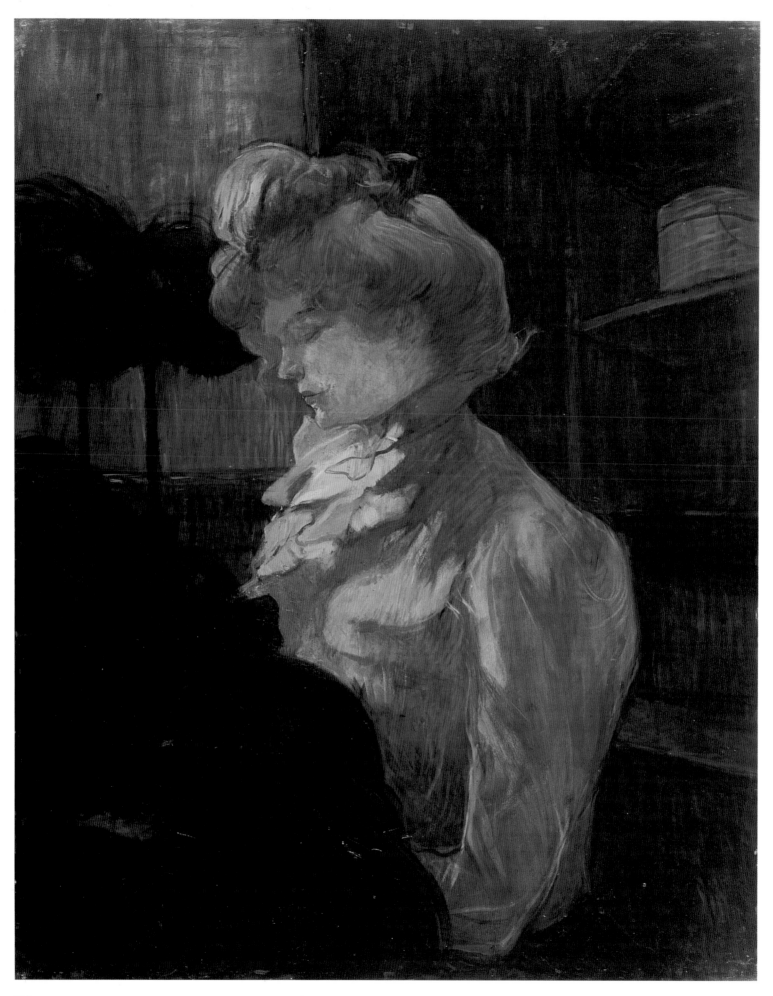

89. (opposite) Henri de Toulouse-Lautrec, *La Modiste* (1900)

90. Edgar Degas, *Les Repasseuses* (1884)

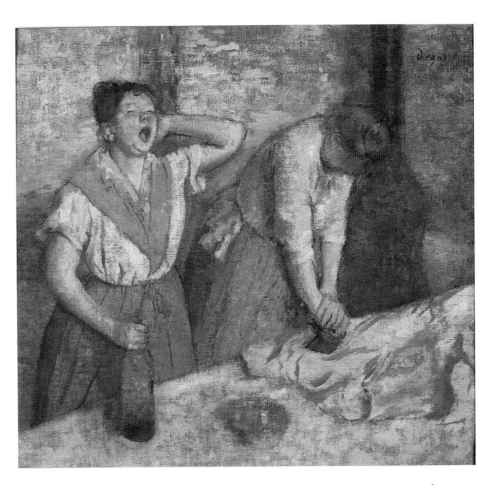

91. Edgar Degas, *Chez la modiste* (1883)

often very luxuriously appointed. The realist writers in France, such as Zola and Maupassant, treated the subject with a matter-of-factness alien to English and American novelists. Indeed, this blunt straightforwardness in dealing with the subject was one of the things which gained French literature a reputation for immorality, and often caused Zola, in particular, to be banned abroad. The Impressionists also devoted a good deal of attention to this class of subject matter.

Manet's first treatment of the theme, *L'Olympia* (*see plate 92*), painted in 1863, is oblique in its approach – giving the subject a mythological title – but the contemporary audience understood his meaning well enough, and were shocked, enraged or delighted, according to their point of view. The painting caused such a sensation when it was exhibited at the Salon, that a guard had to be placed over it. As so often, Manet took a theme hallowed by the Old Masters (his immediate source was Titian's *Venus of Urbino*), and perverted it to serve his own ends; Olympia, clad in a black ribbon, a bracelet and a pair of slippers – one of these has been kicked off – reclines of a couch. Beside her stands a black maid, holding a bouquet which is evidently a tribute from an admirer. But Olympia pays absolutely no attention at all to this offering; instead she gazes very directly at the spectator – a level look, which is both challenging and confident. Because she sells herself she is, paradoxically, in complete charge of her own destiny.

*Nana* (*see plate 94*), which Manet painted fifteen years later, is a variation

93. Edgar Degas, *Trois filles assises* (c. 1879)

94. (opposite) Edouard Manet, *Nana* (1877)

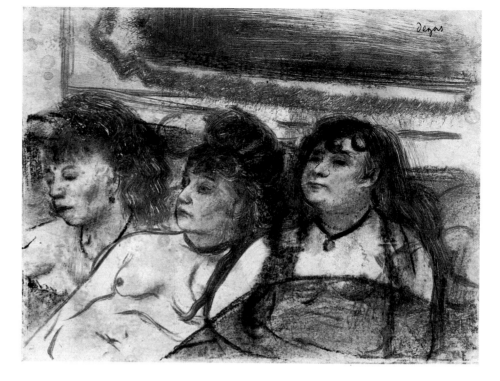

92. Edouard Manet, *L'Olympia* (1863)

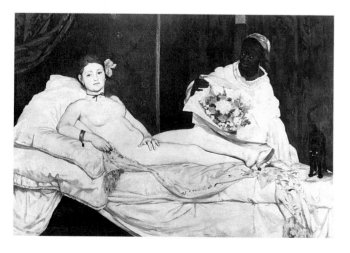

on this theme. The painting depicts a character in Zola's *L'Assomoir*, who was later to give her name to another novel in the sequence. Nana is a girl of working-class origins, who succeeds for a while through ruthlessly exploiting her looks. In Manet's painting she is dressed in her underclothes, and is busy adding the last touches to her make-up. On a sofa in the background sits her protector of the moment, to whom she seems to be listening somewhat distractedly. Perhaps she has become aware of another presence in the room – that of the viewer. Once again Manet creates a dialogue between the picture and its audience, and it is this deliberate inclusion of the spectator which, in both cases, makes the image unsettling. One recalls Baudelaire's apostrophe to the reader of his poems: '*Hypocrite lecteur, mon semblable, mon frère!*' Both the artist and the spectator are Nana's accomplices. It added to the painting's impact on Manet's contemporaries that his model was immediately recognizable: she was the actress Henriette Hauser, the mistress of the Prince of Orange.

Degas's treatment of the theme is very different. He shows not the high-class courtesan, nor the kept woman (for there is a shade of difference between the two), but instead the inhabitants of the licensed brothels. The series of monotypes in which they feature are amongst the most extreme of all Degas's works as regards their challenge to conventional attitudes. *Trois filles assises* (*see plate 93*) looks forward to some aspects of German Expressionism. The women, plump pear-shapes, with sly expressions on their faces, have a kind of jollity, a complacency about their lot, which seems to revolt yet fascinate the artist. Women – these women at any rate – are shown as being little better than animals, shameless, armoured by their own indifference. Yet there is a wry humour in another in the series. In *La fête de la patronne* (*see plate 97*) the girls crowd round, in a state of working undress, to offer flowers and good wishes to their employer, who submits impassively to all the fuss. This work, along with a number of other monotypes from the same series, was later to belong to Picasso, and one can see why he was fascinated by

95. Henri de Toulouse-Lautrec, *Le Salon de la rue des Moulins* (1894)

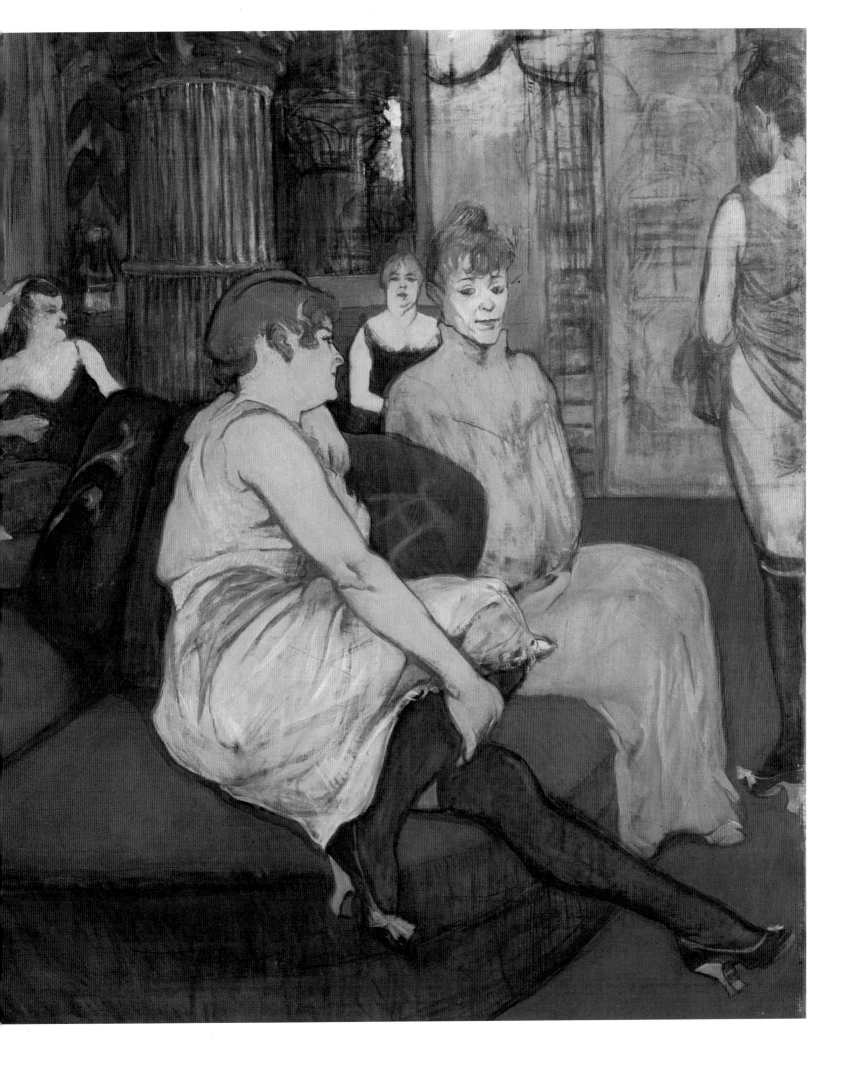

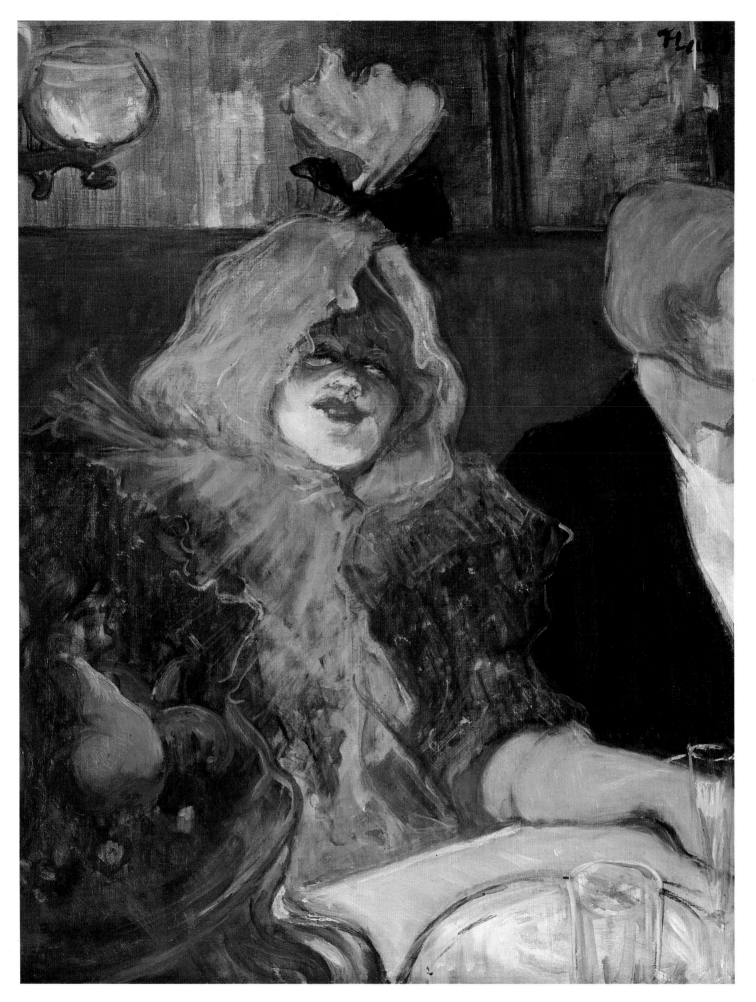

Degas's treatment of the theme. The mingling of the bizarre and the matter-of-fact was exactly designed to appeal to his taste. There is also the fact that the actual drawing is masterly. Degas never achieved anything more direct or more expressive.

Degas's successor in describing the life of the licensed brothels was Toulouse-Lautrec. However, Lautrec's attitudes towards their inhabitants were both more complex and a good deal more sympathetic. *Le Salon de la rue des Moulins* (*see plate 95*) is a view of the main room in the brothel in Paris where Lautrec lived for weeks at a time. It is a slack time, and the women are awaiting the arrival of clients. Lautrec catches all the boredom and claustrophobia of their existence. The figure in the foreground in a blue dress – with her leg drawn up – is generally identified as a girl called Mireille, a particular favourite of Lautrec. He would even pay for her to take a day off so that she could come to pose in his studio. Later, when she left France to go and work in South America, Lautrec complained to a friend:

> Mireille's off to Argentina. Some meatpackers have convinced her she can make her fortune out there. I've tried to talk her out of it, but she really believes all their claptrap. None of the girls who go there ever come back. After two years of it, they're finished.

Lautrec explored, as Degas did not, the attitudes of the prostitutes themselves. He portrayed the daily routine of the brothel in the masterly portfolio of lithographs called *Elles*. There is little emphasis on sexual activity, at least of a heterosexual kind. What Lautrec showed instead was a universe of women – their morning awakenings; the toilet; and then not only the boredom of a place where day and night were scarcely distinguishable from one another, but also the terrible lassitude induced by sex without affection. He also demonstrated the way in which the girls often turned to one another for emotional solace. These images are the culmination of the reinterpretation of the notion of 'realism' first begun by Manet, and continued by Degas.

Finally, it is worth calling attention to a work in which Lautrec portrayed not a prostitute in a *maison close* or brothel, but a *demi-mondaine* of the superior sort, who appears as the chief figure in the painting called *Tête-à-tête Supper* (*see plate 96*) – a portrait of a woman called Lucy Jourdan, said to have been commissioned by her lover. She is shown taking supper in the private room of a fashionable restaurant in the rue Pigalle. The artist brilliantly contrasts her attire – the soft, gauzy headdress which enfolds her face – with her narrowed eyes and sneering smile. With this level of the profession he clearly felt much less sympathy.

97.  Edgar Degas, *La fête de la patronne* (1878–9)

96.  (opposite) Henri de Toulouse-Lautrec, *Tête-à-Tête Supper (Au Rat Mort)* (1899)

# THE WORLD OF ENTERTAINMENT

Impressionist art looked most intensely at women and their personalitites in its representations of the world of entertainment. There were many reasons why the theatre, the dance hall, the cabaret and the circus played so large a part in what the Impressionists chose to depict. Throughout the eighteenth and nineteenth centuries the theatre was the focus of urban life – the place where all classes came together to undergo some kind of collective experience. Political, aesthetic and class confrontations took place within the framework provided by the theatre. The so-called 'Battle of Hernani', for example, took place when Victor Hugo's romantic drama of that title was first staged at the Théâtre Français in 1830 – a near-riot which signalled the triumph of the Romantic Movement in France.

One important feature of theatrical life was the physical separation of the audience; some were in the stalls or pit, while others in the tiers of boxes. The boxes were the domain of the superior classes (*see plate 99*); they were also, most of all, the territory of women. For the Impressionist painters, these boxes and their occupants provided an ever-fertile subject. Perhaps its most famous representation in Impressionist art is Renoir's dazzling *La Loge* (*see plate 100*). An elaborately dressed woman sits well forward, so that her finery can be seen and admired. Behind her a male companion scans the boxes opposite with a pair of opera glasses.

The painting was itself 'staged' to meet the artist's requirements. The woman was an artist's model, whose real surname is unknown but who was known as Nini Gueule de Raie (Nini Fishmouth); and the man was Renoir's brother. It has been suggested that the image was a piece of wish

98.  Edgar Degas, *Miss Lala at the Cirque Fernando* (1879)

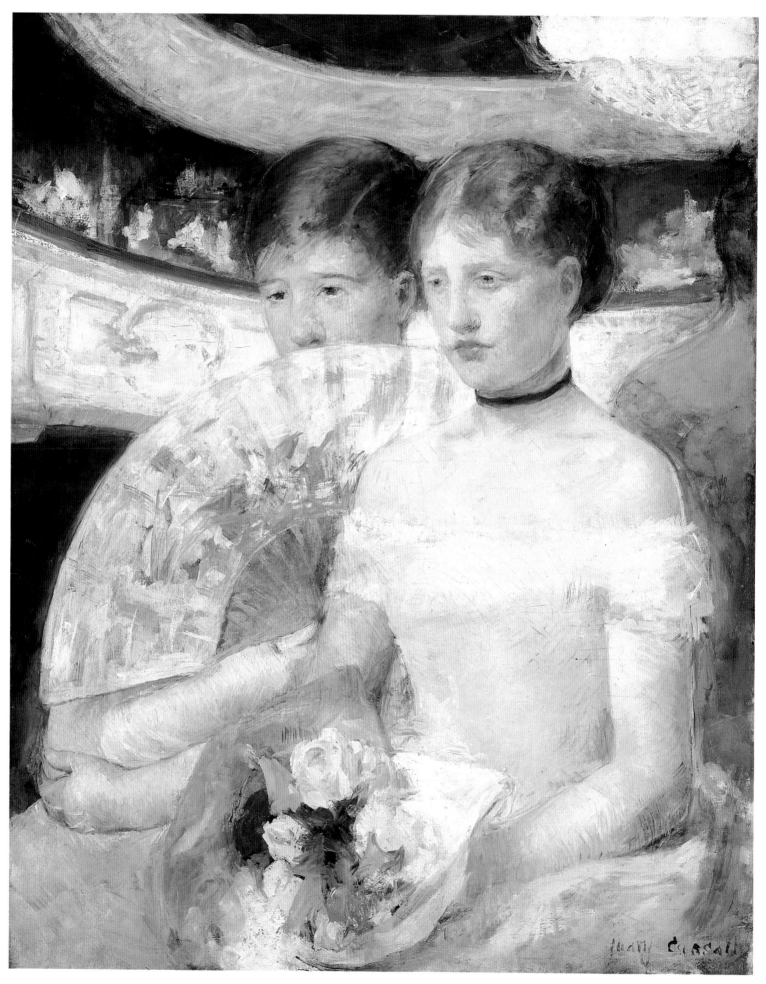

fulfilment: Renoir, still poor and unsuccessful, was painting the kind of fashionable creature he wanted at his side, who would herself have been the symbol of his acceptance in society. However, the painting is subtler than this. The woman is indeed pretty, and the box puts her on display, so that she can make the most of her looks and her fine clothes – but her companion is no longer interested. He may be using his opera glasses, but it is because he is searching for a substitute – as he is looking upwards, he cannot be looking at the stage.

A pair of opera glasses plays an equally eloquent role in Mary Cassatt's representation of the same subject (*see plate 101*). This time we see a woman who is apparently alone in her box. She is dressed severely in black, but she cannot be in mourning, or she would not be at the theatre at all. She is gazing at something across the auditorium with an intent, concentrated look on her face, but at something in the same tier. And she in turn is being quizzed from a box further along, by a man who leans right out in order to get a better look at her. There is a whole history suggested here of people who spy and are spied upon, of private dramas being acted out in a public place.

The relationships are less ambiguous in Eva Gonzalès's *Une Loge au théâtre des Italiens* (*see plate 102*). Here the man is properly intent on his partner, though she is listening to him with only half an ear, and seems to have been distracted by something which leads her to look out of the canvas, towards the viewer. She holds her opera glasses in one hand, ready for use, but has not yet brought them to her eyes.

Some cabarets and café concerts in Paris also had boxes for their more elegant clients, for whom part of the amusement was being able to watch the antics of the *canaille* (rabble). The Divan Japonais, for which Toulouse-Lautrec provided a poster (*see plate 103*), was a small cabaret of this sort. Lautrec portrayed the famous singer Yvette Guilbert on stage, instantly recognizable because of her long black gloves, even though her head is cut off by the top edge of the design. He focused the attention of the viewer, however, not on the performer, but on two of the patrons. The woman is Jane Avril, a celebrated dancer from the Moulin Rouge, whom Lautrec was to depict on other occasions (*see plates 120 and 121*). Here she is simply a symbol of self-confident elegance. Her companion is the literary and musical critic Edouard Dujardin, editor of the Symbolist *Revue Indépendante* and co-editor of the *Revue Wagnérienne*. He was an enthusiastic devotee of the great Symbolist poet Stéphane Mallarmé (already mentioned as a friend of Manet), but the poet was not altogether grateful for this enthusiasm, describing him as 'the offspring of an old sea-dog and a Britanny sea-cow'. Lautrec mischievously transformed this intellectual figure into an image of lecherous decadence, quite properly ignored by his companion.

When the Impressionists portrayed performers, rather than spectators, it was the less intellectual aspects of Parisian entertainment which they preferred to depict. Manet, besotted by Spanish painting, was naturally delighted when a troupe of Spanish dancers came to Paris in the early 1860s. He painted a frieze-like composition showing two of the dancers

99. (opposite) Mary Cassatt, *The Loge* (1882)

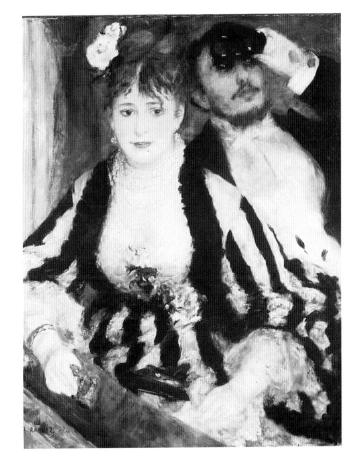

100. Auguste Renoir, *La Loge* (1874)

performing, with others looking on; then painted a portrait of their
prima ballerina, Lola de Valence, standing on stage (*see plate 104*). This
renders her rather harsh features with blunt honesty, and depicts her
costume with brilliant virtuosity. When Manet made an etching of the
picture, Baudelaire wrote a verse to go underneath the image:

> *Entre tant de beautés que partout on peut voir,*
> *Je comprends bien, amis, que le désir balance;*
> *Mais on voit scintiller en Lola de Valence*
> *Le charme inattendu d'un bijou rose et noir.*

Many years later Toulouse-Lautrec was seized with enthusiasm for
another dancer who performed in the Spanish style, but his subject was

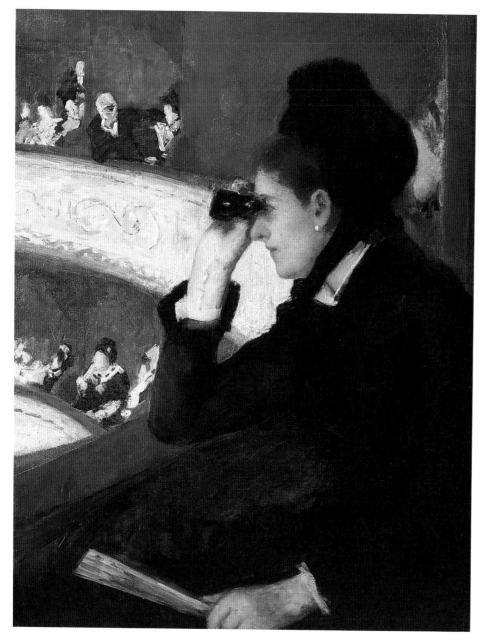

101. Mary Cassatt, *At the Opera* (1880)

102.  Eva Gonzalès, *Une loge au théâtre des Italiens*
(c. 1874)

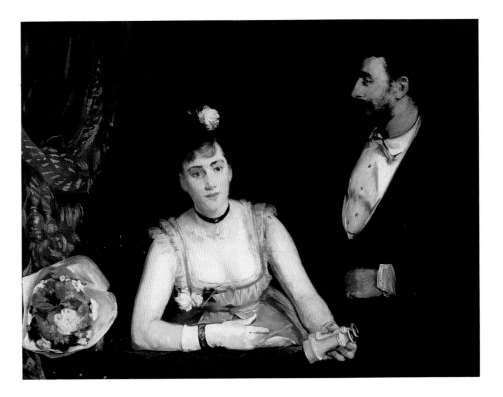

in fact a Frenchwoman. In 1895 the beautiful Marcelle Lender, who had already caught Lautrec's eye in a piece called *Madame Satan*, appeared in a revival of the operetta *Chilpéric*, a Merovingian fantasy by the composer Hervé (Florimund Ronger, 1825–92). For some reason, she was called upon to perform both a fandango and a bolero. Lautrec attended over twenty times. 'I only go there to look at Lender's back,' he said. 'Look at it carefully because you will never see anything finer.' The bolero in *Chilpéric* eventually became the subject of one of Lautrec's more ambitious compositions (*see plate 105*).

The Impressionist painter most closely connected with the idea of dance and dancing was not Manet, at the beginning of the movement, however, nor Lautrec, at the end of it, but Degas. Many strands are entwined in Degas's paintings and pastels of dancers. For Degas, dancing was a form of work, and he did not understate this aspect of it. The ballet was also a forum for sexual and social exploitation, and this appealed to Degas's misogyny. Finally, we may suspect that the artist, who never married, was attracted by the dancers themselves, and perhaps most strongly by the very young girls, called the *rats du ballet*, who were trainees rather than fully fledged dancers.

The ballet, like its companion the opera, was heavily subsidized by the Government, during both the Second Empire, and its successor the Third Republic. In 1861 the ambitious plans prepared by the architect Charles Garnier for a new opera house – the one now standing in the Place de l'Opéra in Paris – were put in hand, but the building was not completed until 1875. Meanwhile performances continued at the old opera house in the rue Le Pelletier. The Government cheerfully undertook the double financial burden. However, it did not feel that it

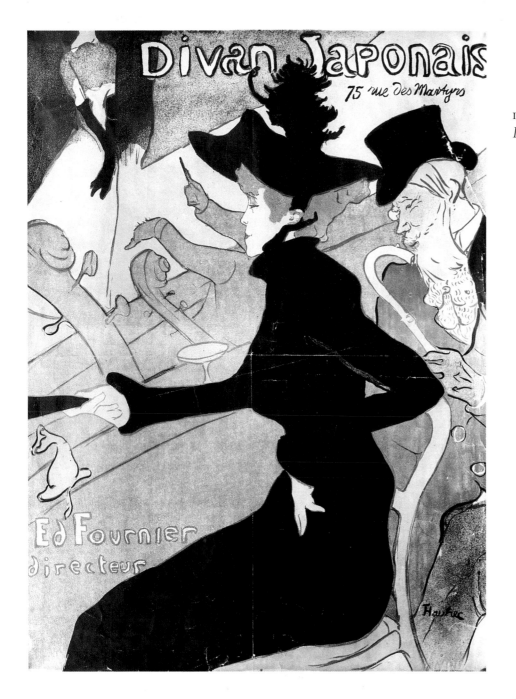

103. Henri de Toulouse-Lautrec, *Poster for Divan Japonais* (1892)

could be held responsible for any particularly good payment for the trainee dancers; they could wait until they, or some of them, achieved star status.

When Degas first became interested in the ballet most of these trainees were working-class girls. They studied first, for some years, without any payment at all. At the age of nine or ten, after passing a number of examinations, they were enrolled in the lowest rank, that of the third quadrille. At this point they were given a salary. Dance classes now took up so much of the children's time that their formal education usually ceased. Many, in consequence, remained illiterate. This situation obviously offered a perfect opportunity to the would-be 'protectors' who swarmed behind the scenes. Moreover, the children's mothers, who accompanied them to and from class, and into the rehearsal rooms, were often quite anxious to push their offspring forward, so that some kind of mutually satisfactory arrangement could be concluded.

'Protectors' came from the highest ranks of society, while the girls

104. (opposite) Edouard Manet, *Lola de Valence* (1862)

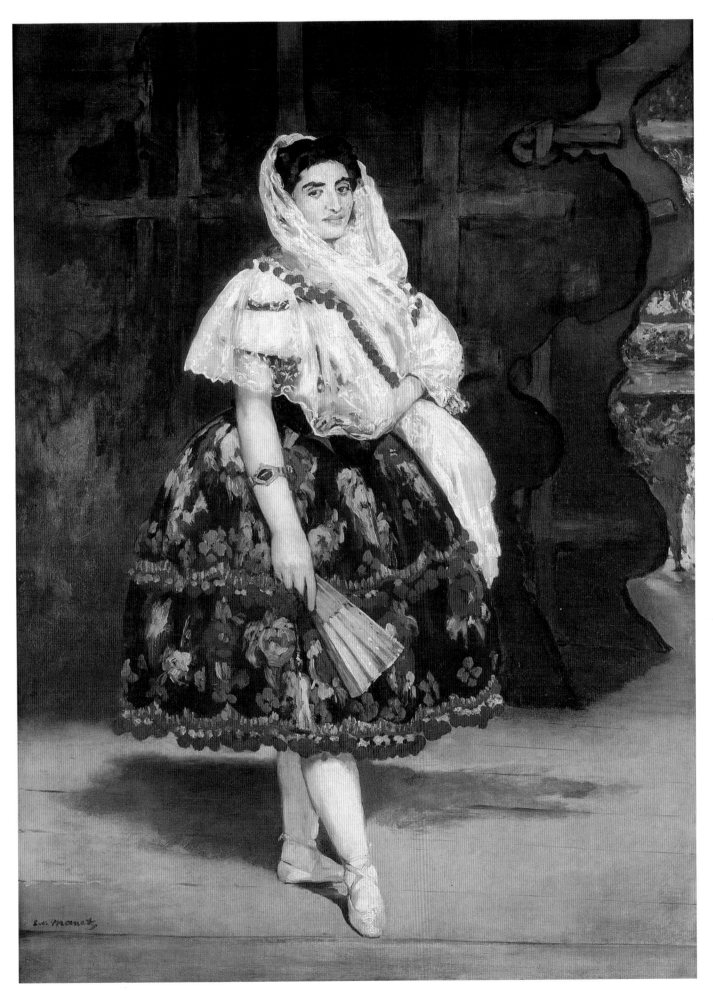

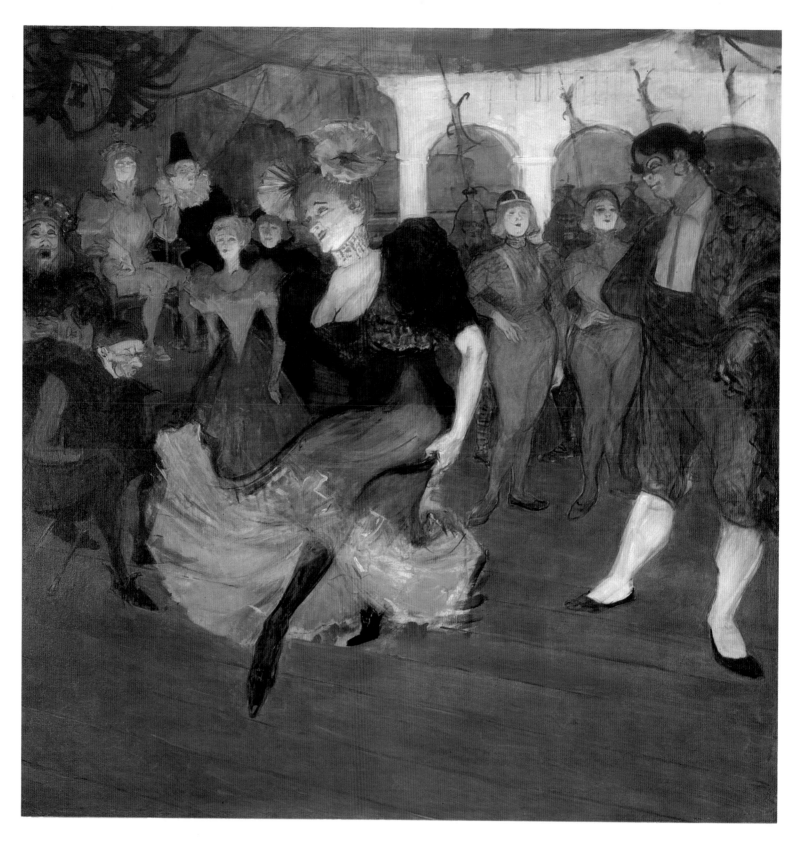

105.  Henri de Toulouse-Lautrec, *Marcelle Lender dancing the Bolero at the Chilpéric* (1895–6)

often came from the lowest. Those who had the right to backstage entry at the Opéra included diplomats, visiting foreigners of high rank, and successful financiers. Most of all, they were drawn from the ranks of the Jockey Club, the smartest men's club in Paris. Under the Second Empire, about fifty members of the Jockey Club occupied seven boxes between them, taking turns to attend on Mondays, Wednesdays and Fridays. It was these box-holders who were most frequently to be encountered behind the scenes and their preferences had a great impact on the way

productions were staged. The ballet was always an interlude in some operatic production rather than being an independent entertainment, and this interlude was customarily placed in the second act, so that those who were chiefly interested in the dancers could have supper beforehand, and arrive at their leisure. One reason for the spectacular failure of Wagner's *Tannhäuser*, when it was first produced in Paris in 1861, was the fact that it broke this rule: the ballet occurred in the first act.

It was only after the move to Garnier's new opera house in 1875 that the power of the members of the Jockey Club was somewhat diminished, though even then not entirely destroyed. At the same time, there was a change in the composition of the members of the ballet corps. The young dancers more and more began to be drawn from the middle class, chiefly from the families of the musicians who played in the orchestra, and of the dance instructors – the families of Opéra staff.

Degas, by birth a member of the upper class, was well aware of all these social nuances. In particular he was friendly with Ludovic Halévy, who was one of Offenbach's librettists. Degas even collaborated with Halévy and his partner Meilhac on a play, *La Cigale* (The Grasshopper), which made fun of the Impressionists. Halévy wrote a series of stories about backstage intrigues at the Opéra called *La Famille Cardinal*, which primarily describes the efforts of a ballet mother, Mme Cardinal, to arrange lucrative marriages for her two pretty daughters, Pauline and Virginie. Degas made a whole series of monotype illustrations to this book, so clearly the theme fascinated him. They were not published in his lifetime or during that of the author, so they were probably only done for his own satisfaction. Halévy himself appears in a number of these illustrations. In general, it seems to have been this friendship which played the major role in encouraging Degas to explore the theme with which he is now most closely associated.

Degas concerned himself with all aspects of the dancers' lives – professional as well as personal. He attended not only the dance classes which took place every day (*see plate 106*), but also the rehearsals, and the performances too. All this gave him a chance to analyse characteristic movements, and he built up a stock of drawings which could be combined and recombined to create different compositions, a method used by Antoine Watteau in the eighteenth century to create his *fêtes galantes*.

A journalist who attended one of the rehearsals at the Opéra when Degas was present left this description of the way the artist worked:

The rehearsal was in full sway: *entrechats* and *pirouettes* followed one another with rigorous regularity; in a laborious tension of all these young and supple bodies, and the spectacle was so curious to a young novice like myself that I was utterly absorbed in silent contemplation from which I would not have emerged for a long while if my companion had not suddenly nudged me.

'You see that fellow over there, the one with the cylindrical head and a beard, sitting in the corner on a chair with a drawing-pad on

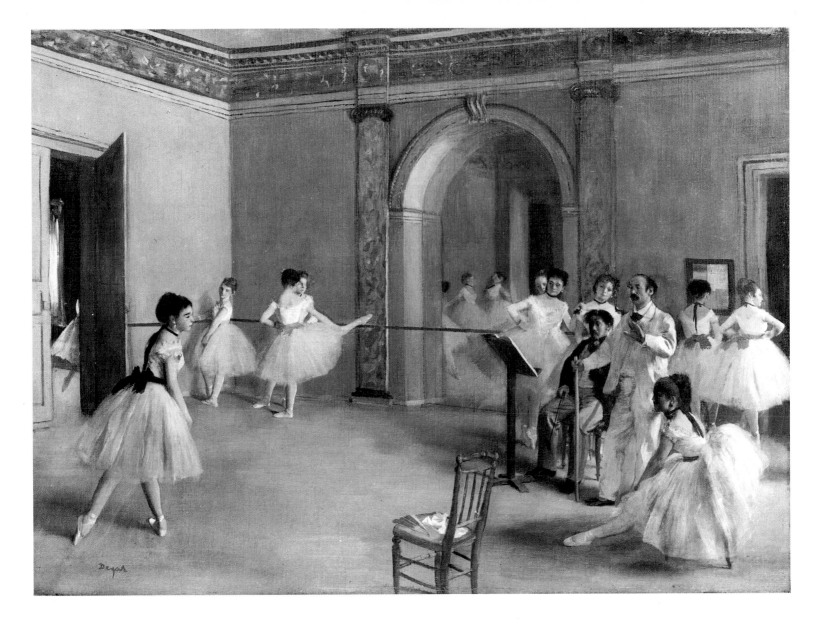

his knees? That's the painter Degas. . . .

    'Degas comes here in the morning. He watches all the exercises in which the movements are analysed, he establishes by successive features the various gradations, half-tempos and all the subtleties. When evening comes, at the performances, when he observes an attitude or a gesture, his memories of the morning recur and guide him in his notations, and nothing of the most complicated steps escapes him. . . . He has an amazing visual memory.'

In fact Degas seems to have preferred the classroom and the rehearsal (*see plate 2*) to the performance itself. When he did depict performances, it was always from some unusual angle (*see plates 107 and 108*) – from a box very close to the proscenium arch; or from a position standing in the wings. This device enabled him to strip away any element of theatrical illusion. Degas's ballet pictures are profoundly lacking in sentimentality; perhaps it is that which distinguishes them most clearly from the many imitations made of them since his own day.

    While Degas was interested in significant gestures, he was not, it seems, very much concerned with the dancers as individual personalities. If their poses are expressive, their features often lack expression. An apparent

106. Edgar Degas, *Foyer de la danse, rue le pelletier* (1872)

107. (opposite) Edgar Degas, *Before the Curtain Call* (1892)

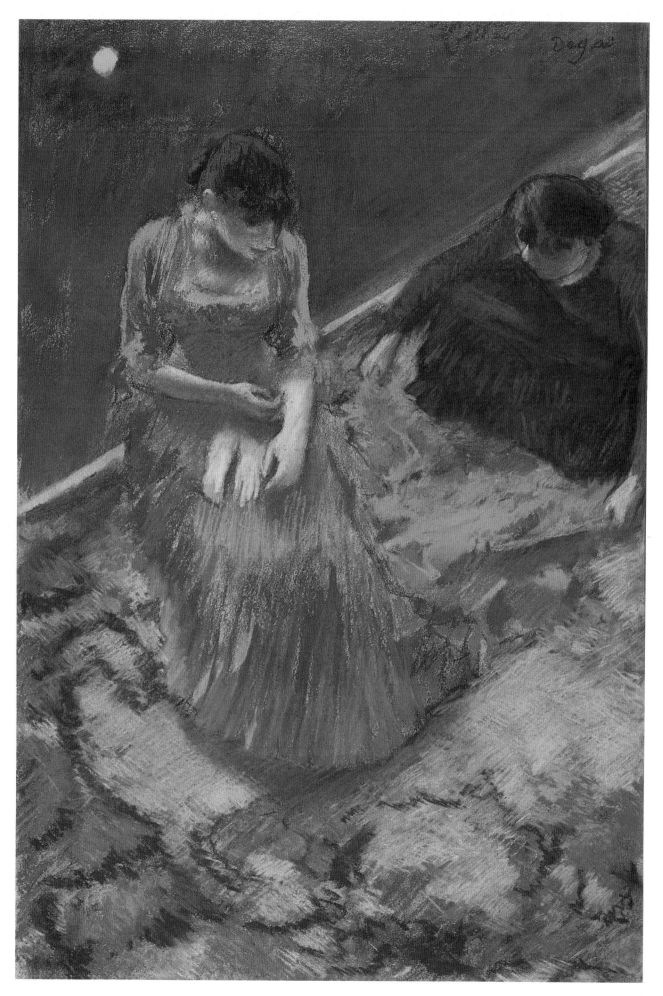

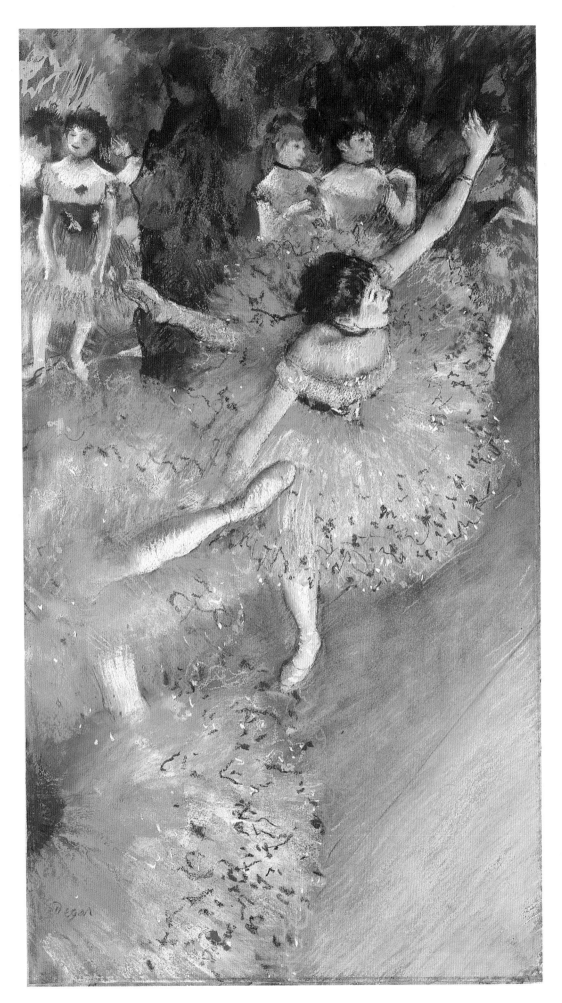

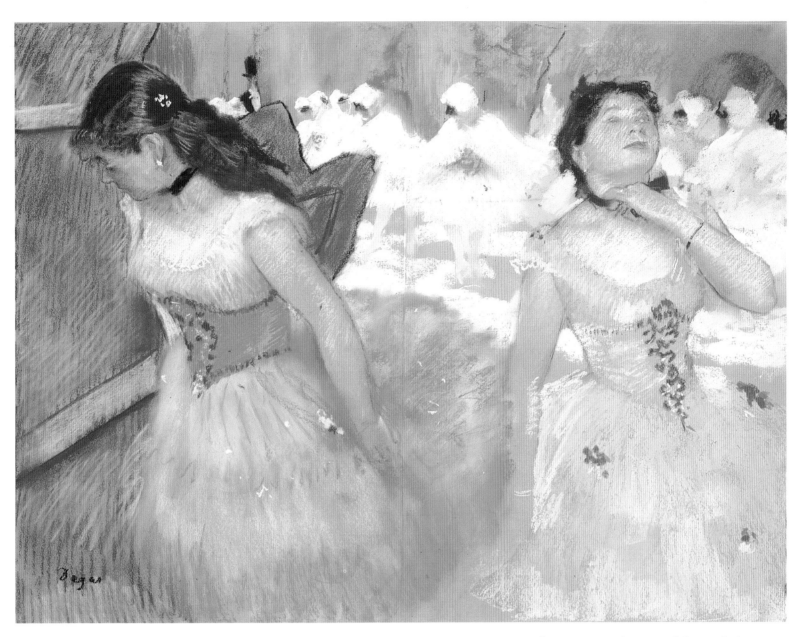

exception is *The Entry of the Masked Dancers* (*see plate 109*), which shows two dancers just offstage, behind a piece of scenery, with the *corps de ballet* in action behind them. In the far distance we get a glimpse of a man in a top hat – one of the privileged male bystanders already described. Of the two dancers who are the centre of attention in the composition, one turns her head away, so that her face is almost invisible. The other closes her eyes and lifts her chin, fingering meanwhile the black ribbon at her throat. The gesture seems to be one of distress and physical weariness; the performance has left her physically drained. But Degas tells us nothing about her inner self.

Degas came to the ballet at a time when the art of dance was at a low ebb, a fact which has sometimes been regretted. His ballet paintings and drawings were made after the great period of Romantic ballet when stars such as Taglioni and Carlotta Grisi were performing for the public, and before the arrival of the Ballets Russes – led by Diaghilev and adorned by Nijinsky and Tamara Karsavina. But had the ballet been less workaday, it would perhaps have been less useful to Degas. Dance experts, who sometimes criticize the poor technique of the dancers depicted by Degas, and their imperfect execution of the standard classical steps, forget that

109.  Edgar Degas, *The Entry of the Masked Dancers* (n.d.)

108.  (opposite) Edgar Degas, *Danseuse basculante* (1877–9)

what interested the artist was precisely the unremitting struggle with human imperfection which the dance class represented for him. The gap between the real and the ideal is one of the great themes of Degas's art.

His attitudes were, however, somewhat different when he transferred his attention from the ballet to the café concert, that most Parisian of institutions. Originating in the open-air concerts which had already been held for years in the tree-shaded space where the Champs-Elysées met the Place de la Concorde, the café concert began to develop in the 1840s. One of the first, and most enduringly famous, was the Café des Ambassadeurs, housed in a structure built in 1841. Degas depicted it on a number of occasions, and his close-up studies of café concert singers, like the one illustrated (*see plate 110*), were probably also based on the sketches he made there.

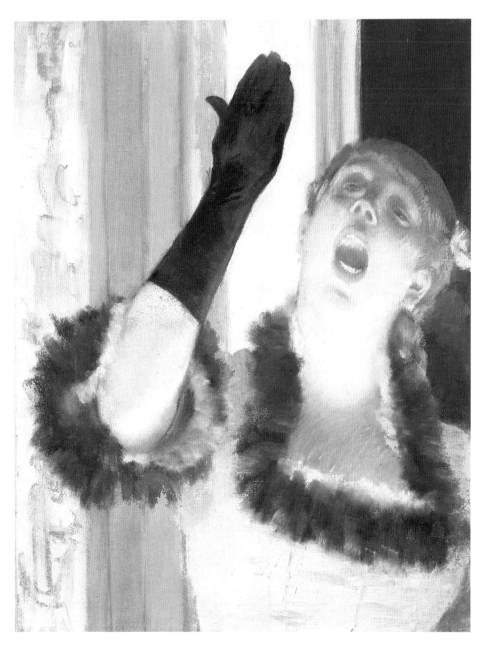

110. Edgar Degas, *Singer with a Glove* (c. 1878)

111. (opposite) Edgar Degas, *Le café concert aux ambassadeurs* (1876–7)

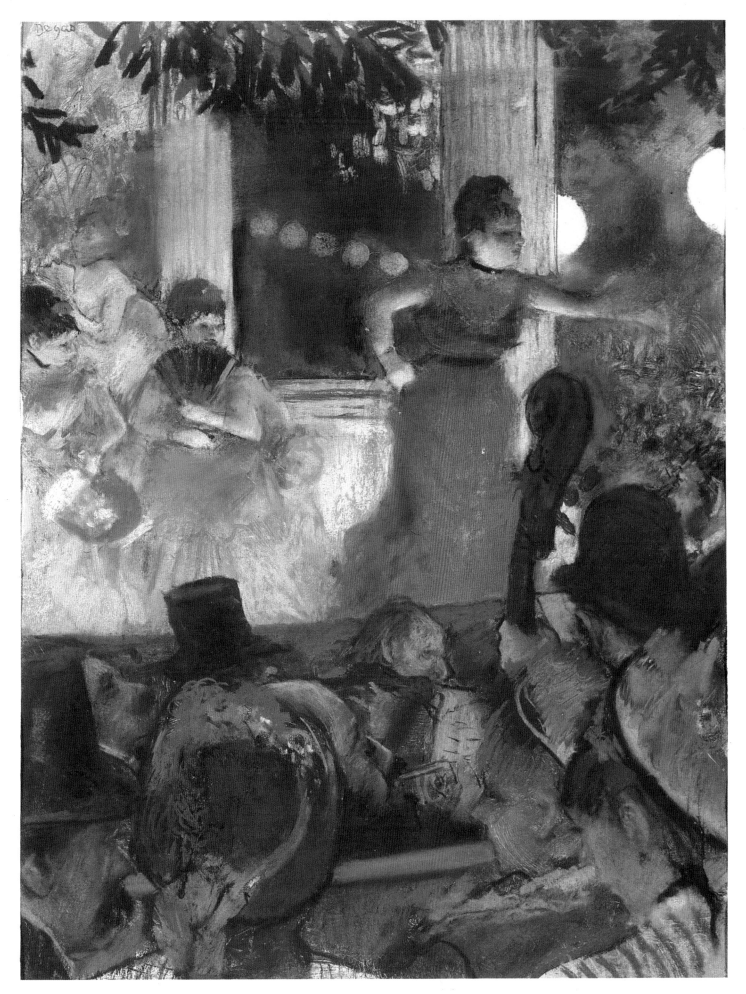

The Café des Ambassadeurs was quite expensive, and did not attract a real working-class audience, which was content instead with much humbler establishments, away from the centre of Paris. It was big, however – it could seat about twelve hundred people – and the social mix was a varied one, ranging from shop assistants to members of the leisured and wealthy class. It attracted many tourists, and respectable middle-class and upper-class women went 'slumming' there – but only in the boxes. Despite the lack of a real working-class audience, the performance itself was rooted in popular urban culture: the stars were themselves children of the people, and they sang with raucous

112. (opposite) Henri de Toulouse-Lautrec, *Yvette Guilbert salutant le public* (1894)

113. Henri de Toulouse-Lautrec, *Poster for May Belfort* (1895)

114.  Edouard Manet, *Bar aux Folies-Bergère*
(1881–2)

115.  (opposite) Hènri de Toulouse-Lautrec,
*L'Anglaise du 'Star'* (1899)

vehemence, with much use of slang. Although the written texts of the songs they performed were often innocent enough, the performers packed them with political and sexual allusions through the skilful use of gesture, of changes of tone, and by the discovery of *double entendre* in apparently blameless material. The audience were encouraged to respond, and to join in the choruses. Degas's *Le café concert aux Ambassadeurs* (*see plate 111*) shows all this clearly.

It also shows the attractive girls who were used to 'dress' the stage and provide a background for the singers. The collective noun for this group was the *corbeille* – a word which suggested a comparison with a basket of fruit or flowers. The *corbeille* was a much appreciated feature of the café concert. The girls often distracted attention from the performance by flourishing their fans and bouquets (tributes from their admirers), so as to convey coded messages to members of the audience.

When Degas focused on one of the performers, as opposed to the general ambience, he did manage to convey a vivid idea of the type of personality who would find favour with an audience of the kind the Café

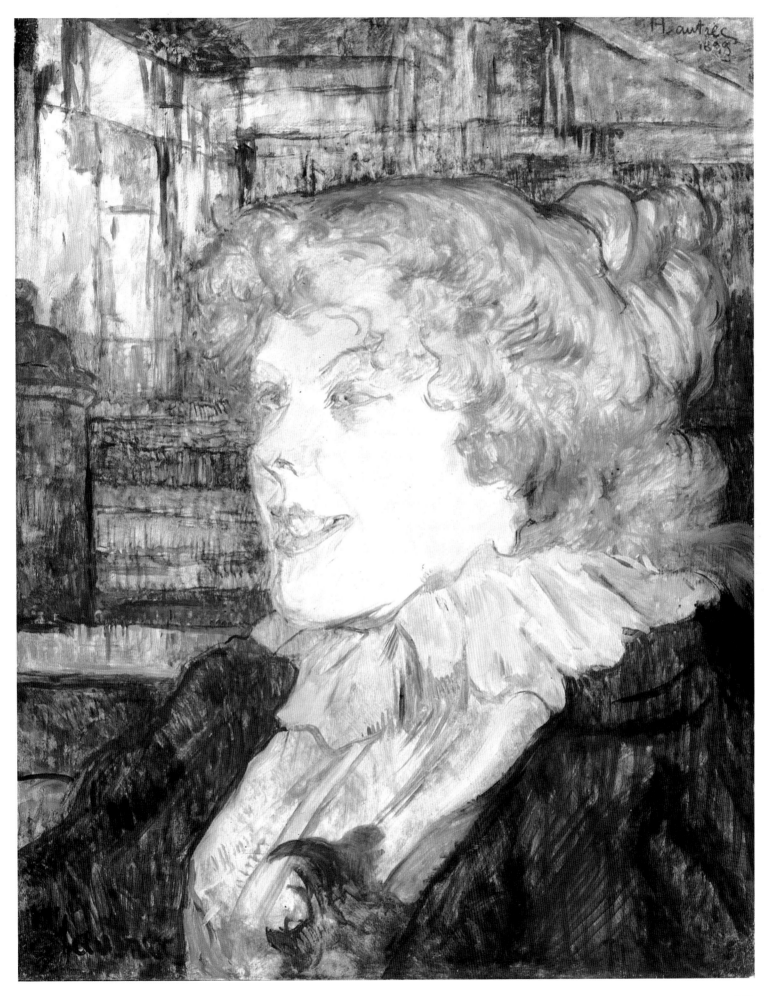

116. Henri de Toulouse-Lautrec, *Moulin de la Galette* (1889)

des Ambassadeurs attracted. But his depiction is still purely generic; he tells the spectator that he is portraying a particular sort of person, rather than a unique personality.

Toulouse-Lautrec, in so many ways Degas's devoted disciple, tackled this kind of subject matter with much greater regard for the individual. The nature of the Parisian café concert had itself begun to change, however, by the time Lautrec was working. Yvette Guilbert, who became the subject of some of Lautrec's most telling images (*see plate 112*), possessed a notoriously weak voice, and would never have been able to hold her own in the large open-air spaces of the Café des Ambassadeurs. Her natural setting was a small, enclosed space like the Divan Japonais, though she also made some early appearances at the Moulin Rouge. Her whole repertoire, though still full of *double entendre*, was more subtle and more literary than the material which would have been familiar to an earlier generation of café concert artistes. Under these circumstances a much greater degree of communication between the artist and his sitter seems only natural. But even Guilbert flinched, at least at first, from the incisiveness of Lautrec's portrayal of her. When he wanted to do a poster of her, his request at first received an unfavourable response:

Dear Sir,
        As I told you, my poster for this winter is already ordered, and is nearly finished. So we'll have to put it off till another time. But for heaven's sake, don't make me so dreadfully ugly! A little less, sir, if you please! . . . Many people who come to see me shriek with horror at the sight of the coloured sketch. . . . Not everyone can see the artistic side of it . . . oh well! With grateful thanks.
                                                                Yvette

Later, she was to realize how large a part Lautrec's portrayals had played in creating her fame.

Another member of the new generation of café concert performers was the Irish girl, May Belfort (*see plate 113*). (Her real name was May Egan.) She was one of a group of English-speaking performers, whose accents were much relished by the sophisticated audiences then attending the new, smaller cabarets. Another was the Glasgow-born singer Cécy Loftus. Lautrec drew then both. May Belfort's act was very simple. She appeared in a frilly Kate Greenaway-style dress, wearing a vast mobcap with a bow, and often holding a cat in her arms. Thus attired, she sang simple nursery rhymes in a lisping voice, packing the words with the maximum of *double entendre*. It is easy to understand that this act, like Yvette Guilbert's, would not have had its full effect in the large spaces of Les Ambassadeurs. But it is also equally easy to see the connection between the singers Degas depicted and May Belfort in particular.

The café concert sometimes took on hybrid forms, in which the

117. Henri de Toulouse-Lautrec, *Les deux valseuses au Moulin Rouge* (1892)

118. Henri de Toulouse-Lautrec, *At the Moulin Rouge: The Dance* (1890)

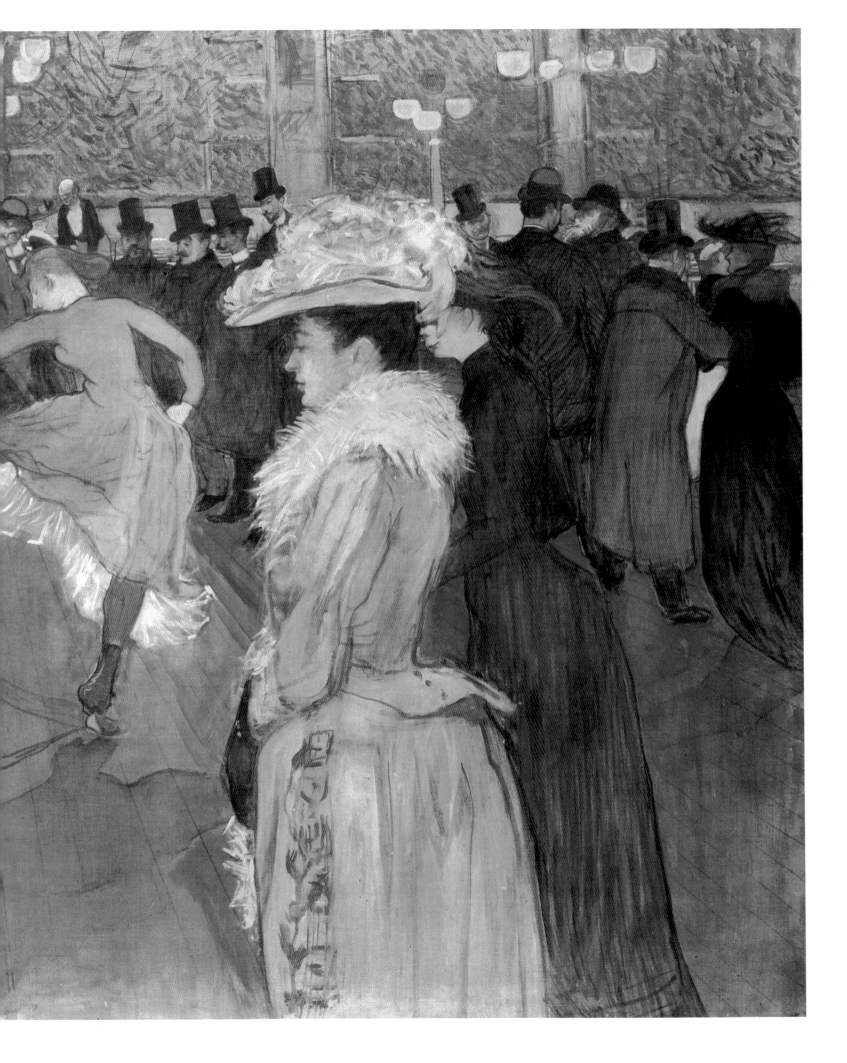

119. Henri de Toulouse-Lautrec, *La Clownesse Cha-U-Kao* (1895)

formula was varied so as to include other and perhaps more ambitious forms of entertainment. The Folies-Bergère was one such. This began in 1860, as nothing more than a store which sold bedding, except that for some reason, there was a *salle des spectacles* attached. The performances here proved so popular that by 1869 it was entirely devoted to theatrical entertainment. In 1871, after the Siege of Paris and the collapse of the Commune, the premises were drastically remodelled, so as to produce two amphitheatres, one fully roofed and the other covered only by an awning, but still with boxes around it. In the covered auditorium many of the seats were removed in order to make room for a promenade, with tables and chairs and a number of bars. There were further promenades behind the boxes on the two tiers above. The visitors thus became part of the spectacle; meanwhile they could socialize as well as watch the various entertainments offered by the management. These were quite ambitious, ranging from circus acts with animals and acrobats to fully staged performances of operetta. It is this establishment which provides the context for Manet's late masterpiece, *Bar aux Folies-Bergère* (*see plate 114*). Like many of his earlier major paintings this is deeply ambiguous, and becomes the more mysterious the longer one looks at it. Basically he aimed to put the spectator in the place of the man whose reflection can be seen in the mirror; the viewer is imagined to be in conversation with the barmaid. However, the two reflections – those of the woman herself and her interlocutor – have been shifted to one side, and the main subject has a strange air of loneliness and isolation amidst the crowded bustle of her surroundings: the vast numbers of people thronging the promenade do not have to be imagined, they can also be seen in the mirror which fills almost the whole space behind her.

Lautrec produced what is in many ways a more convincing (though admittedly far less complex) representation of a barmaid in his portrait of Miss Dolly, the English barmaid of The Star in Le Havre (*see plate 115*). The Star was an English pub on French soil which Lautrec discovered when he was sent on a sea voyage for his health, after a bout of *delirium tremens*. The place had the kind of louche atmosphere he relished and, in addition to painting this brilliant sketch portrait, he made a number of drawings of Miss Dolly singing sea shanties with the sailors.

However, the place of entertainment which will forever be associated with Lautrec's name is not a pub in Le Havre but a dance hall in Montmartre. When he first discovered Parisian nightlife, Lautrec used to frequent the old Moulin de la Galette. His painting of this establishment (*see plate 116*), which dates from March 1889, indicates how much the tone of Parisian social life had changed during the thirteen years since Renoir's depiction of it (*see plate 12*). Lautrec's painting shows a hard-bitten, distinctly raucous crowd in place of the quasi-rustic innocence of Renoir's painting.

Within a year, Lautrec shifted his allegiance to a sister establishment, the Moulin Rouge, which opened its doors in October 1889, scoring an immediate success. The Moulin Rouge offered several different kinds of entertainment. There was a large dance floor, with a promenade on

120. Henri de Toulouse-Lautrec, *Jane Avril leaving the Moulin Rouge* (1872)

121. Henri de Toulouse-Lautrec, *Jane Avril in the Entrance of the Moulin Rouge* (1892)

either side; in good weather it was also possible to stroll in the big garden at the back. The nightly entertainment began with a concert of comic and sentimental songs – the old café concert repertoire; this was followed by dancing between ten o'clock and midnight, with exhibition numbers in the middle of the main dance floor performed by a regular troupe (*see plate 118*) who became famous for their raucous vitality and total lack of inhibition. Charles Zeisler, the owner of the Moulin Rouge, had lured the chief dancers away from a rival dance hall after the public had begun to tire of his original main attraction, the Pétomane – a man who concealed himself inside a *papier-mâché* elephant and entertained his audience by farting loudly and musically.

The dancers were dubbed the Naturalist Quadrille, and their dance was the cancan. The name was a sly pun, for the female dancers wore nothing under their petticoats in the original form of this dance, and as they kicked their legs up, they left absolutely nothing to the spectators' imagination. Lautrec was enchanted by the frank vulgarity of dancers and performers alike.

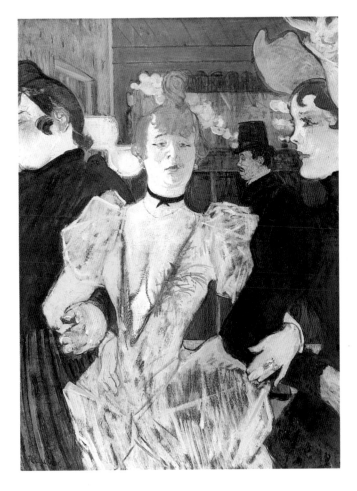

122. Henri de Toulouse-Lautrec, *La Goulue at the Moulin Rouge* (1891–2)

The most striking member of the original quadrille was Louise Weber (1870–1929), known as *La Goulue* (the Glutton). She was a laundry girl from Alsace who came to Paris in 1886, and scored her first success as a dancer at the Moulin de la Galette. She was striking not so much for her looks (though Yvette Guilbert said she was 'pretty and attractive to look at in a vulgar way') as for her ferocious energy. Her coarse, brazen character emerges clearly from Lautrec's studies of her (*see plate 122*). In some, he also hints at another aspect of her nature: the fact that she was not averse to relationships with her own sex. La Goulue's success was somewhat short-lived because, as her nickname suggests, she both ate and drank to excess. By 1895 she was reduced to the belly-dancing in a booth at various suburban fairgrounds. She appealed to Lautrec for help, and he supplied witty decorations for this booth; these were later cut up, but they have now been reunited. By 1904, when she was in her mid-thirties, La Goulue's dancing days were definitely over, and the rest of her life was spent in penury.

The Moulin Rouge was sufficently free and easy in its attitudes towards sexual behaviour to make it permissible for women to dance together. Indeed lesbianism seems to have been quite a marked feature of the clientèle there, and it was a subject which in any case interested Lautrec who, for a period, made a point of frequenting lesbian bars. One of Lautrec's paintings shows a severely dressed female couple waltzing together with an air of intimacy which makes it clear that their involvement with one another is more than purely casual (*see plate 117*).

La Goulue was not the only star of the Moulin Rouge celebrated by Lautrec. Two others were the mysterious Cha-U-Kao and Jane Avril. Little is known of Cha-U-Kao, apart from the fact that she claimed to be Japanese. Lautrec's portraits of her make it immediately obvious that this claim had absolutely no foundation in fact (*see plate 119*). Even her adopted name, which if anything sounds Chinese rather than Japanese, is in fact a French pun on the words *chahut* – the high kick typical of the cancan – and *chaos*. This allusion to the *chahut* makes it sound as if she was one of the dancers, but Lautrec never shows her dancing; instead she is always dressed as a female clown. This is really the sum of our knowledge about her. The portraits Lautrec made of Cha-U-Kao impress for unexpected reasons – most of all, because she always radiates such a formidable air of detachment from her surroundings.

Much more is known about another of Lautrec's favourites, Jane Avril. Her mother was a *demi-mondaine* and her father an Italian officer. She had a conspicuously harsh childhood; she was often beaten, and was sometimes forced to beg in the streets. She suffered a severe nervous breakdown during adolescence as a result of her mother's treatment of her, but later, although she had no training as a dancer, she managed to get a job at the Moulin Rouge. It was here, when she was still in the chorus, that Lautrec spotted her ability, and recommended her for a part in the Naturalist Quadrille, alongside La Goulue. He relished the strange dichotomy of her personality. When she danced, she was, as one eyewitness said, 'like an orchid in ecstasy'. Her nickname at the Moulin Rouge was *La Mélénite*

123. James Tissot, *Ces Dames des Chars* (1883–5)

124. Auguste Renoir, *Two Little Circus Girls* (1879)

(Dynamite). Offstage, meanwhile, she was conspicuously reserved. Lautrec did a pair of portraits of Jane Avril going through the transition from the public to the private sphere – entering the Moulin Rouge in her street clothes (*see plate 121*), and leaving it again after a performance (*see plate 120*). These serve to highlight the repressed aspect of her personality.

There was one other popular entertainment which deeply interested the Impressionists. The circus, then at the very height of its popularity, was enjoyed by intellectuals quite as much as by the mass audience.

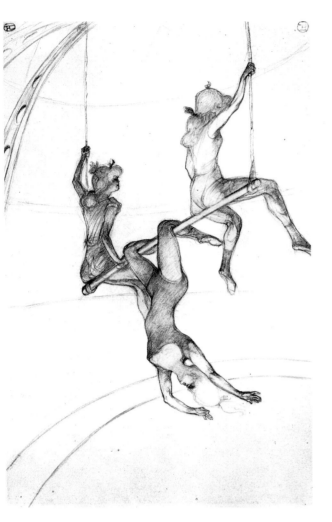

126. Henri de Toulouse-Lautrec, *The Flying Trapeze* (1899)

125. (opposite) Georges Seurat, *Le Cirque* (1890–1)

Among the painters who tackled the theme were Tissot (*see plate 123*), who gives a circus procession the cold triumphalism of some festivity in Ancient Rome, and Renoir (*see plate 124*), who made it the excuse for one of his most enchanting studies of childhood. Degas painted one major circus picture, *Miss Lala at the Cirque Fernando* (*see plate 98*). Lautrec drew and painted circus performers many times (*see plate 126*). His release from the clinic in Neuilly (where he had been incarcerated after his attack of *delirium tremens*) was aided by the series of circus drawings he made from memory, which convinced his doctors that he was on the road to recovery. The circus is also the subject of the Neo-Impressionist Georges Seurat's last picture, left unfinished at the time of his death (*see plate 125*). The paintings by Degas and Seurat make a fascinating contrast. Both are impersonal, but impersonal in quite different ways. Degas focuses on just one incident: a performer swinging high above the ring, drawn up by the metal bar she holds clenched between her teeth. Seurat takes a more familiar stunt: the bareback rider careering round the ring, standing on her horse. He transforms this subject into a decorative pattern echoing Art Nouveau designs in its whiplash lines. Degas is interested in reproducing what he sees, and in making the incident immediate for the spectator; Seurat distances what is going on, and makes everything remote and frozen.

The realist element in Degas's painting is in this case rather specialized, but it links even this work to the rest of Impressionist art. Seurat, though dubbed a Neo-Impressionist in the history books was, in this final work, renouncing almost everything Impressionism stood for. For all the artists connected with the Impressionist group, to render what they had actually seen and experienced was the central purpose of their activity. Their representations of women always fit within this intellectual framework. Some Impressionist paintings are amongst the most seductive images of the female sex ever produced. But to be seductive was not their overriding purpose. Impressionist prettiness, where it exists, is always balanced by something else – an incisiveness of vision, an obsessive interest in the thing seen which keeps sentimentality at bay. Many Impressionist images of women are not, in fact, 'pretty' at all. They are memorable, not for their charm, but for their unblinking pursuit of truth.

# Selected Artists' Biographies

## Frédéric Bazille
## (1841-70)

Bazille came from a wealthy background and trained in Gleyre's atelier, where he met Sisley, Renoir and Monet – the latter two owing much to his generosity during the early part of their careers. By the mid-1860s he was friendly with Manet, Courbet and Cézanne, and in 1864 he was painting with Monet at Honfleur. Many of these relationships are commemorated in his large picture *My Studio*, which shows Manet, Monet, Renoir, Bazille himself (painted by Manet), and the writers Edmond Maître and Emile Zola. The painting was refused by the Salon of 1870, which took place shortly before the outbreak of the Franco-Prussian War, in which Bazille was killed at the Battle of Beaune-la-Rolande.

## Marie Bracquemond
## (d. 1916)

Marie Bracquemond was a pupil of Ingres. Her husband Félix, whom she married in 1869, was a leading printmaker, and was in close contact with the Impressionist circle. Marie became deeply interested in the new style in the late 1870s, under the influence of Monet and Renoir, while her husband became increasingly opposed to it. From this time onwards she began to depict subjects from contemporary life, using a *plein air* technique, and showed her work in the Impressionist exhibitions of 1879, 1880 and 1886. However, her activity as an artist was increasingly hampered by her husband's disapproval and consequently, in the interest of domestic harmony, she more or less abandoned painting in 1890, producing only a few small canvases thereafter.

## Gustave Caillebotte
## (1848-94)

Caillebotte was the son of a government contractor who supplied bedding to the French army. He was independently wealthy all his life, and had no need to sell his work, which has only recently begun to attract the attention it deserves. Having first studied for a law degree, Caillebotte then became a pupil of the Salon portraitist Léon Bonnat. He came into contact with the Impressionist group through the first Impressionist exhibition in 1874, and immediately began to form a collection of their paintings. (He left this collection to the French state at his death, but it was only accepted in part.) He showed his own work in the second Impressionist exhibition in 1876, and continued to show with the group until 1882.

Caillebotte's work is notable not for brilliance of hue or looseness of brushwork, but for a tightness of construction and a clever but rather bizarre use of perspectival devices. Originally he felt an affinity with Degas, but later what he considered to be Degas's difficult personality pushed him towards Renoir and Monet (who became a close friend) and their circle. At first he painted primarily city scenes, often interior views of apartments; later, after he settled permanently at Petit-Gennevilliers on the Seine, he concentrated on yachting and boating subjects although at this stage in his career he also produced quite a large number of landscapes and garden scenes. When he was not painting Caillebotte was an enthusiastic gardener, a keen oarsman and a yachtsman.

Up until 1882, he was one of the chief organizers of the regular Impressionist shows, but after this date he started to drift away from the Impressionists. He stopped collecting and exhibited very little. Caillebotte died prematurely in 1894. Following his death the fate of his bequest to the nation was for a time uncertain, although Monet and Renoir – with great diplomacy and tact – conducted the prolonged negotiations with the French museum authorities.

## Mary Cassatt
## (1844-1926)

Mary Cassatt, the only American member of the core group of Impressionist painters, was born near Pittsburgh. Her family was rich and cultivated, and her European

travels began early when she visited France and Germany between 1850 and 1855 with her family. She returned to the United States with them, and studied painting at the Pennsylvania Academy of Fine Arts; then again went to Europe to continue her artistic education. She worked there with a number of leading academic artists, among them Jean-Léon Gérôme and Thomas Couture. At this stage she seems already to have begun her rebellion against the art establishment, though as yet only half consciously. However, she conformed sufficiently to have a painting accepted by the Salon in 1868, before she was forced to return home by the outbreak of the Franco-Prussian War.

In 1872 she travelled to Italy, and studied in Parma; then she went to Spain, and on to Antwerp, Paris and Rome. During this period she made an intensive study of the Old Masters. She was also impressed by certain then popular modern artists – by Carolus-Duran among others – but the realist impulse remained uppermost in her work. In 1874 she exhibited a modest portrait in the Salon which immediately impressed Degas. The next year, she had her own first glimpse of Degas's own work. Many years later she wrote to her friend, the American collector Louisine Havemeyer: 'How well I remember, nearly forty years ago, seeing for the first time Degas's pastels in the window of a picture-dealer on the Boulevard Haussmann. I used to go and flatten my nose against that window and absorb all I could of his art. It changed my life. I saw art then as I wanted to see it.'

Cassatt and Degas were soon introduced to one another, and they formed a long-lasting friendship. In 1877 Degas invited her to show with the newly formed Impressionist group. She accepted gladly, and her first appearance with these artists was in 1879. She was by this time firmly settled in Paris, having been joined by her parents and by her sister Lydia, with whom she had an extremely close relationship. Indeed Lydia remained – until her early death in 1882 – one of Cassatt's most frequent models. Cassatt also painted other members of her family, and particularly her brother Alexander's children, when they accompanied their father on a prolonged visit to France in 1880. She continued to show work in the Impressionist exhibitions until 1882, when both she and her mentor Degas were absent, because of a split within the group. For the final Impressionist show of 1886, however, Cassatt served as one of the chief organizers.

Cassatt had always, from the beginning of her career, specialized in domestic scenes, and from the end of the 1880s she began to concentrate on the mother and child motif. These works, solidly designed and constructed, display an impulse to return to more traditional values – the same urge to have overtaken Renoir a few years earlier, and which was also visible in the work of Berthe Morisot. At the same time Cassatt began to make increasingly bold and confident experiments with print-making. Her activities in this field culminated in 1891, when she exhibited ten recently completed colour prints with Durand-Ruel. These prints demonstrate how thoroughly she had absorbed the influences of Japanese art.

In 1892 she was approached by the Chicago collector and philanthropist, Mrs Potter Palmer, with a commission to produce a mural for the Women's Building which was to be erected as part of the World Columbian Exhibition in 1893. The theme was 'Modern Woman', and Cassatt painted a vast decorative design. This is now lost, but it is known not only from photographs, but from her studies and later paraphrases which are amongst the most beautiful images she ever produced. A number of them figured in her 1893 exhibition at Durand-Ruel's gallery.

The 1890s were a period of change in Cassatt's life. Her father died in 1891, and her mother in 1895. Between these two events – in 1894 – she bought and renovated the Château de Beaufresne, which lies fifty miles north-west of Paris. This was to be her country home for the rest of her life. In 1898–9 she made her first visit to the United States for over twenty years.

From 1901 onwards, Cassatt was increasingly distracted from painting by her activities as adviser to the collectors Louisine Havemeyer and her husband H.O. Havemeyer, who relied not only on her intimate knowledge of Impressionist art but also on her judgement of Old Master painting. She was by now something of a public figure, and her work was much sought after by collectors. She was awarded the Légion d'honneur by the French Government in 1904, and a Gold Medal of Honour by the Pennsylvania Academy of Fine Arts in 1914.

The first monograph on her work, written in French, had been published in 1913. By this time, however, her eyesight had begun to fail: she had her first operation for cataract in 1911–12, and by 1915 was no longer able to paint. During the First World War she spent most of her time on the Riviera, often visiting Renoir, who was now based at Cagnes-sur-mer. While Renoir took a sympathetic interest in the new art of the Fauves, and especially in that of Matisse, who was another frequent visitor to his house, Cassatt could not bring herself to do so. In a letter to a niece, written when the stir created by the Fauves was still

new, she said scornfully: 'As to Matisse, one has only to see his early work to understand him. His pictures were extremely feeble in execution and commonplace in vision. . . . At his exhibition in Paris you never hear French spoken, only German, Scandinavian and other Germanic languages; and then people think notoriety is fame and even buy these pictures or daubs. Of course all this has only "*un temps*"; it will die out. Only really good work survives.' The radical who worshipped Degas became a conservative at last.

# Paul Cézanne
## (1839–1906)

Paul Cézanne was born in Aix, the son of a self-made banker, regarded as an upstart by the local community. He was educated at the Collège Bourbon in Aix, where he struck up a close friendship with his contemporary, the young Emile Zola. On leaving the collège Bourbon, Cézanne went to law school, but soon rebelled and told his father that he wanted to be an artist. Although his father was firmly against the idea, Cézanne was finally allowed to go to Paris to study art in 1861. Unfortunately he was still very immature, even for his age, and so, torn by depression and self-doubt, he soon retreated home, and entered his father's bank. He soon returned to work at his easel, however, and began to shake off the academic influences hitherto governing the direction taken by his painting. In November 1862 he again left Aix for Paris.

Once there he soon became interested in Manet's work (though he never liked Manet as a man). He began to frequent the Café Guérbois where Manet held court, and became famous with its *habitués* for his unkempt appearance and boorish manners. His own painting at this time was far from being in any way Impressionist or proto-Impressionist. His early work shows a lumpish violence, whose chief influences appear to be Daumier and Delacroix. Cézanne repeatedly submitted work to the Salon in the 1860s, and, not surprisingly, was always rejected.

When the Franco-Prussian War broke out, Cézanne avoided conscription and took refuge at L'Estaque, near Marseilles. With him was his model, Hortense Fiquet, who had also become his mistress. (One reason for not returning home was that he was anxious to conceal the relationship from his father.) Shortly after they returned to Paris, in January 1872, Hortense gave birth to a son, also called Paul.

Cézanne had now formed a close friendship with Camille Pissarro, who at this stage of his career acted as a kind of artistic father figure to him. In the second half of 1872, he followed Pissarro to Pontoise, and then to Auvers-sur-Oise. This was the period when Cézanne's style came closest to that of his Impressionist contemporaries, but he did not catch the public eye as they had begun to do. Pissarro never succeeded in interesting the dealer Durand-Ruel in Cézanne's work – in fact, very few people took the artist seriously. However, Pissarro did succeed in getting his colleagues to accept Cézanne's work for the first Impressionist exhibition in 1874, even though Manet gave Cézanne's presence in the group as one of his reasons for refusing to exhibit with them. Sure enough, when the exhibition opened, it was Cézanne's paintings which attracted the greatest scorn.

Cézanne continued to show his work in successive Impressionist exhibitions but, by the late 1870s, was moving further and further from Impressionist techniques. He also drifted away from the Impressionists socially, and rarely appeared at their new meeting-place, the Café Nouvelle-Athènes in the Place Pigalle. In 1878 he returned to the Midi, taking Hortense and his son with him. He settled them near Marseilles, and went to live separately, closer to his parents. His father, who opened Cézanne's correspondence as a matter of course, soon discovered the existence of Hortense and her child. In the ensuing family row, Cézanne persisted in denying the relationship. His father cut his allowance by half, saying that it was more than that required by a single man. By now Cézanne's friend Zola was already a successful writer, and it was only subsidies from him which kept the artist's family afloat.

In 1882 Cézanne's work was accepted at the Salon for the first time, thanks to his friend Armand Guillemet – one of the jury members that year – who exercised his right to rescue the work of a 'pupil'. In October Cézanne retreated yet again to his father's country house, the Jas de Bouffan, apparently defeated. His immediate family continued to misunderstand his work; Hortense, who had dutifully settled nearby, had grown tired of Provence, and was determined to live in Paris. In 1885 Cézanne complicated matters further by becoming infatuated with a maid who worked in the family house. He fled to Zola for comfort.

In December 1885 Zola's latest novel, *L'Oeuvre*, began to be serialized. However, it was probably only when it appeared in book form, and Zola sent him a copy, that Cézanne discovered that the central character, Claude Lantier (a failed artist), was an unmistakable portrait of

himself. He immediately severed his friendship with Zola, and never communicated with him again, though apparently he was overwhelmed with grief when he heard of Zola's death in 1902.

At the end of April 1886, less than a month after this break with his oldest friend, Cézanne finally married Hortense. Six months later his father died, leaving his son enough money to live comfortably for the rest of his life. In 1887 Cézanne received his first sign of official recognition – an invitation to exhibit with Les Vingt in Brussels. But he was now set in his ways – he refused to alter his farouche manners, or change his reclusive way of life. Hortense, who was often at odds with Cézanne's mother and his sister Marie, spent much of her time in Paris; Cézanne alternated between Paris or its environs and the Jas de Bouffan. Yet his work did reflect a change of mood from c.1888 onwards, becoming much calmer and more classical in spirit.

In the 1890s, beginning to suffer increasingly from the effects of diabetes, Cézanne gradually became a hero figure for a new generation of artists and critics. He also started to attract the attention of dealers – though, even now, it was mostly artists who bought his work. Among them were Degas, Monet and Gauguin. In 1895 Ambroise Vollard, the leading light amongst the younger dealers, organized an exhibition of Cézanne's work, which was at least a *succès d'estime*. Cézanne characteristically refused to attend the opening, though his wife and son were there. Among the critics who praised the show was Thadée Natanson, editor of *La Revue Blanche*. Later that year Cézanne heard that three of his paintings (from the Caillebotte Bequest) were to be hung in the Jeu de Paume in Paris.

By the 1900s his reputation at last began to establish itself. Maurice Denis painted *Homage to Cézanne* – in imitation of Fantin-Latour's earlier *Homage to Manet* – which was hung in the Salon des Indépendants in 1901. A year earlier the Berlin National Gallery had bought one of his paintings. His family situation, however, was once again unsettled. His mother died, and his sister Marie decided to move to Aix. Hortense refused to live at the Jas de Bouffan, and Cézanne was quite incapable of running the house on his own, and so was forced to sell the property. Marie rented a flat and studio for her brother in Aix itself and found him a housekeeper. Despite his growing fame in Paris he remained a figure of fun in his home town, and was also the subject of malicious gossip; urchins threw stones at him, and he received anonymous letters telling him to get out.

By 1904 his diabetes had grown much worse – he suffered from vertigo, and had difficulty in walking. The dealers were beginning to pester him, so he delegated his business affairs to his son, who managed them shrewdly. In October 1906 he got caught in a rainstorm, collapsed by the roadside and went into a coma. Next day, though suffering from pneumonia, he refused to admit that he was ill, and set out to paint. He was forced to turn back and took to his bed. Sensing that Cézanne's death was imminent, his sister Marie summoned the rest of the family. Sadly, Paul and Hortense arrived too late to say their last farewells because Hortense, on receiving Marie's telegram addressed to Paul, hid it away so as not to have to cancel a dress-fitting.

# Edgar Degas
## (1834-1917)

Degas was born in Paris, the son of a banker. His paternal grandfather had also been a banker; he had settled in Naples after the French Revolution and, as a result, Degas had numerous Italian relations. Because his mother came from New Orleans, he also had relations in the United States. Degas's father, in addition to being a banker was an art collector, and keenly interested in music.

Degas was educated at the Lycée Louis le Grand in Paris – then the most prestigious school in France. After gaining his Baccalauréat in 1853, he began to study law, but soon turned to painting, the career he had always wished to pursue. His father seems to have offered no opposition to this move. He studied privately under one of Ingres's pupils (Ingres was to be a significant influence on him throughout his career), then briefly at the Ecole des Beaux-Arts, but largely taught himself by copying the Old Masters in the Louvre. In 1856 he set off for Italy, which he had already visited as a child. He stayed with relations in Naples and visited the museums there, and spent time in Rome and Florence, before finally returning to Paris in April 1859.

Soon after his return to Paris he began to make the acquaintance of artists of his own generation – Fantin-Latour, Félix Bracquemond, Alphonse Legros and Whistler. Around 1862 he met Manet, whilst they were both copying in the Louvre. Under his influence Degas began to take an interest in 'modern life' subjects, as opposed to the portraits and paintings on historical themes which he had previously favoured.

Degas and Manet came from very similar backgrounds,

but differed widely in their attitudes towards the official art establishment. Degas never had any difficulty in being accepted by the Salon juries – his work being exhibited every year between 1865 and 1870 – yet he increasingly despised everything for which the Salon stood, and never valued the kind of recognition it offered.

During the Franco-Prussian War, Degas served in the National Guard, defending Paris during the Siege. Like his friend Manet, he left immediately after the surrender, returning only after the defeat of the Commune. In 1872, perhaps in an effort to erase the events of the war and its aftermath from his mind, he decided to cross the Atlantic and visit his relatives in New Orleans. His brother René was living there by then, having married a cousin on his mother's side.

In 1873, immediately after Degas had returned home, his father fell seriously ill while on a trip to Italy, and died in Naples. The family's financial affairs were subsequently found to be in poor shape, and Degas had to make substantial sacrifices in order to avoid bankruptcy. He sold the art collection he had begun to put together and – for the first time – was under pressure to sell his own work. These problems, however, did not prevent him from taking an active part in the organization of the first Impressionist exhibition of 1874. Degas saw this not as something which reflected a single stylistic tendency, but as a forum for all independent artists who were prepared to describe themselves as 'realists'. Once the Impressionist exhibitions became established, he stopped exhibiting in the Salon (in fact, he submitted nothing after 1870), and indeed was inclined to condemn those who, like Manet, continued to show there. Degas was an exhibitor in seven of the eight Impressionist exhibitions; the only one in which his work did not appear was that of 1882. His colleagues, particularly Caillebotte, found him difficult to get on with; and it is clear that he was increasingly at odds with the more radical members of the group.

In 1877 Degas was introduced to Mary Cassatt, who became one of his closest friends, and may have hoped to marry him. Degas was in sympathy with her work – he had already commented favourably on it before they met – but was not attracted to her physically. Despite this and other friendships with women – he was close to Berthe Morisot too – Degas remained a bachelor all his life, and was looked after by a succession of devoted and tyrannical housekeepers. His life settled into a pattern of increasing withdrawal, mitigated by extensive travel during the summer months. He went twice to Spain; the second time

he travelled in the company of the Italian society portraitist Giovanni Boldini, and they actually got as far as Morocco. He also visited Switzerland and the south of France. Some friendships broke up because of his caustic tongue; others because of differences in politics. Degas was increasingly conservative in his political views, and was vehemently anti-Dreyfusard during the period of the Dreyfus case (1894), which cut him off from many Jewish friends.

As his financial position improved (he was the first of the Impressionist painters to find a steady market), Degas became a fanatical collector of works of art. As well as many works by Ingres, whom he had always idolized, he also bought a vast amount of work by Delacroix (he had thirteen paintings and nearly two hundred drawings), and Daumier. Among his contemporaries he owned works by Manet, Pissarro, Cassatt, Morisot, Gauguin and Van Gogh. Monet, whom he never admired, was absent from his collection.

During the later part of his career Degas battled constantly against increasingly poor eyesight (discovered as early as 1870, when he served in the National Guard), which affected the development of his style. He nevertheless continued to work until five years before his death, when he was forced out of his house in the rue Victor Massé because the lease had expired and the property was to be redeveloped. When he no longer felt able to paint, or to draw in pastels (in which he had worked as an easier and more flexible medium), he turned to sculpture, with which he had begun to experiment as early as 1878. At the end of the 1880s there was a period when he wrote a good deal of poetry; and in 1895 he also experimented with photography.

Degas's final years were pitiable. After his enforced move from the rue Victor Massé, he spent most of his time, almost blind as he was, walking aimlessly round the streets of Paris, resolutely ignoring the traffic. On meeting one old friend at the auction of a mutual acquaintance's collection, he said: 'It's astonishing, old age – how indifferent you become.'

## Paul Gauguin
### (1848–1903)

Gauguin was born in Paris, the son of a newspaper editor and a mother with Peruvian blood. The year after his birth the family left for Peru. Tragically, Gauguin's father died

on the voyage, but the rest of the family moved in with a great-uncle and remained in Lima until 1854. They then returned to France and settled in Orleans, with Paul's paternal grandfather. In 1861 Gauguin's mother moved back to Paris, where she worked as a seamstress. (This does not mean, however, as it so often would have done, that she was destitute. Indeed, when she died she left a considerable amount of property.) Her son lived with her only part of the time, and she implies in her will that they did not get on well.

In 1865 Gauguin enlisted in the French merchant marine, later transferring to the navy. He saw action in the Franco-Prussian War, and was released from active service when it was over. Through the influence of his guardian, he then became a stockbroker. In 1873 he met and married a Danish girl, Mette Gad, by whom he was to have five children. But it was his guardian – an art collector himself – who seems to have been the person responsible for firing Gauguin's interest in art. Gauguin began to work as a part-time painter, later studying sculpture as well. In 1876 he exhibited for the first time at the Salon. He got to know members of the Impressionist group, notably Pissarro and Degas, and in 1879 was invited (apparently at the last minute) to take part in the fourth Impressionist exhibition. He submitted a sculpture – a portrait of one of his children. In subsequent years he was to participate in the fifth, sixth, seventh and eighth Impressionist exhibitions. During the earlier part of this period (1880–6) he also enthusiastically collected Impressionist art. In 1882, however, a stockmarket collapse found him out of work. While his financial fortunes were never to recover, the misfortune seems to have hardened his resolve to become a full-time painter; after all, he had already sold a few of his own paintings to Durand-Ruel.

In 1884 Gauguin and his family went back to Denmark, but he returned to Paris the following year, accompanied by his son Clovis but not by his wife. Although they were never to live with one another again, the couple kept in touch more or less until the end of his life.

His life as a professional artist really began at this point, concurrent with his gradual separation from orthodox Impressionism. In July 1886 he went to Pont Aven in Brittany, and made contact with the artists working there. In the autumn he returned once again to Paris; he met Van Gogh and engineered a deliberate break with Pissarro. Then came a brief interlude in 1887, during which he went to Panama with his friend, the painter Charles Laval. He worked very briefly for the company constructing the

Panama Canal, before going on to Martinique – his first experience of the tropics since his seafaring days. Back in France at the end of the year, he succeeded in selling a little of his work. At the beginning of 1888 he returned to Britanny – seeing himself now as the leader of a new group of painters rebelling against the realist element still strongly present in Impressionism. He had begun to gather a group of disciples. Then, after a period of hesitation which lasted all summer, Gauguin allowed himself to be lured away to Arles, to work with Vincent Van Gogh. The arrangement was not a success, the worst time coming just before Christmas when Van Gogh suffered an attack of madness. Gauguin's new position of leadership among the younger avant-garde artists was consolidated when he appeared as the central figure in *L'Exposition de peintures du groupe impressioniste et symboliste*, held in 1889 at the Café Volpini (Café des Arts), itself in the grounds of the Universal Exhibition which was being held in Paris.

In 1891, in order to fulfil a lifelong dream of going to the South Seas, Gauguin held an auction of his work at the Hotel Drouot. With the profits he visited Copenhagen, saw his wife and children for the last time, and then set out for Tahiti, where he remained until 1893. He created some of his best-known paintings during this first visit. Having resolved to return to Europe, he arrived at Marseilles in August 1893, more or less destitute. He soon succeeded, however, in organizing a one-man show for himself – to be held in November at Durand-Ruel's gallery. Despite considerable publicity, sales were not as good as the artist had hoped, though two of the eleven paintings sold went to Degas. For a generation of avant-gardists younger than himself, Gauguin was a fascinating celebrity and many artists and writers visited his exotically decorated lodgings in the rue Vencingetorix in Paris. He paid a final visit to Brittany, which was marred by a brawl with some local sailors in which Gauguin's leg was broken, before he decided to return to Tahiti.

In 1895 he left on his final voyage to the South Seas. Having arrived in Tahiti, he began to suffer from bouts of ill health; he was by this time beginning to exhibit symptoms of tertiary syphilis. Nevertheless, he remained immensely productive, creating some of his largest and most important paintings. Meanwhile, his reputation in France was steadily growing; indeed, he now had a contract arrangement with an ambitious new dealer, Ambroise Vollard. In 1901 he decided to move to the still more remote Marquesas. He settled on the island of Hivaoa, where he died in May 1903.

## Eva Gonzalès
## (1849–83)

Eva Gonzalès was a member of an aristocratic family from the principality of Monaco, and the daughter of a popular novelist of the day. She started to study painting in 1867, and in 1869 (to the horror of her father, who disliked Manet's work), asked Manet to give her lessons. Fascinated by her rather Spanish looks, Manet agreed and she became his only real pupil. (Morisot was already a fully trained artist when she met Manet.) When Gonzalès exhibited her work at the Salon she announced herself in the catalogues as Manet's pupil, and sometimes paid the penalty of critical disapproval for the association. Like Manet himself, however, she preferred to stay within the official system, and kept away from the exhibitions organized by the Impressionist group, just as he did. Furthermore she made it plain that she did not much care for the *plein air* paintings which Manet produced in the 1870s, under Impressionist influence. Because of this difference of opinion, she gradually ceased working in Manet's studio, though they remained friends to the end of their lives. In 1877, she married the engraver Henri Guérard, and was pregnant with her first child just as Manet's fatal illness was reaching its crisis. She gave birth to a son shortly before hearing of his death, which distressed her greatly. She died of an embolism on 5 May 1883.

## Edouard Manet
## (1832–83)

Edouard Manet, the reluctant revolutionary who was responsible for giving the Impressionist movement its first impetus, was the son of Auguste Manet, the principal private secretary at the French Ministry of Justice. Soon after Edouard's birth Auguste became a judge. The Manet family was well off, and possessed considerable private property at Gennevilliers on the Seine.

The young Edouard was a poor scholar, and when he announced that he wanted to become an artist his father was horrified, for he had planned for his son to become a lawyer. It was decided instead that Edouard should embark on a naval career, and in preparation for this he was sent on a voyage to Rio at the end of 1848. Auguste Manet's resistance to Edouard's choice of career finally collapsed when his son returned from this trip, and in 1850 Manet

was allowed to enter the studio of Thomas Couture. The aspiring artist seems to have chosen this studio because although Couture was successful at the Salon, he had nevertheless remained something of an outsider in relation to the official arts establishment. Manet remained Couture's pupil for more than six years, despite his dealings with his master often becoming stormy.

During this period he met and entered into a liaison with Suzanne Leenhoff, a Dutch-born piano teacher. In 1852 they had a son, Léon, but the child was not registered as Manet's, and the relationship was concealed from the painter's father and also from all his friends; indeed he was only to marry Suzanne after his father's death.

In 1861 Manet had his first acceptance from the Salon jury. *The Guitar Player* was well received because it reflected the current fashion for all things Spanish: Manet received an honourable mention in the official list of awards. Nevertheless, in 1863 he became identified as an opponent of the official system, and achieved widespread notoriety, when *Le Déjeuner sur l'herbe* was rejected by the Salon only to form the centrepiece of the Salon des Refusés later in the year (established through the personal intervention of the Emperor Napoleon III). Public clamour against Manet redoubled in 1865, when his *Olympia* (*see plate 92*) was exhibited, this time on the walls of the Salon itself.

The two pictures typify Manet's art in being both deeply ambiguous in their attitude towards tradition, and 'realistic' only in a very limited sense. *Le Déjeuner sur l'herbe* was inspired by Giorgione's *Tempesta*, and the composition is based on an engraving by Marcantonio Raimondi after Raphael. The source for *Olympia* is Titian's classic nude, the *Venus of Urbino*. But in both cases the source material is transposed into contemporary terms. The two male figures in *Le Déjeuner* are dressed as nineteenth-century art students (making the fact that their female companions are nude seem shocking to Manet's original audience). *Olympia* resembles one of the courtesans of the day, especially as she is being presented with a bouquet from an admirer which is still wrapped in florist's paper.

Manet's art is full of ironic and provocative touches of this kind, but there are also minor details which seem to contradict any straightforward realistic effect. It was these perpetually dissonant elements, as much as the extreme freedom of his technique, which gained him a reputation as an insolent revolutionary. Strangely enough, Manet himself often seems to have been unaware of the effect which his mixture of emotional tones would have on the public, and in particular, on those who were responsible

for the distribution of official honours. The tumultuous reception given to these two teasingly mysterious canvases set the tone for the rest of his career.

By 1866 Manet was regarded as the leader of a new and subversive school of artists – dubbed 'the Batignolles group' – who met at the Café Guérbois in Paris. Among those who came to this café to take part in discussions there were the painters Frédéric Bazille, Edgar Degas, Alfred Stevens, Whistler, and eventually Pissarro and Cézanne. Among the writers who joined the group was the then little-known Emile Zola; in 1866 he started a violent campaign in Manet's favour in a newspaper called *l'Evénement*. His articles were later published as a separate pamphlet. The late 1860s also saw the beginning of Manet's relationships with Berthe Morisot and Eva Gonzalès.

During the Franco-Prussian War Manet participated in the defence of Paris; he left the city after its surrender to the Prussians, only returning in time to see the bloody reprisals as the Commune was suppressed. In the early 1870s his fortunes – in common with those of his young followers, Monet and Renoir – took a turn for the better. In 1872 the dealer Durand-Ruel bought over 50,000 francs' worth of his paintings; and in 1873 his Hals-like painting, *Le Bon Bock*, was a vast success with the Salon public. Perhaps because of these signs of acceptance, Manet refused to participate in the first Impressionist exhibition of 1874, just as he was to refuse to participate in subsequent Impressionist group showings. It soon appeared, however, that the hostility felt by the official art world towards him remained unappeased. In 1876 his two submissions to the Salon were both rejected. He organized a private showing in his studio instead. Four thousand people attended, thereby re-affirming his position as a celebrity.

In 1877 the first signs of the disease which was to kill Manet began to manifest themselves; he had contracted syphilis in his youth, perhaps during his visit to Brazil, but it had lain dormant up to this point. He suffered ever-increasing ill health for the rest of his life. In 1880, however, he held a highly successful exhibition at the gallery run by the periodical *La Vie Moderne*, and in 1881 he at last received a second-class medal at the Salon. This placed his subsequent submissions *hors concours* – they could no longer be rejected by any jury. In December 1881 he was appointed Chevalier de la Légion d'honneur, thanks to the intervention of his friend Antonin Proust, who had become Minister of Fine Arts in a government headed by Gambetta. By the beginning of April 1883 Manet was desperately ill; he developed gangrene in his left leg, which

had to be amputated on 19 April, and he died on 30 April. His illness and death had been a public event: throngs of people visited his sickbed; and a doctor's bulletin concerning his progress had to be posted daily at the porter's lodge of the building where he lived.

# Claude Monet
## (1840-1926)

Monet was born in Paris, but his family moved to Le Havre, Normandy when he was five. His father was a wholesaler and ships' chandler. Father and son never got on well, and their relationship worsened when Monet's mother died – when he was only seventeen. By then he was already cherishing the ambition of becoming an artist, but received the decisive push when he met the landscape painter Eugène Boudin, then working in the neighbourhood of Le Havre. By 1859, despite his father's opposition, Monet was in Paris, studying at the Académie Suisse, one of the 'free academies' where artists worked without a teacher.

Monet's father, unreconciled to his son's choice of career, tried to use the fact that his son was liable for military service as a means of getting him to join the family business; he refused to buy Monet out of the army unless he agreed to give up his ambition to be an artist. Monet refused, however, and signed up for seven years, but was soon home on long leave having contracted typhoid. His aunt, an amateur painter, took pity on him, and offered to help if he would agree to study art under a regular master. In 1862 Monet joined the studio of Charles Gleyre. Though he disliked the idea of being taught, he stayed for eighteen months, until Gleyre closed his atelier. (He later refused to acknowledge Gleyre's teaching and claimed that he had stayed for only a week.)

Whilst studying with Gleyre, Monet met and made friends with Renoir, Sisley, and the wealthy Bazille, who often helped Renoir by lending him money, providing him with studio space, and buying his paintings. Monet's career began well. In 1865 he showed two seascapes at the Salon which were well received by the critics. This success was repeated the following year, when he exhibited *Camille*, or *The Green Dress* (*see plate 33*). Soon afterwards, however, Monet's work ceased to find approval with the Salon jury and life became very difficult for him. The situation was exacerbated by his liaison with Camille Doncieux, the subject of *The Green Dress* and the model for other pictures painted at this time. She became pregnant, and Monet's

family applied pressure to separate them. Their first son was born in October 1867.

Monet suffered a further crisis in 1870 – one which, in some senses, was shared by the whole of France. In June of that year he had married Camille, and in July the Franco-Prussian war broke out. Still on the military reserve, and anxious to avoid service, Monet fled to England, followed some days later by Camille and their child. In London he met the dealer Durand-Ruel, who was to play an important role in popularizing his work. From England he went to Holland in May 1871, and then finally, when things had calmed down, back to Paris. He settled in the riverside suburb of Argenteuil, where some of his most typically 'Impressionist' canvases were to be painted. Here, thanks to the efforts of Durand-Ruel, he enjoyed a brief period of prosperity. He also became famous, or rather infamous, as the prominent figure in the first Impressionist exhibition of 1874. It was one of his canvases, *Impression, Sunrise*, which gave its name to the whole movement.

One of Monet's new patrons was a flamboyant but financially unstable businessman called Ernest Hoschedé. Monet visited Hoschedé's château in the autumn of 1876, and at about that time formed a close relationship with his patron's wife, Alice. Just before this happened, things took a turn for the worse financially. Durand-Ruel had to stop buying; Hoschedé was in financial trouble, and had to sell his collection – for the second time – in 1878. The Hoschedé and Monet households decided to join forces. They all moved to Vétheuil, still on the river, but a little further from Paris. By this time Camille Monet was seriously ill, having never recovered from the birth of her second son, Michel, in March 1878. Alice Hoschedé began nursing her and continued to do so devotedly until she died in September 1879. Ernest Hoschedé had been increasingly absent from the ménage, and now he disappeared altogether. In 1881 Monet, Alice and their respective children moved to Poissy, where their relationship was at last formally declared. Hoschedé's attempts to win Alice back were all to no avail.

Just prior to this event, in 1880, Monet had quarrelled with the Impressionist group. Under pressure from one of his dealers, Georges Petit, he had decided to exhibit again at the Salon, because of the respectability this conferred. He submitted two landscapes, one of which was accepted, much to the fury of Pissarro and Degas. Monet only contributed to one more Impressionist exhibition (1882), but did not, in the event, continue to show at the Salon either. He began to hold one-man exhibitions, the first of

which was held in 1880, at the offices of the periodical *La Vie Moderne*, where Manet and Renoir had already shown.

This development was particularly suited to Monet's increasing tendency to produce series of paintings. At the same time, his way of life altered and became more settled. In 1883 he moved to yet another new house, at Giverny, near Vernon – not far from the Seine – where he was to remain for the rest of his life. In 1889 he held a major retrospective at the Georges Petit gallery. Having finally achieved financial security, in 1890 he bought his house at Giverny, which previously he had only rented.

Throughout the 1890s his use of the series became more and more methodical. In 1891, at the Galérie Durand-Ruel, he showed fifteen canvases of haystacks in which the conditions of weather and light differed from painting to painting. The show was an immense success, and Monet went on to produce further groups of paintings, whose motifs included the west front of Rouen cathedral, and a row of poplars on the Epte, near Giverny. There were also paintings of the River Thames, and of Venice. Now that he was able to afford it, Monet continued to expand his property at Giverny, and gradually created a magnificent water garden, which provided him with the subject matter for his last great series, the *Waterlilies*.

However, he was not without his troubles. In 1891, after Ernest Hoschedé died, he was finally able to marry Alice; but in 1911 she died too. Monet was henceforward looked after by one of Alice's daughters, who had married Monet's elder son, Jean. The summer after Alice died, Monet suffered his first serious bout of eye trouble, and cataracts in both eyes were diagnosed. His eyesight was to trouble him for the rest of his life, and he often could not accurately distinguish colours – the *Waterlily* paintings of this period represent a response to these special difficulties that he was experiencing. Despite treatment and operations, plus specially designed glasses, his eyesight continued to degenerate until he died. His final paintings, those of the Japanese bridge spanning his great waterlily pond, have a feverish Expressionist intensity about them comparable to the late pastels of Degas, which were created under very similar conditions.

## Berthe Morisot
## (1841-95)

Berthe Morisot, born in Bourges, was the daughter of a high-ranking civil servant. For the first ten years of her life

the family moved around France according to her father's employment. But around 1852 they settled in Passy, one of the western suburbs of Paris; this was to be Morisot's base for the rest of her life.

In 1855 Berthe and her two older sisters, Yves and Edma, began to take painting lessons – a birthday surprise from their father. Yves, the eldest, soon lost interest, but Berthe and Edma continued to study (privately because they could not attend the Ecole des Beaux-Arts, which did not open its doors to women until 1897). Through her activities as a copyist in the Louvre, Berthe met Félix Bracquemond, the engraver, and the painter Fantin-Latour. In 1864 both girls – classified at this time as followers of Corot – received their first acceptances at the Salon. It was perhaps through Edma's fiancé, Adolphe Pontillon, that they came to know Manet by the late 1860s; now a naval officer, Pontillon had served with Manet as a cadet in 1848.

Berthe agreed to be one of the models for Manet's ambitious painting *On the Balcony*, a figure composition based on a painting by Goya. As a result, the whole Morisot family became more closely involved with the nascent Impressionist group. In 1870, just before the outbreak of the Franco-Prussian War, Manet produced a large, full-length portrait of Berthe (*see plate 40*). By this time, both were strongly attracted to one another, though neither cared to admit it.

Although she and her parents went away from Paris during the Commune of 1871, Morisot herself had stayed in the capital throughout the Siege (1870–1), and it is said that the privations she endured undermined her health. In 1874, after some initial hesitancy, she agreed to exhibit at the first Impressionist exhibition, thus definitively casting in her lot with the avant-garde. She was to be one of the most constant exhibitors at the Impressionist shows. In December 1874 she married Manet's brother Eugène, an amateur painter and a writer (he published one novel), about whom surprisingly little is known.

The 1880s were a period of frequent bereavements for Morisot. Manet died in 1883; her other brother-in-law Gustave died in December 1884; and her mother-in-law in January 1885. Nevertheless this was to be the period when her art developed most powerfully and originally, her most frequent model now being her daughter, Julie Manet. Her contribution to the final Impressionist show of 1886 was recognized by critics as being one of the strongest. She – like Renoir at this time – was looking back at the art of the eighteenth century; the copies she produced show that she was particularly interested in Boucher.

Eugène Manet's health began to fail in 1891; he died in April 1892. Morisot nevertheless went ahead, according to his wish, with a large retrospective exhibition which had already been arranged at the Boussod and Valadon Gallery in Paris. It opened in May that year and was the largest exhibition of Morisot's work held in her lifetime.

In 1895 Morisot died of a pulmonary congestion of the lungs. Her last few years are fully recorded in her daughter Julie's delightful diary.

## Camille Pissarro
## (1830–1903)

Both Pissarro's parents were practising Jews. Although his father came from Bordeaux, they were living in the West Indies on the Danish island of St Thomas (part of the Virgin Islands group) when Camille was born. Because Abraham Pissarro wanted his son to have a French education, Camille was sent to a boarding school near Paris in 1842; he returned home five years later to join the family business. In 1852 he set off again, this time for Venezuela, in the company of the Danish artist Fritz Melbye, and spent the following two years there. It was in 1855 that he decided to give up business and become a professional painter.

He returned to France and worked with Fritz Melbye's brother Anton. In the late 1850s and early 1860s the chief influence on his work was that of Corot, although he met and became a friend of Monet in 1859, and had his first encounter with Cézanne as early as 1861. During this period of his life he lived mainly off a small monthly allowance provided by his parents. His father died in 1865, however, and he was forced to do various odd jobs, working at one stage as a lawyer's messenger and later painting blinds and shop-fronts.

When the Franco-Prussian War broke out he was living in Louveciennes, just outside Paris. Forced to abandon his house there (which was afterwards requisitioned and pillaged), he moved briefly to England, where he met the dealer Durand-Ruel. When he returned to France he involved himself more energetically in the activities of the burgeoning Impressionist group, and was well represented in the first Impressionist exhibition of 1874. He was now living in Pontoise, which was some distance from the true centres of Impressionist activity in Argenteuil and Paris, but he kept in constant touch with Monet, and also worked closely during this period with both Cézanne and Gauguin. His work in the 1870s derived much from the

powerful mid-century realist and painter of peasant life, J.F. Millet.

In 1883 Pissarro had his first solo exhibition with Durand-Ruel, and in 1884 he settled permanently at Eragny-sur-Epte. It was at about this time that he began to adopt the libertarian and anarchist ideas to which he would remain firmly attached for the rest of his career. He contributed to small anarchist periodicals when requested, and gave help to the families of arrested and exiled anarchists. He had already, long before this, built up a reputation for helping artists less fortunate than himself. Vincent Van Gogh was one of those he nurtured.

The mid-1880s also witnessed Pissarro's increasing enthusiasm for pointillism – the characteristically Neo-Impressionist technique of painting with small dots or 'points' of colour. In 1886, at the eighth and last Impressionist exhibition, Pissarro's work was hung in a separate room with that of his new colleagues Seurat and Signac, and that of his own son Lucien. However, by 1896 he was ready to abandon pointillism and return to a more conventional Impressionist technique.

Pissarro's reputation grew more slowly than those of Monet and Renoir, and it was not until the 1890s that he could regard himself as being fully established, despite the enormous respect he enjoyed in the artistic community, as much for his high moral principles and generous nature as for his work. But during this decade he suffered increasing bouts of eye trouble and was forced to undergo several eye operations. He died in 1903.

# Pierre Auguste Renoir (1841–1919)

Renoir was born in Limoges. Unlike the other leading Impressionist painters, who had middle-class backgrounds, his family was working class. Son of a tailor and a seamstress, who moved to Paris in 1846, Renoir was educated at a free Catholic school. At the age of fifteen, having shown signs of artistic talent, he was apprenticed to a china-painter. Later he began to copy paintings in the Louvre and in 1861 managed to get himself admitted to Charles Gleyre's atelier. Here he met Monet, Sisley and Bazille, who all arrived the following year, and in 1863 he met Pissarro and Cézanne.

He first exhibited at the Salon in 1864, with a painting which he subsequently destroyed, and he then had further acceptances in 1865 and 1866. Throughout this period

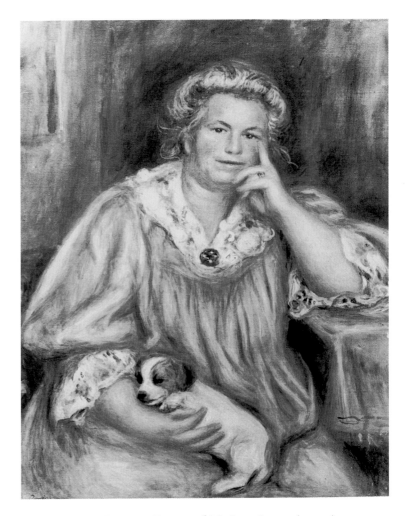

127. Auguste Renoir, *Portrait of Madame Renoir* (c. 1910)

Renoir was very poor and had to depend heavily on friends for financial assistance. Help came from the Sisley family, who were still prosperous, and above all from Bazille, whose studio he often shared. By 1869 he had become a habitué of the Café Guérbois, where he met Manet and Degas, and also the writer Zola.

At the outbreak of the Franco-Prussian War Renoir was drafted into the army for four months, but saw no action at the front. Bazille was killed, and Renoir subsequently became increasingly close to Monet, with whom he was soon working, often on the same motif. In 1872 Monet introduced Renoir to the dealer Durand-Ruel. Renoir was still having great difficulty in selling his pictures (though the compositions he produced during the 1870s are amongst the most charming of all Impressionist works), and was therefore keen to participate in the first Impressionist exhibition of 1874. He eventually showed seven works there.

The following year he met some of his most important

early patrons, among them the publisher Georges Charpentier and his wife, Marguerite. He was commissioned by them to paint a large group portrait of *Mme Charpentier and Her Children* (*see plate 66*). This picture's acceptance at the Salon in 1879 marked a breach with Renoir's Impressionist confrères, but also the beginning of a period of modest prosperity, during which he received a number of portrait commissions. He also held a one-man show in 1879 – at the offices of *La Vie Moderne* – and met Aline Charigot, the young laundress from Burgundy who was to become his wife. Perhaps because of her lack of education and humble origins, her very existence was at first sedulously concealed from Renoir's friends.

In 1881 Renoir made a trip to Algeria, and later in the year another to Italy. He got as far as Palermo, where he painted a portrait of the composer Richard Wagner – another Charpentier commission. Renoir returned to the Impressionist fold in 1882, and showed twenty-five works at the seventh Impressionist exhibition, held that year at the Durand-Ruel Gallery. This did not, however, mean that he renounced the Salon altogether – he also showed one painting there in 1882. In 1883 Durand-Ruel gave Renoir his first major one-man show.

Despite these signs of growing success, the 1880s were a period of mixed fortunes for Renoir, both personally and artistically. He was exhibiting more and more often abroad – with Les Vingt in Brussels, and at the pioneering French Impressionist show in New York. Yet he was also depressed and uncertain about his work. In 1883 he underwent a radical change in style; his work became much chalkier in tone, and also more linear. Various influences have been detected in Renoir's art at this time: Ingres is often cited, but the Renaissance frescoes he saw in Italy should also be considered, alongside the painting of Puvis de Chavannes and (perhaps in contradiction to this) the mythological compositions of Boucher (influencing Morisot too at about the same period). Renoir's large canvas entitled *The Bathers* (1887) marks the culmination of this new development. This was somewhat poorly received by some of Renoir's longtime supporters, and indeed still excites controversy today. Renoir's personal life also underwent significant changes during this period. His eldest son Pierre was born in 1885, the real inspiration behind the mother and child theme which was to play so conspicuous a role in his later work. He and Aline finally married in 1890, and it was only at this moment that most of Renoir's friends learned of the relationship. Cézanne was an exception but his situation was also somewhat irregular. More

ominously, Renoir had his first attack of rheumatoid arthritis in 1888; this painful disease was gradually to cripple him completely.

In 1892 Renoir received his first sign of official recognition in France, when his *Girls at the Piano* (1892) was bought by the French state. He was also well represented (with six canvases) in the Caillebotte Collection – left to the nation in 1894, accepted by the French Government in 1895, and first put on show in 1897. In 1900 he was made Chevalier de la Légion d'honneur and later he was to be promoted to Officier and Commander. By this time he was so celebrated that his work was already being extensively faked, as he discovered in 1904.

From 1899 onwards Renoir began to spend increasing amounts of time in the South of France, where the warm climate was favourable to his arthritis. In 1907, after numerous visits to the region, he bought land at Cagnes-sur-Mer and built a villa, which was ready for occupation the following year. This house became his base for the rest of his life. In 1911 the German scholar Julius Meier-Graefe published the first biography to be written about him. It was significant that this book originated in Germany as Renoir's style – though retaining some elements of classicism from the 1880s – had now lost the hard contours of his middle period, to become warm, even hot in colour, suiting the taste of a German public just then coming to terms with Expressionism. In 1913 Renoir had exhibitions in Munich, Berlin, Dresden and Stuttgart; and in 1914 another in Dresden, and another in Bremen.

The war years were hard for Renoir: not only were two of his three sons wounded, but his wife Aline died, at the early age of fifty-six, apparently having overstrained herself going to see one of their offspring in hospital. By now Renoir was perhaps the most celebrated artist in France, and he was still struggling valiantly to paint in spite of his crippling infirmities. His brushes had to be thrust into the hollows of his distorted hands, and held there with pads made of rags. Renoir survived into the first year of peace, and continued painting until his death in 1919.

## John Singer Sargent (1856–1925)

Sargent was born in Florence, the son of cultivated American parents. The family travelled extensively throughout Europe, and Sargent grew up speaking several languages fluently. He decided very early on that he

wanted to be an artist and met only slight opposition from his father, who would have preferred him to enter the American navy. Opportunities for art training in Italy at that time were limited, so in 1874 Sargent moved to Paris, to enter the atelier of the successful portrait painter Carolus-Duran. He soon began to make his way in French artistic circles, exhibiting at the Salon for the first time in 1877. However, his steady progress was checked by the scandal caused by his portrait of *Madame X* (Madame Pierre Gautreau) (*see plate 76*) shown at the Salon of 1884.

Sargent had already exhibited successfully at the Royal Academy in London, and in 1885 he decided to move to England. After a brief initial resistance from the art establishment there to his 'cleverness' and 'French' qualities, he soon became the most fashionable and sought-after portrait painter in the country. He also produced the occasional picture – such as *Carnation, Lily, Lily, Rose* – in which the influence of Impressionism is perhaps more apparent than in the work he produced while still in France. In 1890 he produced a portrait of the Spanish singer and dancer *La Carmencita*, which is an obvious tribute to Manet's *Lola de Valence* (*see plate 104*). It was bought by the Luxembourg Museum.

By 1906 Sargent had grown tired of portrait painting, and turned down nearly all the commissions he received, though he did consent to make bravura portrait drawings instead. He was heavily occupied by a series of Symbolist murals (commissioned in 1890) for the Boston Public Library. He also made numerous landscape and figure compositions in both oils and watercolour, on visits to Italy and Spain, in which Impressionist influence is again apparent. At the very end of his career Sargent executed some technically brilliant work as an Official War Artist, which has nevertheless been criticized for its apparent lack of emotion.

# George Seurat
## (1859-91)

George Seurat was born in Paris in 1859. His father, a minor legal functionary, seems to have been a somewhat eccentric character; he maintained a separate house, some seven miles from the family, where he insisted on living alone for most of the year. Seurat attended the local municipal drawing school, then, in 1877, went to the Ecole des Beaux-Arts. His teachers found him dull and ungifted, but he was very industrious, making numerous copies

from the Antique and after the Old Masters as well as many life drawings. In 1879–80 he did a year of compulsory military service during which he continued to draw in a notebook that he carried around with him. When he was released, he returned to studying, but showed little interest in what the Impressionists were doing, even though the movement was now receiving much critical attention. An important influence at this stage was the classicizing Symbolist, Puvis de Chavannes.

In 1883 Seurat exhibited for the first time in public – a portrait drawing of his friend and fellow artist Aman-Jean was accepted for that year's Salon. This was a more fully realized version of the powerful chiaroscuro drawings of everyday subjects that he had been making for sometime. He was also producing small oil sketches which showed affinity with the work of Jean François Millet, not only in their subject matter (agricultural landscapes, peasants and labourers), but in their radical simplification of form.

In 1883–4 Seurat was working on a large modern-life subject, *Une Baignade, Asnières*, which depicted people bathing and sunning themselves on the banks of the Seine near Paris. The painting shows that he was beginning to use the pointillist or divisionist technique in which dots or dashes of pure colour were applied, so that an optical blend was obtained. This technique – one that he was to continue using throughout his career – was more fully developed in Seurat's next major work, *A Summer Sunday Afternoon at the Grande Jatte*, painted in 1886–7. This was both a continuation of Impressionism and a direct contradiction of some of its central ideas. It featured typical Impressionist subject matter, but rejected all informality and turned the trivia of contemporary life into something hieratic and monumental.

Not surprisingly, the established Impressionists felt they were being directly challenged by this uncompromising new approach. It was only as a result of Camille Pissarro's intervention that Seurat was able to show *La Grande Jatte* at the eighth and final Impressionist exhibition. Pissarro accused his old colleagues of 'trying to ruin the exhibition before it is even on the wall'. When the show opened, Seurat's work was immediately hailed by Félix Fénéon, one of the most far-sighted critics of the time, who contributed to the *Chat Noir* and later to the Symbolist *Revue Blanche*. His review quite clearly stated: 'This is the kind of painting in which cheating is impossible and "stylish handling" quite pointless.'

Seurat was secretive, solitary, very certain of his own originality, and intensely aware of his claim to be a leader

and inventor. His sudden illness and death (from what seems to have been a form of meningitis) came as a great blow to his small group of friends and admirers. His ability to compartmentalize his life had been such that no one had been remotely aware that the artist had had a mistress, Madeleine Knobloch. They had a baby son, too, who died less than a fortnight later of the same disease.

## Alfred Sisley
## (1839-99)

Sisley was born in France of English parents. His father was a prosperous businessman, who sold artificial flowers to the South American market. This trade was ruined by the Franco-Prussian War of 1870; the family business collapsed – an event which was to cast a long shadow over the rest of the painter's career.

Sent by his parents to London to study commerce at the age of eighteen, Sisley seems to have spent most of his time in museums, where he was particularly fascinated by the work of the great English landscapists of the first half of the nineteenth century – Turner, Constable and Bonington. When he returned to Paris, in 1862, his parents allowed him to enrol in the studio of the noted academic painter Charles Gleyre. Here he met Monet and Renoir. In 1866 he married Eugénie Lesconezec, a model and a florist; she is always described as sensitive and elegant. Throughout their lives together they were a devoted couple. Shortly after the marriage Renoir painted their double portrait (see plate 54).

Before the outbreak of the Franco-Prussian War Sisley seems to have produced very little. After it – forced to rely on art for his livelihood – he became more prolific. Unlike Renoir and Monet, however, he confined himself strictly to landscape. He suffered severe financial hardship throughout his professional life. In 1879 he was actually evicted from his home, and had to appeal to the publisher Georges Charpentier for help.

In the 1880s his work was shown by Durand-Ruel – then the chief Impressionist dealer – but even he could not make it popular. In 1897 the Georges Petit Gallery gave him a full-scale retrospective exhibition, but this too was widely ignored. By the 1890s both Sisley and his wife were in poor health. In October 1898 Mme Sisley died, having been devotedly nursed by her husband. And in the following January Sisley himself was finally overcome by cancer of the throat.

## James Tissot
## (1836-1902)

Tissot's father was a self-made businessman; his mother, from Brittany, was religious and had a mystical streak which her son inherited. Brought up in Nantes, the young Tissot came to Paris to study art at the age of nineteen. There he met Degas and Whistler, eventually becoming close friends with the former.

His first paintings were romantic and idealizing – their subjects taken from the Bible and Goethe's Faust (which had already attracted Delacroix). In the later 1860s he began to paint fashionable genre scenes taken from contemporary life. It was at this stage that Degas produced a strikingly dandified portrait of him, seated in an artist's studio.

In Paris during the Siege of 1870, Tissot later became involved in the Commune of 1871, and was forced to flee to London to escape reprisals. Here he continued to develop the style of fashionable genre painting on which he had begun to work in Paris. His pictures pleased the English public, and he was soon hugely successful. Berthe Morisot visited him in London at this time, and described him as living like a king. She found him 'very nice, very decent – but a little vulgar'.

His English success was compromised when he formed a close relationship with the beautiful divorcée Kathleen Newton, whose looks became an obsession with him. She was already ill with consumption when they met. Because of the irregular nature of their relationship, Tissot was forced to live an increasingly retired life to look after her. In 1882 she died, and Tissot returned to Paris. At first he worked on scenes of Parisian life; later, after a mystic vision, he embarked on an ambitious series of illustrations of the Life of Christ, making two journeys to Palestine to study the topography first hand. A third journey to Palestine and a series of illustrations of the Old Testament followed, but Tissot died in 1902, leaving this series incomplete.

## Henri de Toulouse-Lautrec
## (1864-1901)

Born in Albi, Lautrec was a direct descendant of the medieval counts of Toulouse. His father was somewhat eccentric, given, for example, to making appearances in fancy dress – as a cowboy, or a Circassian, or, on one

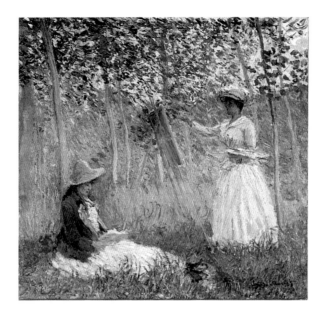

128. Claude Monet, *In the Woods at Giverny:*
*Blanche Monet at her easel with Suzanne*
*Hoschedé reading* (c. 1885–90)

occasion, wearing a Scottish plaid and a dancer's tutu at the same time. But his passions for hawking and hunting, and the pursuit of young women were suitably aristocratic. And he was also interested in art, and worked as an amateur sculptor.

The pattern of Lautrec's life was set by two childhood accidents: he broke one leg in 1878 and the other in 1879, and after this his legs stopped growing, though his torso developed normally. He turned into a grotesque dwarf. He was already by this time interested in art, and, in view of his pitiable physical infirmity, his family saw no harm in letting him pursue this. He had been studying, before his accidents, in the studio of René Princeteau, a well-known sporting artist who was a friend of his father. Now, in 1882, he entered the studio of the portraitist Léon Bonnat, with whom a number of the Impressionists had begun their training. Bonnat was nearing the end of his career as a teacher, and when he finally closed his studio, Lautrec migrated – with the other students – to the atelier of Fernand Cormon. This move had two important consequences: he became friends with his fellow student Emile Bernard, who was able to tell him about Impressionism at first hand; and, because Cormon's atelier was in Montmartre, Lautrec discovered the local cabarets and dance halls.

His work progressed rapidly so that by 1888 he had made sufficient progress to be asked to exhibit with Les Vingt in

Brussels, at that stage the most advanced exhibition society in Europe. He also soon established a pattern of living which was to be characteristic of his behaviour for the rest of his life. He had enormous energy, and an equally huge capacity for alcohol; working by day, he spent his nights rambling round Montmartre, surrounded by a little court.

His fame in Paris was established not by his paintings, but by his brilliant posters – most of all those he produced for his favourite dance hall, the Moulin Rouge, and for the cabaret artistes he admired, such as Aristide Bruant. His lifestyle only varied when he was seized with a passion: either for a certain performer, whom he would then go and see night after night; or for a specialized milieu. At one point he haunted the lesbian bars; he also spent several weeks immured in one of the luxurious licensed brothels (known as the *maisons closes*). He would even have his letters and messages addressed there.

Lautrec's way of life affected his health. Despite his grotesque appearance, he was sexually extremely active; he used to refer to himself as 'a little teapot with a big spout'. He contracted syphilis around 1888, and by the mid-1890s he was an alcoholic. In February 1899 he suffered an attack of *delirium tremens*, and was taken to an asylum in Neuilly; he was confined here until May and then released, but he was soon to begin drinking again. In August 1901 he had a paralytic stroke while on holiday in the country. He died three weeks later at his mother's house.

# List of Illustrations

42  *The Donkey Ride*, c. 1880
Oil on canvas, 32 × 39½ (81.3 × 100.3)
City of Bristol Museum and Art Gallery

84  *The Milliner*, c. 1877
Pastel and gouache on canvas, 17¾ × 14½ (45.3 × 37)
© 1988 The Art Institute of Chicago, All Rights
Reserved (Lewis Larned Coburn Memorial
Collection, 1972.362)

102  *Une loge au théâtre des Italiens*, c. 1874
Oil on canvas, 38¾ × 51½ (98 × 130)
Musée d'Orsay, Paris
Photo Réunion des musées nationaux

### MANET, Edouard (1832–83)

3  *Argenteuil*, 1874
Oil on canvas, 58¼ × 45¼ (148 × 115)
Musée des Beaux-Arts, Tournai, Belgium
Photo Giraudon

7  *Skating*, 1877
Oil on canvas, 36¼ × 28¼ (92 × 71.6)
Fogg Art Museum, Harvard University, Cambridge,
Massachusetts
(Bequest of Collection of Maurice Wertheim, Class of
1906)

8  *The Game of Croquet*, 1873
Oil on canvas, 28¼ × 41¾ (72 × 106)
Städelsches Institut, Frankfurt

16  *Chez Le Père Lathuille*, 1879
Oil on canvas, 36½ × 44 (93 × 112)
Musée des Beaux-Arts, Tournai, Belgium
Photo Giraudon

21  *Gare Saint-Lazare*, 1873
Oil on canvas, 36¾ × 45 (93.3 × 114.5)
National Gallery of Art, Washington DC
(Gift of Horace Havemeyer in memory of his mother,
Louisine W. Havemeyer)

36  *The Monet Family in their Garden*, 1874
Oil on canvas, 24 × 39¼ (61 × 99.7)
The Metropolitan Museum of Art, New York
(Bequest of Joan Whitney Payson, 1975)

38  *Madame Manet dans la serre*, 1876
Oil on canvas, 31¾ × 39¼ (81 × 100)
Nasjonalgalleriet, Oslo
Photo J. Lathion

39  *Sur le plage*, 1873
Oil on canvas, 23½ × 28¾ (59.6 × 73.2)
Musée d'Orsay, Paris
Photo Réunion des musées nationaux

40  *Le Repos* (Portrait of Berthe Morisot), 1870
Oil on canvas, 58¼ × 43¾ (147.9 × 111.1)
Museum of Art, Rhode Island School of Design
(Bequest of the Estate of Mrs Edith Stuyvesant
Vanderbilt Gerry)

41  *Portrait of Eva Gonzalès*, 1869–70
Oil on canvas, 75¼ × 52¼ (191 × 133)
By courtesy of the Trustees, National Gallery, London

72  *La Parisienne* (Portrait of Ellen Andrée), c. 1876
Oil on canvas, 75½ × 49¼ (192 × 125)
Nationalmuseum, Stockholm

73  *La dame aux éventails* (Portrait of Nina de Callias,
musicienne et artiste), 1873
Oil on canvas, 44¾ × 65½ (113.5 × 166.5)
Musée d'Orsay, Paris
Photo Réunion des musées nationaux

74  *Portrait of Isabelle Lemonnier*, c. 1879

Oil on canvas, 36 × 28¾ (91.4 × 73)
Dallas Museum of Fine Arts (Gift of Mr and Mrs Algur
H. Meadows and the Meadows Foundation Inc.)

75  *L'Automne* (Portrait of Méry Laurent), 1881
Oil on canvas, 28¼ × 19¾ (72 × 50)
Musée des Beaux-Arts, Nancy

81  *The Street Singer*, c. 1862
Oil on canvas, 67½ × 41¾ (171.3 × 105.8)
Courtesy of the Museum of Fine Arts, Boston
(Bequest of Sarah Choate Sears in memory of her
husband Joshua Montgomery Sears)

83  *La serveuse de bocks*, 1878–9
Oil on canvas, 30½ × 25½ (77.5 × 65)
Musée d'Orsay, Paris
Photo Réunion des musées nationaux

85  *At the Milliner's*, 1879
Oil on canvas, 33½ × 29 (85 × 73.7)
The Fine Arts Museums of San Francisco
(Mildred Anna Williams Collection)

92  *L'Olympia*, 1863
Oil on canvas, 51¼ × 74¾ (130 × 190)
Musée d'Orsay, Paris
Photo Réunion des musées nationaux

94  *Nana*, 1877
Oil on canvas, 59 × 45½ (150 × 116)
Kunsthalle, Hamburg
Photo Ralph Kleinhempel

104  *Lola de Valence*, 1862
Oil on canvas, 48½ × 36¼ (123 × 92)
Musée d'Orsay, Paris
Photo Réunion des musées nationaux

114  *Bar at the Folies-Bergère*, c. 1881–2
Oil on canvas, 37¾ × 51¼ (96 × 130)
Courtauld Institute Galleries, London
(Courtauld Collection)

### MONET, Claude (1840–1926)

22  *Le Déjeuner*, 1868
Oil on canvas, 90½ × 59 (230 × 150)
Städelsches Institut, Frankfurt

29  *Femmes au jardin*, 1867
Oil on canvas, 88½ × 80¾ (225 × 205)
Musée d'Orsay, Paris
Photo Réunion des musées nationaux

33  *Camille*, 1886
Oil on canvas, 91 × 59½ (231 × 151)
Kunsthalle, Bremen

34  *La Japonaise* (Camille Monet in Japanese
costume), 1875–6
Oil on canvas, 91¼ × 56 (231.6 × 142.3)
Courtesy of the Museum of Fine Arts, Boston
(1951 Purchase Fund)

35  *Woman with a Parasol*, 1875
Oil on canvas, 39¼ × 32 (100 × 81)
National Gallery of Art, Washington DC
(Collection of Mr and Mrs Paul Mellon)

59  *Portrait of Madame Gaudibert*, 1868
Oil on canvas, 85½ × 54½ (217 × 138.5)
Musée d'Orsay, Paris (Galerie du Jeu de Paume)
Photo Réunion des musées nationaux

128  *In the Woods at Giverny: Blanche Monet at her easel with
Suzanne Hoschedé reading*, c. 1885–90
Oil on canvas, 36 × 38½ (91.4 × 97.8)
The Los Angeles County Museum of Art (Mr and Mrs
George Gard De Sylva Collection) M.46.3.4

### MORISOT, Berthe (1841–95)

1  *Le Berceau*, 1872
Oil on canvas, 22½ × 18½ (56 × 46)
Musée d'Orsay, Paris
Photo Réunion des musées nationaux

26  *The Artist's Sister, Mme Pontillon, seated on the Grass*, 1873
Oil on canvas, 17¾ × 28½ (45.1 × 72.4)
The Cleveland Museum of Art (Gift of Hanna Fund)

43  *The Mother and Sister of the Artist*, 1869–70
Oil on canvas, 39½ × 32¼ (100.3 × 81.9)
National Gallery of Art, Washington DC
(Chester Dale Collection)

58  *At the Ball*, 1875
Oil on canvas, 24½ × 20½ (62.2 × 52.1)
Musée Marmottan, Paris
Photo Routhier, Studio Lourmel 77, Paris

78  *Portrait of Madame Pontillon*, 1871
Pastel, 32 × 25½ (81 × 65)
Musée d'Orsay, Paris
Photo Réunion des musées nationaux

### PISSARRO, Camille (1830–1903)

79  *The Little Country Maid*, 1882
Oil on canvas, 25 × 20¾ (63.5 × 53)
Tate Gallery, London

80  *The Pork Butcher*, 1883
Oil on canvas, 25½ × 21¼ (65.1 × 54.3)
Tate Gallery, London

### RENOIR, Auguste (1814–1919)

page 2  *At the Concert*, 1880
Oil on canvas, 39 × 31¾ (99.2 × 80.6)
Sterling and Francine Clark Art Institute,
Williamstown, Massachusetts

4  *Diana*, 1867
Oil on canvas, 77 × 55¼ (199.5 × 129.5)
National Gallery of Art, Washington DC
(Chester Dale Collection, 1962)

5  *Bather Arranging Her Hair*, 1885
Oil on canvas, 36¼ × 28¾ (92.1 × 73)
Sterling and Francine Clark Art Institute,
Williamstown, Massachusetts

9  *The Lovers*, c. 1875
Oil on canvas, 68¾ × 51¼ (175 × 130)
Národní Galerie, Prague
Photo Milan Posselt

10  *Dance at Bougival*, 1882–3
Oil on canvas, 71½ × 38½ (182 × 98)
Courtesy of the Museum of Fine Arts, Boston
(Purchase, Picture Fund, 1937)

11  *Danse à la ville*, 1883
Oil on canvas, 71 × 35½ (180 × 90)
Musée d'Orsay, Paris
Photo Réunion des musées nationaux

12  *Le Moulin de la Galette à Montmartre*, 1876
Oil on canvas, 51½ × 68¾ (131 × 175)
Musée d'Orsay, Paris
Photo Réunion des musées nationaux

13  *The Luncheon of the Boating Party*, 1881
Oil on canvas, 51 × 68 (129.5 × 172.5)
The Phillips Collection, Washington DC

14  *La Grenouillère*, 1869
Oil on canvas, 26 × 32 (66 × 81.3)
Nationalmuseum, Stockholm

# Select Bibliography

**GENERAL**

GARB, TAMAR *Women Impressionists*, Phaidon, Oxford, 1986
HERBERT, ROBERT L. *Impressionism: Art, Leisure and Parisian Society*, Yale University Press, New Haven and London, 1988

**CAILLEBOTTE**

VARNEDOE, KIRK *Gustave Caillebotte*, Yale University Press, New Haven and London, 1987

**CASSATT**

BREESKIN, ADELYN DOHME *Mary Cassatt: a catalogue raisonné*, Smithsonian Institute Press, Washington DC, 1970
MATTHEWS, NANCY MOWLL *Mary Cassatt*, Harry N. Abrams Inc., New York, 1987

**CÉZANNE**

LONDON, THE ROYAL ACADEMY OF ARTS *Cézanne: The Early Years 1859–1872*, catalogue, 1988
RUBIN, WILLIAM (ed.) *Cézanne: The Late Work*, Thames & Hudson, London, 1977

**DEGAS**

DUNLOP, IAN *Degas*, Thames & Hudson, London, 1979
GORDON, RICHARD and FORGE, ANDREW *Degas*, Thames & Hudson, London, 1988

**GAUGUIN**

BRETTELL, RICHARD et al *The Art of Paul Gauguin*, National Gallery of Art, Washington and the Art Association of Chicago, in association with New York Graphic Society, Little Brown and Company, Boston, 1988

**MANET**

PARIS, GALERIES NATIONALES DU GRAND PALAIS *Manet*, catalogue, 1983
PERRUCHOT, HENRI *Manet*, Perpetua Books, London, 1962

**MONET**

GORDON, ROBERT and FORGE, ANDREW *Monet*, Harry N. Abrams Inc., New York, 1963

**MORISOT**

STUCKEY, CHARLES F. and SCOTT, WILLIAM P. *Berthe Morisot, Impressionist*, Hudson Hills Press, New York, 1987

**PISSARRO**

LONDON, HAYWARD GALLERY *Pissarro*, catalogue, 1980

**RENOIR**

WHITE, BARBARA EHRLICH *Renoir: His Life, Art and Letters*, Harry N. Abrams Inc., New York, 1984

**SEURAT**

HOMER, WILLIAM INNES *Seurat and the Science of Painting* the M.I.T. Press, Cambridge, Mass., 1964
RUSSELL, JOHN *Seurat*, Thames & Hudson, London, 1965

**TOULOUSE-LAUTREC**

ADRIANI, GOTZ *Toulouse-Lautrec: the Complete Graphic Works*, the Royal Academy of Arts/Thames & Hudson, London, 1988
COOPER, DOUGLAS *Toulouse-Lautrec*, revised edition, Thames & Hudson, London, 1988

# Index